THE COMPLETE GUIDE TO DIGITAL

NIGHT & LOW-LIGHT PHOTOGRAPHY

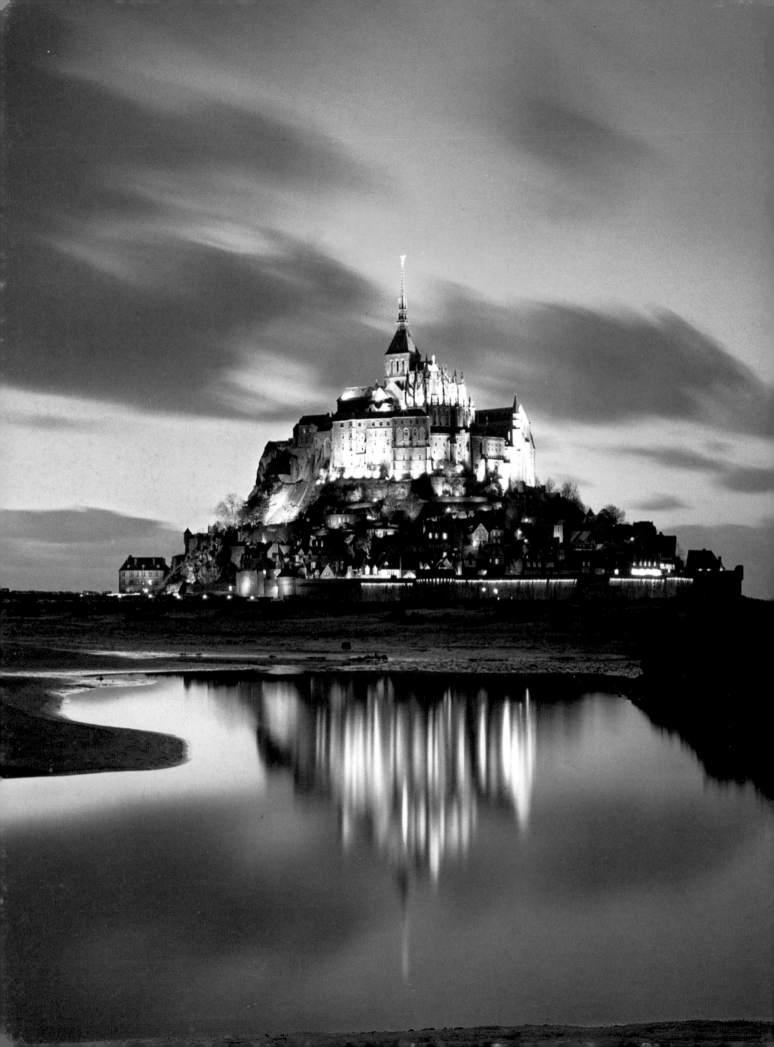

THE COMPLETE GUIDE TO DIGITAL

NIGHT & LOW-LIGHT PHOTOGRAPHY

TONY WOROBIEC

D&C
David and Charles

For my wife and life-long soulmate, Eva

A DAVID & CHARLES BOOK
Copyright © David & Charles Limited 2009

David & Charles is an F+W Media Inc. company
4700 East Galbraith Road
Cincinnati, OH 45236

First published in the UK and USA in 2009
First paperback edition 2009. Reprinted 2010

Text and photographs copyright © Tony Worobiec 2009, except
photographs on pp. 48 (bottom left), 62 (right), 69, 77 (top left and
bottom left), 85 (bottom), 106 (top) copyright © Eva Worobiec 2009

Tony Worobiec his asserted his right to be identified as author of
this work in accordance with the Copyright, Designs and Patents
Act, 1988.

A catalogue record for this book is available from the
British Library.

ISBN-13: 978-0-7153-3012-8 hardback
ISBN-10: 0-7153-3012-8 hardback

ISBN-13: 978-0-7153-3855-1 paperback
ISBN-10: 0-7153-3855-2 paperback

Printed in China by RR Donnelley
for David & Charles
Brunel House Newton Abbot Devon

Commissioning Editor: Neil Baber
Desk Editor: Emily Rae
Project Editor: Nicola Hodgson
Art Editor: Sarah Clark
Production Controller: Beverley Richardson

Visit our website at www.davidandcharles.co.uk

CONTENTS

INTRODUCTION

I have to confess that in recent years I have been increasingly drawn to photographers who work in low light. Alfred Seiland's impressive publication *East Coast–West Coast* certainly whetted my appetite, as indeed have the wonderful images that Joel Meyerowitz has produced over numerous years. Both photographers have illustrated contemporary America, and by shooting largely in low light, they have been able to present images that have an extraordinary and disquieting beauty.

I was eventually drawn to the idea of using low light in my own creative work when I saw an exhibition at the Victoria and Albert Museum in London entitled *Twilight: Photography in the Magic Hour.* This featured the work of contemporary image-makers such as Philip Lorca diCorcia, Robert Adams and the amazing Gregory Crewdson. To say that I was blown away by the work I saw is an understatement. In addition, stepping outside the world of photography, I must name another source of inspiration, namely the hauntingly beautiful paintings of the American painter Edward Hopper (1882–1967). I particularly admire his ability to use light and colour to imbue an otherwise commonplace scene with a strange and theatrical sense of alienation.

What these great artists have taught me is that the banal can look exciting in low light. Familiar objects can appear sculptural when they are illuminated by a single light source. Things that we are accustomed to seeing in daylight are transformed, frequently assuming wonderfully saturated colours when viewed at night. The pattern of people's lives change at this time of the day. As the roads become deserted, people are at home relaxing or possibly sleeping, and the world becomes a much quieter place. Familiar buildings that in the daytime you might never give a second glance can be changed into palaces of light at nighttime. A stretch of coastline that had become just too familiar can be seen afresh when photographed over a period of minutes, while heavily polluting industry, which could never be described as beautiful, changes out of all recognition.

It was only after working on several personal low-light projects that I fully appreciated the many opportunities I had been missing. Averaged out over the year, each day offers us just 50 per cent light, but when you consider that at least an hour of that can reasonably be described as twilight you begin to appreciate how much low light we each encounter. Factor in those numerous occasions when we experience low

light through poor weather, flat lighting, or the many times that we find potentially exciting photographic opportunities indoors, and I am left wondering about the enormous scope that this specialized area of photography offers.

It is worth noting that there are virtually no climatic conditions that do not offer excellent photographic opportunities. Whether you have a dramatic sunrise or a very dour sunset, something exciting will occur. As many of the exposures made will be lengthy, it is important that you learn to embrace the unexpected. Figures or vehicles will appear out of nowhere, but often they add an interesting further dimension to your work. But most importantly, this is the genre of the unplanned and unforeseen, and it is essential that you learn to approach each situation with an open mind.

Does using a modern digital SLR make the task of photographing in low light any easier? It certainly does, in my opinion. What I aim to do in this book is to examine the many standard features of a modern DSLR camera and think specifically how these can help us in our low-light photography. I shall also consider suitable lenses and other pieces of equipment that could prove useful. There are a wide variety of in-camera techniques – some conventional and others less so – that can be used when photographing in low light, and we will also attempt to cover a comprehensive range of situations.

While it is always desirable that any changes are made in-camera, sometimes that is not always possible, so in the final chapter we look at some of the post-production techniques that may be helpful.

Ultimately, I hope this book inspires you to take exciting images in the dark. In essence, you should be able to take photographs at any time of the day, irrespective of the available light. By being able to view the LCD on your camera, you receive almost immediate feedback, which in itself should encourage innovation and spontaneity. Photograph anything that vaguely looks interesting in low light and you will be surprised by how many new opportunities will materialize. Whether your penchant is for landscape or seascape, or you simply want to learn to photograph interiors, this book should help you to photograph in low-light situations.

Try something new today!

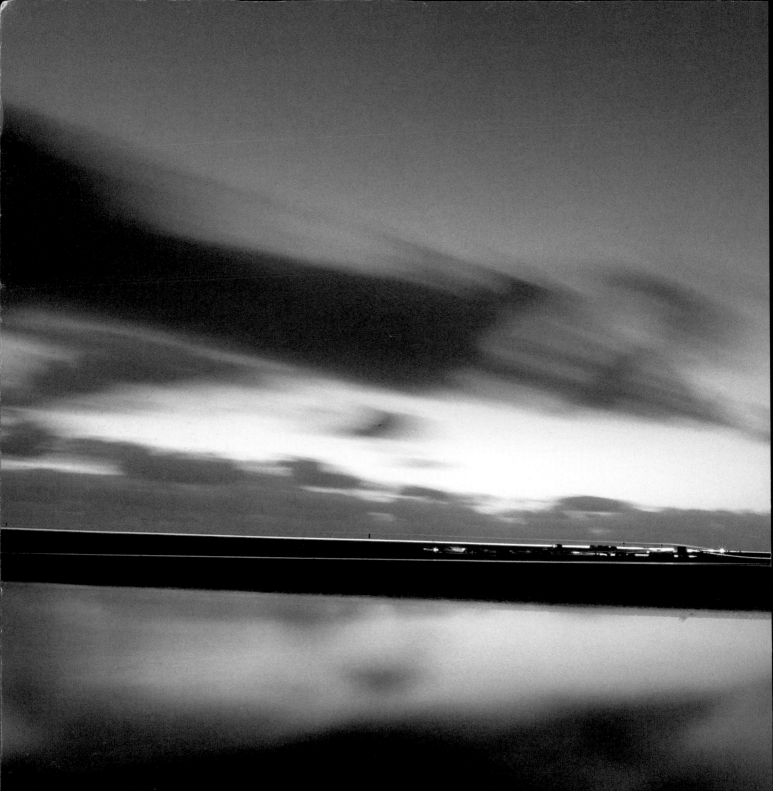

CHAPTER ONE
YOUR EQUIPMENT

KNOW YOUR DIGITAL SLR CAMERA

If you have upgraded to a digital SLR (DSLR) from a compact, or have recently given up film to go digital, then there will be many features that you will recognize, but possibly one or two that you will find less familiar. While individual models vary slightly, most DSLRs conform to a generic type. One thing is for certain: the quality of capture from DSLRs has improved enormously in recent years. It was only a few years ago that I was marvelling with a colleague about the ten-megapixel breakthrough that one or two manufacturers were achieving. This is now commonplace and some cameras coming onto the market now are offering even more.

As a long-time user of medium-format cameras, I must acknowledge that the quality that can now be achieved from a modestly priced DSLR can reasonably compete with a smaller medium-format camera. It is also important to note that the number of available megapixels should not be seen as the only criterion to achieve great photographs – the quality of the lenses is equally important. The cheaper ones can suffer from chromatic aberration and pincushion

and barrel distortion. Often DSLRs are sold as a package including a cheap single zoom lens, so try to buy the camera body separate from the lens and then buy the best and most suitable lens you can afford. Pay particular attention to the colour saturation, contrast, colour accuracy and sharpness of the lens. These comparative specifications are often comprehensively and objectively reviewed in photography magazines. Unlike a compact, lenses for a DSLR are interchangeable. Consequently, you can add to your equipment as your finances allow. While they share similarities with a traditional film lens, the sensors in all but a very few DSLRs are smaller than standard 35mm film. Therefore they need a shorter focal length for the same angle of view. As a simple rule of thumb, multiply the DSLR magnification by 1.6. Most lenses will come as autofocus; in most circumstances that is an excellent facility, although occasionally it is worth operating your lens in Manual mode.

Exposure modes

Most DSLRs offer at least four exposure modes: Program, Shutter priority, Aperture priority and Manual.

Program mode (P)

This mode automatically works out the best aperture and speed for the current lighting situation. Generally when using this mode the exposure will be accurate, but you are abdicating far too many decisions to the camera. It is a good

The Canon EOS 40D is typical of the many excellent medium-range DSLRs currently available. Virtually all research and development in photography is being channelled into producing better and more sophisticated digital cameras. Getting to know your camera is an essential part of being able to maximize its potential.

Always in pursuit of excellence, camera manufacturers now produce full-frame DSLR cameras that feature larger sensors than the standard DSLR and consequently boast higher resolution. The Canon EOS 5D was one of the first of this new breed of DSLRs.

option to use when you need to act very quickly and do not have sufficient time to set either the aperture or speed rating in advance; however, if you wish to be in total control, you may prefer to select another option.

Shutter priority (Tv)

This is a semi-automatic mode where you select the shutter speed while the camera works out the correct aperture relative to the available light. This mode is best suited when capturing movement is the priority and the depth of field is of secondary importance. Typically a sports photographer, street photographer or photojournalist might opt for this.

Aperture priority (Av)

This is a semi-automatic mode where the aperture is set by the photographer and the camera works out the required shutter speed. This option is usually favoured by landscape photographers who want full control of depth of field, where speed is not really an issue.

Manual mode (M)

This is often ignored by inexperienced photographers, but in tricky lighting situations – particularly in low-light photography – making a light reading independent of the camera and then selecting the correct aperture and shutter speed is often the best solution. Your camera cannot think for you in every situation, so take control.

Metering modes

One of the great advantages of modern DSLR cameras is the variety of metering modes they offer. These are designed to ensure that your exposure is accurate every time. In most lighting conditions, the Evaluative metering mode works extremely well. However, it is important to appreciate that your metering system is designed to achieve a notional 18 per cent grey and can easily be fooled by very bright or very dark situations. The classic error is photographing snow; as the meter is trying to achieve 18 per cent grey, this often leads to underexposure. This is where using the bracketing mode of the camera really helps.

On a similar note, backlighting can also present difficulties. The Centre-weighted mode copes particularly well in these circumstances; however, if the subject is backlit and the surrounding light is strong then using the Partial metering mode might be a better option. When shooting digitally, the rule of thumb is to expose for the highlights, as shadow detail is much easier to retrieve post-camera. Similarly, if you are metering off-camera, take your light readings from the highlights, or bracket your exposures.

Modern DSLR cameras generally offer various metering modes, which make the task of photographing in low light considerably easier.
Canon EOS 5D, 50mm lens, 4 sec at f/16, ISO 50

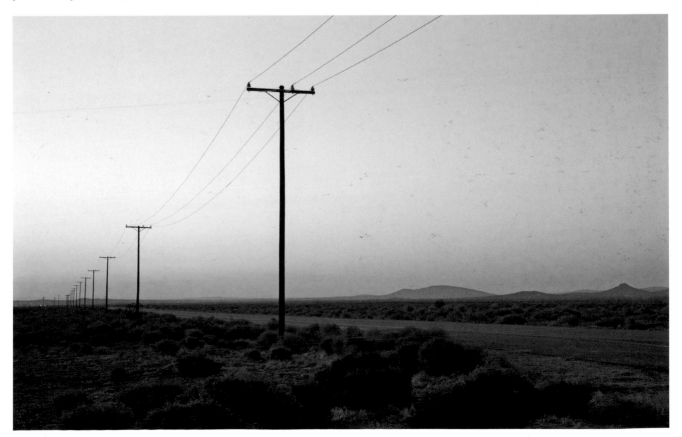

The ISO range

One of the biggest advantages of DSLRs is that you can change your ISO rating frame by frame. You might want to take a shot of moving water in low light and create an atmospheric blur; selecting an ISO rating of 100 or less would be most appropriate. Conversely, your next shot might require photographing a moving figure at twilight. By upgrading your ISO to 1600 or 3200, you should be able to achieve this while still handholding the camera. You simply need to match the ISO rating to the task in hand.

Most DSLRs operate between ISO 100 and ISO 1600, although some of the more expensive ones have an ISO range of 50–3200. The lower the ISO rating, the slower it is. However, it should be able to deliver very fine detail. A fast ISO rating such as 1600 or 3200 is excellent when speed is required, but noise can be apparent, particularly if the image is over-magnified. A parallel can be drawn with film – the faster it is, the more grainy the image is likely to be.

Autofocus facility

There are cases when you might want to use autofocus, particularly if you are involved with sports photography, reportage or wildlife photography. It is less useful when taking a landscape shot on a tripod when a very small aperture has been selected. The autofocus facility can be especially troublesome in very low light. The lens has difficultly establishing a suitable point of focus and consequently goes into 'hunt' mode, which prevents you taking your shot. In those situations, it is best simply to switch it off and focus manually. Getting into the habit of pre-focusing in low-light situations can prove helpful.

The memory card

The memory card replaces what once was film. There are several types; popular ones include CompactFlash (CF), and the Secure Card (SD). If you are shooting Raw, then you will need a memory card of at least 4GB. The largest cards go up to 12 or 16GB, and can store a considerable number of images – although when out on location you should always have two memory cards in case one fills up, or just fails. Moreover, it is worth buying a card reader in order to speed up download times.

It is sometimes suggested that you should buy a memory card with the largest memory, as this greatly reduces the number of cards you need for any photographic trip you wish to make. But in some ways you risk putting all your eggs in one basket. If all of your prized shots are stored on a single memory card and it failed in some way or was lost, all your images would be lost too. It is far better to spread your capture over several smaller cards. Personally, I find using several cards, each with 4GB of memory, adequate for most circumstances.

You might also consider purchasing a personal storage device; these are, in effect, small mobile external hard drives. They can store several thousand images at a time and allow you to view your files on a high-resolution screen.

Color Space

The Color Space refers to the range of reproducible colours. All DSLRs and some top-end compacts offer a choice of sRGB and RGB in the submenus. They both offer the same number of colours. If you are shooting Raw, it does not matter which one you choose because the processing

LEFT It is often tempting to use a memory card with a large file size, but you might risk losing your images by storing them all in the same place. Using several 2GB or 4GB cards files is a more sensible policy.

RIGHT The LCD is not only useful for displaying images just taken; it is also used for displaying the menu options. Illuminated in this way, it makes the task of selecting the appropriate menu considerably easier, particularly in low-light situations.

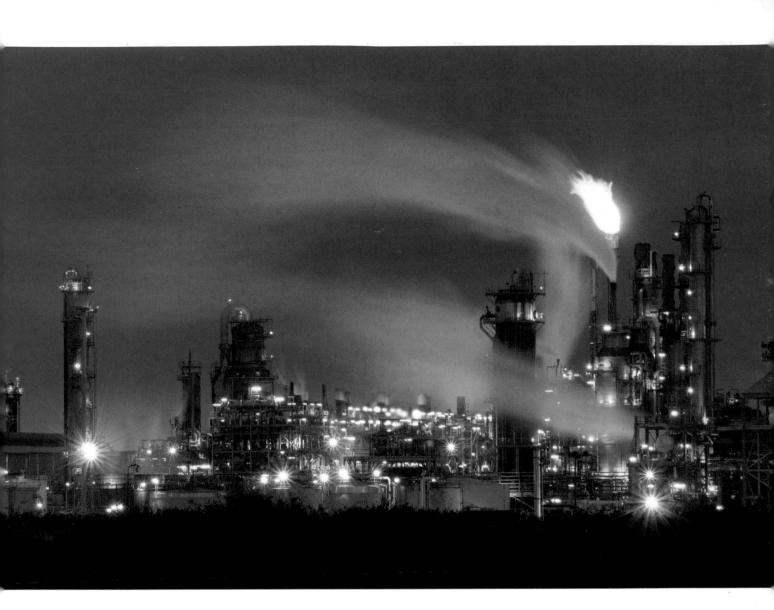

software can override it. Camera manufacturers often suggest that you shoot sRGB. However, if you intend to do some post-production work with software such as Photoshop, you should use Adobe RGB.

Software

All DSLRs come with bundled software to help you edit your images. These are of some use; however, should you wish to edit your images more seriously, you would be well advised to buy one of the Photoshop packages. These are generally viewed as being the industry standard. The techniques discussed in most photography magazines generally assume that you are a Photoshop user, although increasing reference is being made to Lightbox. You should also be able to obtain software to help you convert your Raw digital files; sometimes this needs to be downloaded directly from the camera manufacturer's website.

The LCD monitor

The LCD monitor is the other great advantage of using a DSLR camera; you can review your shot straight away. There will be a zoom facility that allows you to check the image for composition or sharpness, although I am not convinced that you can accurately assess exposure; you are far better off referring to the histogram instead. The LCD is also used to display the menu options.

Most low-light situations are unpredictable, such as in this example where outpourings of steam and gas occured suddenly, without warning, and had an effect on the best exposure. Being able to refer to a monitor in such situations is particularly helpful, although it is also worth checking the histogram.
Canon EOS 5D, 70–200 zoom lens, 14 sec at f/11, ISO 100

tip

If you buy a new memory card before going on an important photographic assignment, check that it works before you leave.

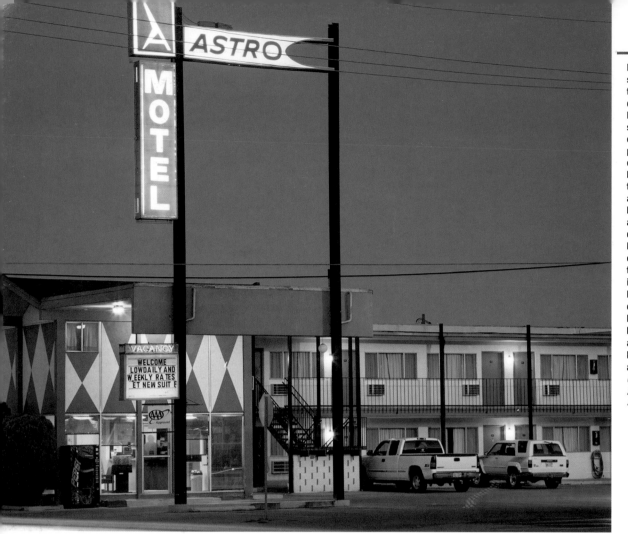

THE WHITE BALANCE FACILITY

The White Balance (WB) facility is a feature common to all DSLR cameras that can greatly help the photographer in difficult lighting conditions. It is perhaps a measure of how things have moved on, but White Balance was not an issue when using a film SLR camera. Most photographers would opt to use a normal daylight film for most low-light situations and would possibly use a tungsten film for some tricky interior shots. The problem was that once you had put a tungsten-balanced film into the camera, you were committed to using it until it was completed, even if it was inappropriate to do so with some of the subsequent shots; this was truly a recipe for wasted film. Another solution was to use a tungsten correction filter, but this would increase the length of exposure, which only served to exacerbate reciprocity failure. An enormous advantage of using a DSLR camera is that you are able to select the correct White Balance frame by frame. Moreover, you have far greater choice as you are able to tailor the White Balance facility to very specific lighting situations.

The traditional daylight film was balanced to 5500 Kelvins (5500k) – the measure of light one would anticipate at noon on a sunny day, so that a white object (a small building on a hill, for example) would appear white. The higher the colour temperature the bluer the light; the lower the colour temperature the more orange the light. In the late afternoon, as the sun begins to fall, the measure of light in Kelvins is likely to drop to around 3000. The colour of an object is constantly changing depending on the ambient lighting conditions at the time, as it is conditional on the height of the sun and whether it is cloudy or not. Generally, a modern DSLR camera can read these variations using the White Balance function.

Taking the same white building as an example, if you photographed it in the late afternoon you should expect it to have a warm golden glow (which, strictly speaking, is a colour cast). Colour casts are always most evident in white areas or in areas you would expect to appear as grey. This process of warming up the colours increases as the sun falls, and most landscapes assume a distinctive orange/red glow at sunset. The question, of course, is whether you want to keep that colour cast. In most cases you do. However, there are occasions when you do not, particularly in overcast light when the cast created is not so attractive. This can be avoided by selecting one of the White Balance presets.

Interiors can be challenging because the sources of lighting are often mixed. If you are certain that an interior is lit by either tungsten or fluorescent, select the appropriate White Balance setting. Otherwise, opt for Auto and, if necessary, make further changes in the Raw dialog.
Canon EOS 5D, 24–105mm zoom lens, 33 sec at f/22, ISO 200

Using a DSLR set to the Auto White Balance (AWB) setting copes well with most situations. However, low-light photography poses its own set of challenges, which often require setting the White Balance facility manually. In addition to the AWB facility, most DSLRs offer the following presets:

- Daylight – approximately 5200k
- Shade – 7000k
- Cloudy – 6000k
- Tungsten light – 3200k
- White fluorescent light – 4000k

Many DSLRs feature numerous sophisticated facilities; some even provide a White Balance correction facility that allows you to make small incremental changes to the White Balance set. Most offer a White Balance auto-bracketing facility. When this is selected, with each shot taken three images will be recorded simultaneously showing varying colour tones. For example, in addition to the preset White Balance, it will record one with either a blue or amber bias, and one with a green or magenta bias.

Raw versus JPEG

It needs to be understood that all indoor lighting will create a cast, as will some outdoor situations, particularly in low light. Only if flash is used can this be reliably overcome, but there may be many reasons why this is not practical. There will be occasions when it is simply not feasible to make adjustments to your menu. Or it may be difficult to judge the precise source of light, and deciding on a definitive setting becomes harder. Also, it is surprising how often the lighting is mixed in many low-light situations, so which White Balance setting do you opt for?

I will often emphasize the merits of shooting Raw, but certainly when shooting in difficult lighting situations shooting Raw has distinct advantages. The most obvious one is that the White Balance can be changed later on at your leisure. Low-light photography often requires making quick decisions, and the fewer you need to make the better. The major bonus of using JPEGs is that they take up less space on your memory card and allow you to shoot fast action. Raw, however, offers the best quality possible and also offers numerous editing facilities. Most low-light photographic situations require long exposures; coupled with the advantage of being able to make White Balance changes after the image has been taken, the argument for shooting Raw becomes compelling.

LENSES AND LENS HOODS

When thinking about lens options, cost is generally the main consideration, although you should also think about the style of photography you are interested in. Many independent manufacturers now produce lenses that are cheaper than those produced by the camera manufacturers but are of equal quality. Do your research thoroughly before buying; magazine reviews are an excellent source of up-to-date information.

Problems with legacy lenses

Lenses designed for traditional SLRs made the assumption that light passes directly through the lens onto the film; therefore, some lens manufacturers did not bother to coat the rear of the lens. When using these uncoated lenses with a DSLR, problems can arise as some of the light reflects back off the sensor; this results in a soft image. While some of the bigger camera manufacturers (Canon and Nikon, to name but two) always did coat the rear lens, all lens manufacturers now do. Quality aside, most recently produced lenses designed for 35mm cameras can also be used on a DSLR camera. However, increasingly lens manufacturers produce lenses that will work with a 35mm system but are matching the image circle to the smaller CCD or CMOS sensors typical in most DSLRs. These sensors are smaller than the traditional 35mm film format. Consequently, the focal range of any of the lenses needs to be increased by, on average, 1.6. To give an example, a 35mm lens that traditionally would have been seen as a medium wide-angle lens will effectively operate as a 56mm lens when used on a DSLR camera, thereby making it an ideal standard lens. There are exceptions: some of the most expensive DSLRs are produced as full-frame cameras, and therefore their lenses will operate as if on a standard 35mm camera.

Using a telephoto lens reduces the distortions one often encounters when using a wider-angle lens, particularly when photographing architectural details.

The standard lens

Traditionally, the 50mm lens was seen as the standard lens. It will operate on most digital cameras as a very short telephoto lens, but it still offers considerable advantages. As these lenses are cheaper to manufacture than most other lenses, it is possible to make them with a larger maximum aperture; f/2.8 is the norm, but some of the more expensive standard lenses go down to f/1.4, which offers enormous benefits in terms of low light. If you use a moderately fast ISO setting coupled with a shutter speed of 1/60 sec, there will be many low-light situations where you should be able to handhold your camera when using one of these lenses. If the lens comes with a lens stabilizer, you should be able to handhold down to 1/15 sec. Situations where a lens of this kind will prove particularly useful include photographing reportage in low light and taking informal portraits.

The wide-angle lens

The wide-angle lens has a broader angle of view than the standard lens and also a much deeper depth of field. Even at f/8, most wide-angle lenses can show everything in focus. Traditionally, a wide-angle lens started with a 35mm. However, once we apply the 1.6 increase, effectively a wide-angle lens starts at 24mm. Because of their short focal length, it is possible to handhold the camera at speeds as low as 1/30 sec even without a stabilizer. Coupled with a flexible depth of field, this is another lens you can handhold in many low-light situations. These lenses are also an excellent choice when you want to take a wide-angle view within a confined space. Consequently, they are often used to take architectural or interior shots. Moreover, many landscape photographers use a wide-angle lens in order to capture a full panorama.

The downside to using wide-angle lenses, particularly ultra-wide-angle lenses, is that they are prone to distorting the image. This is particularly noticeable when photographing buildings, as the verticals appear to converge. You can buy specialist wide-angle shift lenses to overcome this problem, but they are costly. One post-production solution is to use the Transform facility in Photoshop.

Telephoto or long-angle lenses

These are often assumed to be the same, but although they perform similar tasks, they are quite different. Long-angle lenses are so called not just because of the angle of view they offer but because of their physical length. Increasingly manufacturers are producing telephoto lenses that, because they are constructed with two groups of lenses, converge at the front and diverge at the back and are much shorter than the older long-angle lens. These lenses tend to be slower than the standard lens, and they operate with a much

Zoom lenses can be used to produce creative effects. In this example, I zoomed the lens during a 2-second exposure.
Canon EOS 5D, 70–200mm zoom lens, 2 sec at f/8, ISO 50

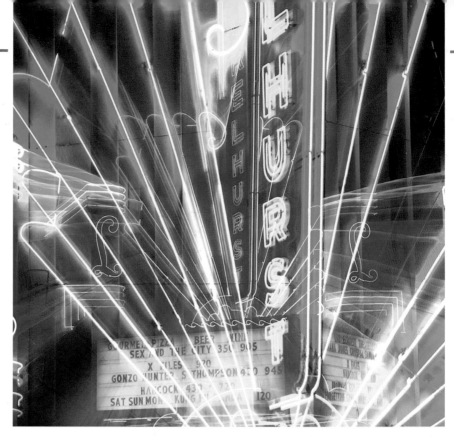

tip

When in an interesting location, be prepared to experiment with a variety of lenses: do not always opt for the obvious choice.

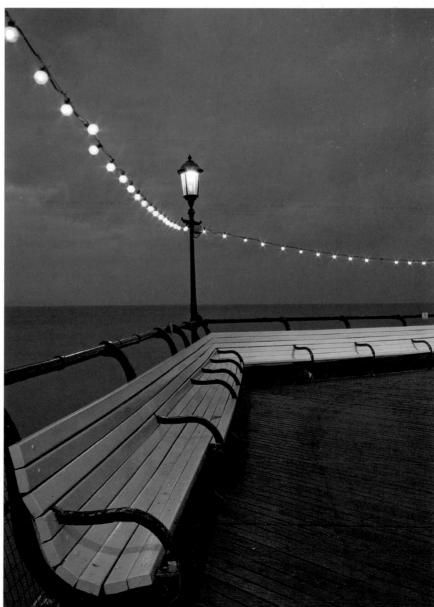

One of the greatest advantages of a wide-angle lens is that it allows you to take shots in tight situations. In this case, there was a kiosk almost immediately behind me that prevented me from using a longer-angle lens.
Canon EOS 5D, 20mm lens, 2 sec at f/16, ISO 100

reduced depth of field. As you require a very small aperture to ensure that everything is in focus, they necessitate being used on a tripod, particularly in low light. You can, however, achieve wonderful results when using these lenses with the aperture wide open, as an effect called 'circles of confusion' will appear in those areas that are out of focus. This works particularly well when a subject is photographed against a city background. Telephotos are also useful when you wish to isolate a subject from the background by using a narrow depth of field. Consequently they are often used for portrait and figure work.

Zoom lenses

The quality of these lenses has vastly improved in recent years, and many photographers get by with just one or two zooms. They offer enormous advantages. Being able to switch from standard to wide, or perhaps to telephoto, offers the photographer not only convenience but a genuine aid to creativity. What we see with our eyes is not always matched by what we see through the viewfinder, but being able to see the subject instantly through varying focal lengths offers us enormous scope. Good composition is always at the heart of good photography, and zooms certainly help. Zoom lenses also offer considerable benefits from a practical standpoint. For example, changing lenses in a low-light situation can be difficult, but you should be able to avoid this by using a zoom.

Lens hoods

It is sometimes assumed that lens hoods are no longer required when the sun has disappeared, but artificial lighting from adjacent streets or building can also create flare. Many telephoto and zoom lenses come with an integral lens hood, as do some wide-angle lenses. It is these that are particularly prone to flare, so if your wide-angle lens does not come equipped with a hood you should consider getting one. It is important that these are accurately fitted over the lens, or you may experience vignetting.

Lens converters

These are becoming increasingly popular for extending the focal length of a lens or possibly for converting a lens to macro. While they can serve a purpose, do not expect them to achieve the standard of quality you would expect from a prime lens.

Keeping your lens clean

There is little point in buying an expensive lens if you do not keep it clean. A dirty lens can quite markedly affect the final image, causing a loss of contrast, marks across the image and loss of sharpness. The general rule is to use a UV filter. These are designed to absorb UV radiation, but they have only a minimal effect on the overall colour of the image, making them the ideal filter to use to protect the outer

Often the most exciting use of a lens can be seen when you illustrate its limitations. Telephoto lenses have a very narrow depth of field when using a wide aperture, but this can be used dramatically to throw the background out of focus. The characteristic 'circles of confusion' are particularly noticeable in this sort of lighting.
Canon EOS 5D, 70–200mm zoom lens, 2 sec at f/5.6, ISO 400

element of the lens. It should also offer a slight improvement to the colour saturation. A filter can easily be cleaned and, if damaged, replaced far more cheaply than a lens. Try never to touch your camera lens; the natural grease on one's fingers contains an acid that can harm the surface. If you do cause a mark, make sure that you clean it using only specially designed lens-cleaning tissues.

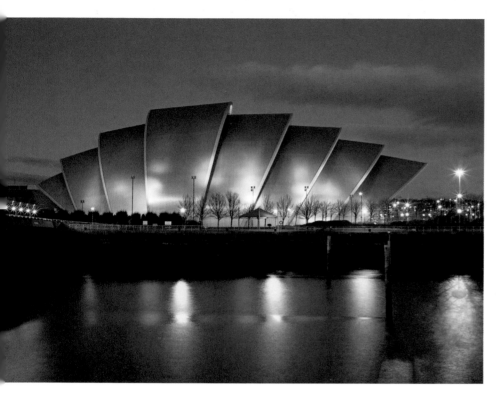

LEFT Situated on the banks of the River Clyde in Glasgow, Scotland, this fabulously intriguing structure is known locally as 'the slug'. It is easy to overlook the virtues of the standard 50mm lens, which is the one that comes closest to our eyes' natural focal length. As these lenses tend to be cheaper to construct than most other lenses, most have a maximum aperture of f/2.8. Some of the more expensive ones can be as large as f/1.8 or f/1.4, which makes them particularly suited to low-light and night photography.
Canon EOS 40D, 50mm lens, 23 sec at f/22, 100 ISO

BELOW One of the great features of a wide-angle lens is its capacity to exaggerate perspective. By taking this viewpoint, I made Bournemouth pier in the south of England look far longer than it actually is.
Canon EOS 5D, 20mm lens, 24 sec at f/16, ISO 100

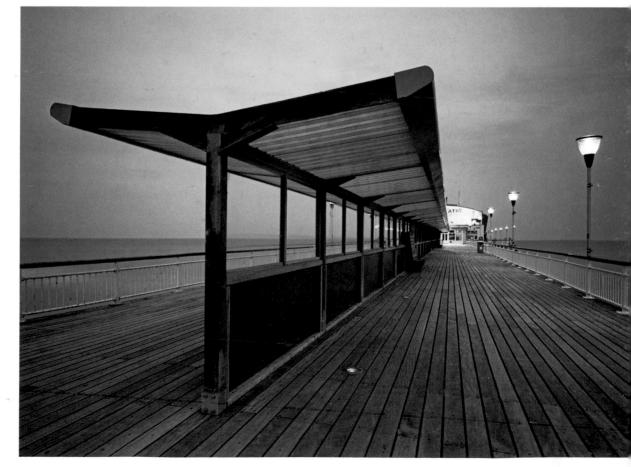

CAMERA SUPPORT

I suggest that low-light photography can be defined as any exposure requiring an exposure of one second or more when using a shutter speed of f/22 and an ISO rating of just 100. These settings will, of course, introduce technical problems, especially that of images blurring. Here are some methods to support the camera and combat this problem.

The tripod

The majority of images captured in low light will be taken on a tripod or similar support system. From a personal standpoint, I view my tripod second only in importance to my camera. With it, I know that I am able to choose any ISO I want in conjunction with whatever aperture I need. I regard it as an indispensable part of my equipment. I would suggest that you buy the best tripod that you can afford and the heaviest you can comfortably carry. Your tripod will be expected to do more than just support your camera and lens; as some of your exposures might extend to five minutes or more, you are likely to encounter wind; gusts can be particularly troublesome, so you will require a tripod capable of withstanding a fair amount of buffeting. You can try to select a spot sheltered from the wind. If that is not possible, use your body as a shield and, if your tripod has an appropriate hook, attach your camera bag to weigh it down. Whatever happens, do not underestimate the capacity for gusts of wind to spoil a potentially good shot.

Another sometimes overlooked feature is the tripod head. It needs to be robust enough to support your camera and lens. With many photographers electing to use a motor drive, coupled with the size and weight of some faster long-angle zoom lenses, the tripod head needs to be substantial. Flexibility is another important issue; when you are working in low light you need to be able to manoeuvre your camera quickly. Many cheaper tripods come with a head already fixed, which allows vertical tilt (forward and backward), together with lateral and swivel movement. These three-way heads are adequate when operating in normal situations, but when you are working under pressure the ball-and-socket design is far more flexible. You may also consider buying a quick-release tripod head, particularly if you anticipate making continuous camera changes.

A feature that I find indispensable is a spirit level. Use this to assess a correct horizon in low light.

I also find spirit levels useful. These are sometimes integrated into the head, but if not you can buy them independently and attach them to the camera. Either way, assessing a correct horizon in low light can be difficult and a spirit level undoubtedly helps.

Cable release

There is nothing more frustrating than having your cable release malfunction just as you are about to take the perfect low-light shot. Once again, I would urge you to buy the best model you can afford, and make sure that it has a locking device. More and more DSLR camera users work with an infrared-operated wireless remote release. These are ideal, particularly if you wish to use fill-in flash, because they allow you to operate away from your camera. One you may wish to consider is the Seculine Twin wireless remote release, which has been adapted to fit most cameras (www.intro2020.co.uk). This can trigger the shutter for up to 50m (164ft).

Self-timers

All DSLRs come equipped with a self-timer. If your camera is securely attached to a tripod, you should be able to use this without creating camera shake providing it goes for ten seconds or more; two seconds is not long enough. Having selected self-timer from the menu, simply press the shutter button; a bleeper will warn you that your camera is on stand-by and will then fire. Do not stand in front of the camera when setting off the shutter, otherwise your camera will autofocus on you.

With many lenses now fitted with stabilizers, it is possible to handhold a camera at surprisingly low shutter speeds. With your legs set apart one in front of the other, your body will be better balanced. Momentarily hold your breath and gently press down on the shutter.

Mirror lock

This is one of very few features of a modern DSLR camera that I regret has gone electronic. With any SLR camera, the mirror moves out of position once the shutter has been released, which at a speed below 1/60 sec can cause camera shake. Locking the mirror prior to exposure prevents this. With older SLRs, this was done mechanically, but with most modern DSLRs you need to check the custom functions in your menu and select mirror. This can be time-consuming, but do not underestimate the problems of camera shake created by mirror movement, particularly with exposures of one to two seconds. Camera shake is particularly evident when using either a macro or extreme telephoto lens.

Lens stabilizers

Each lens manufacturer uses different technology for lens stabilization, but essentially the lens uses a movement detector coupled to an electronically driven optical device that cancels out the camera shake. It does, of course, depend on the lens, but you should be able to handhold your camera at three shutter speeds slower than you normally would. So, if you could handhold your camera at 1/60 sec without a stabilizer, it should be possible to handhold at just 1/8 sec with a stabilizer. This offers enormous advantages, particularly if you wish to fire discreetly and do not want to use flash.

There are many low-light situations when it is neither possible nor appropriate to use a tripod and the lens you are using does not have a stabilizer. By using a high ISO rating and a wide aperture together with a bit of care, you can handhold the camera without experiencing noticeable camera shake. Ideally, if you are able to brace your body against a wall or other firm vertical surface, then this offers considerable stability. If this is not possible, hold the camera while creating a triangle by bracing your elbows tight against your chest. With your legs set apart one in front of the other, your body will be better balanced. Hold your breath for a moment and then *gently* press the shutter.

When photographing in low light, your tripod will be an essential part of your equipment.

tip

Buy the best tripod you can afford and the heaviest that you can comfortably carry.

FLASHGUNS AND OTHER ACCESSORIES

After the tripod, a flashgun unit is possibly the most important accessory you can use in low-light situations. It can be useful in several ways. First, it can be used to supplement available light. The major advantage of using flash is that it offers a natural light, which neutralizes colour casts. Second, it can illuminate shadow areas in order to create a better visual balance. Third, it is helpful when dealing with difficult backlit subjects.

Because the burst of flash is very quick, it must be accurately timed with the camera's shutter mechanism. As SLR and DSLR cameras use a mirror and a pentaprism, it is important that the sequence of the mirror moving up and the burst of flash are fully synchronized. While you are able to select any speed to match the flash if using a rangefinder camera, you will be restricted when working with a DSLR; this will vary from camera to camera, but a shutter speed of 1/200 sec or less is generally the norm. If, however, you are using a lengthy exposure of several seconds or more and wish to use a burst of flash, there is no need to worry so much about synchronization. Providing you operate the flash at some time within the extended exposure period everything should be fine.

The most basic flashguns require you to make an estimate of the camera's distance from the subject and set the aperture after referring to the manufacturer's instructions. However, most flashguns these days have sensors that automatically measure the amount of light reflected off the subject.

Built-in flash systems

Commonly associated with compacts, an increasing number of sophisticated DSLR cameras now come with an integral flash unit. The range of the flash will be partly governed by the manufacturer, but also by the ISO speed you select. The slower the speed, the shorter the flash's operating distance. This can also be affected by whether you are using a wide-angle or a telephoto lens. Obviously, if the subject is further away, increasing the ISO setting will increase the effective range of the flash. Some lens hoods can interfere with the light coming from a built-in flash, so you may need to remove them. By their very nature, built-in flash units lack flexibility and rarely have the power to do much more than illuminate the near distance.

Accessory flash units

If you intend to do serious work with flash, you should consider purchasing an independent flashgun that fits onto the camera's hotshoe. (Even if your camera has built-in flash, it should also have a hotshoe.) Many camera manufacturers produce their own dedicated range of flashguns that can automatically measure the light output required and then set the correct aperture. There are also various independent flash manufacturers that make dedicated flash units specifically for particular cameras. It should also be noted that your camera may not operate properly when using a flash unit from another camera brand.

Irrespective of which model you use, all independent flash units operate like a built-in flash except that they have other important advantages. First, they are generally more powerful. It is a matter of deciding what you want from your flashgun, but the effective range can be considerable. Second, the more sophisticated flashguns have a tilt and swivel facility. This means you can change the direction of the head, thus allowing you to 'bounce' the flash. This offers many advantages. Finally, some independent flash units can be used off-camera, as they are attached to the sync-socket by a flash lead. This is particularly useful when you wish to alter the direction of the light source. The hammerhead style of flashguns offers considerable power and flexibility.

While many DSLR cameras have an integral flash unit, they are relatively modest in terms of performance. If you are considering using flash extensively in low-light situations, you should obtain an independent flash unit, which sits on the camera's hotshoe.

Useful accessories

In addition to the flash unit, there are a number of accessories you can use to ensure that you illuminate your subject more successfully.

Slave units

These are small independent flash units that can be placed off-camera. They are often used by architectural or interior photographers to illuminate large interiors such as churches. Slave units can be remotely triggered by the master flash; if they are strategically placed, a much larger space can be illuminated effectively.

Light bouncer

This is a white plastic screen that is attached over the flash unit and can be angled. By directing the flash directly upwards, the flash is then bounced towards the subject. This is done to soften the harshness sometimes created by using flash lighting. When using a bouncer, the flash will lose one stop, which needs to be compensated for. A cheaper alternative is to use a sheet of white card, which you can hold over the flashgun. It is important that the flash head is tilted upwards and the card is directed at the subject. Once again, expect to lose one stop.

Flash filters

With the advent of DSLRs and the ability to change the White Balance, fewer flash units now come with coloured flash filters designed to overcome colour casts. However, if you do have some, they can be used in very creative ways – as we discuss in Chapter two.

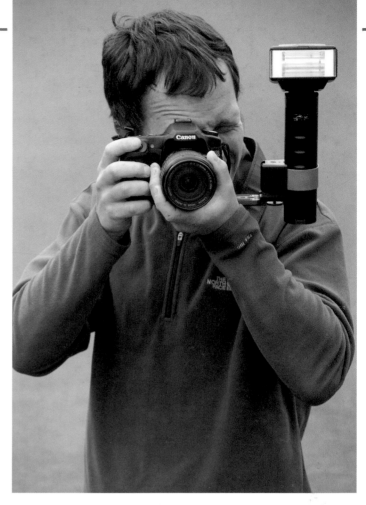

The power and flexibility of the hammerhead-style flashgun makes it a particularly useful piece of equipment, especially in low-light and night situations.

A number of DSLR cameras offer an integral flash unit. Although they can serve many functions, particularly when fill-in flash is required, don't expect to illuminate particularly large areas.

FILTERS FOR LOW-LIGHT PHOTOGRAPHY

It is frequently suggested that there is no longer any need to use filters, as their effects can be easily produced using Photoshop or other image-editing software. This is partly true. However, while some filter effects can be effectively simulated, certain key filters that are used in low-light and night photography are difficult to recreate digitally. Moreover, why rely on creating a digital effect post-production when using a filter in the first place can obviate an unnecessary chore?

What is a filter?

A filter is simply a glass or plastic screen that is placed in front of the lens in order to reduce or control the light reaching the sensor.

Filters come in many shapes and sizes, but there are two generic types: the screw-on types typically manufactured by Hoya and B&W, and the modular types that require placing a rectangular filter in an adapter and holder. These are typically manufactured by Lee Filters and Cokin.

Graduated neutral density filter

One of the many problems one encounters with low-light photography is excessive contrast, particularly when photographing landscape. A graduated neutral density filter is a useful means for balancing the exposure. There can often be a three or four-stop difference between the light reading for the foreground and the sky. If you expose for the sky, the foreground will appear unacceptably dark, but if you meter for the foreground, the sky will appear burnt out. The graduated filter redresses this imbalance. It is possible to buy a screw-on graduated filter, but they are more commonly part of a modular system. The filter is half-grey and half-clear; by ensuring that the darker part filters out the lighter part of the scene, exposure balance is restored.

Graduated filters come in different strengths. You can have a '3' (which equates to a one-stop reduction of light), a '6' (which equates to two stops), and a '9' (which equates to three stops). These filters also come as hard or soft. This describes the transition between the grey and the clear areas, which can be gentle or harsh. It is possible to use two filters in combination so the overall exposure is reduced. This is useful when you wish to achieve a low-light effect in normal light. In this way they effectively become a neutral density filter (see p. 26). They can also be stacked in order to increase the strength of the filtration.

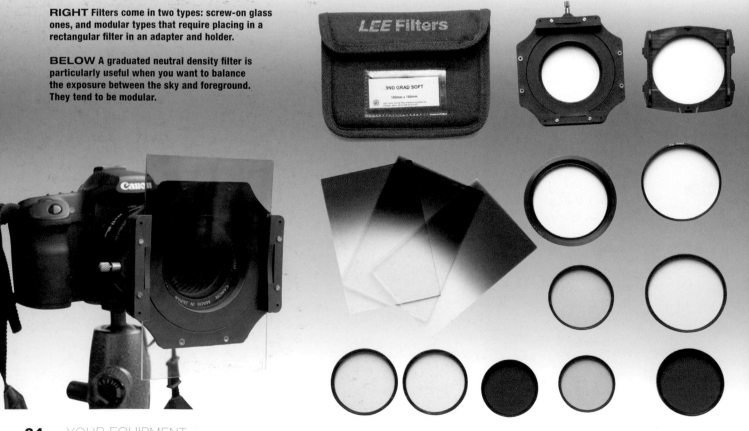

RIGHT Filters come in two types: screw-on glass ones, and modular types that require placing in a rectangular filter in an adapter and holder.

BELOW A graduated neutral density filter is particularly useful when you want to balance the exposure between the sky and foreground. They tend to be modular.

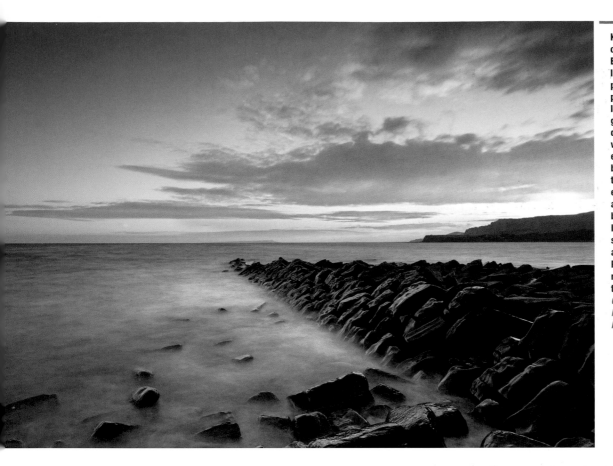

Kimmeridge on the coast of Dorset, England, is a popular location for many photographers, particularly in low light. Using a graduated neutral density filter is useful when you wish to equalize the exposure between the sky and the foreground. In this example there was a 3-stop difference between the two. It is possible to make some post-production adjustments using Photoshop, but you risk losing detail in this way.
Canon EOS 5D, 20mm lens, 32 sec at f/20, ISO 100

Metering with a graduated filter

This can prove problematic. The metering system on a standard DSLR can easily be fooled, resulting in the foreground appearing too light. There are a number of ways to overcome this.

- Take two independent light readings, one of the sky and one of the foreground, set the camera to expose for the foreground, then select the appropriate graduated neutral density filter to achieve an overall balanced exposure. It should also be noted that while the effect of the filter can be seen through the viewfinder, it is being viewed with its maximum aperture. By using the depth-of-field preview facility you can see the effect that the filter has with the aperture you have selected. If the effect is too harsh, you may wish to use a larger aperture.
- Meter the subject first without the filter, use the camera's auto exposure facility to memorize the reading, then add the filter and expose.
- Meter manually without the filter, make the necessary camera adjustments, and then put the filter over the lens.
- Bracket; this is easy when working digitally.

TOP There are two types of polarizing filters: linear and circular. When using a polarizer with a DSLR camera it is important to use the latter, or its autofocus and exposures systems could be compromised.

BOTTOM RIGHT A neutral density filter is like a graduated filter except that it reduces the light evenly across the whole scene. These filters are most commonly manufactured as screw-on filters and act rather like a pair of sunglasses.

BOTTOM LEFT A UV filter has only a minimal effect on the image but it can serve to protect the front element of the lens.

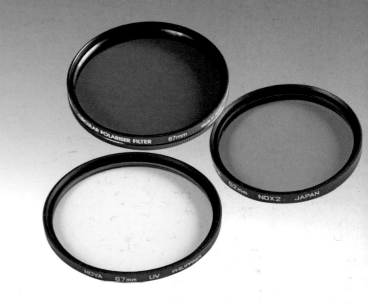

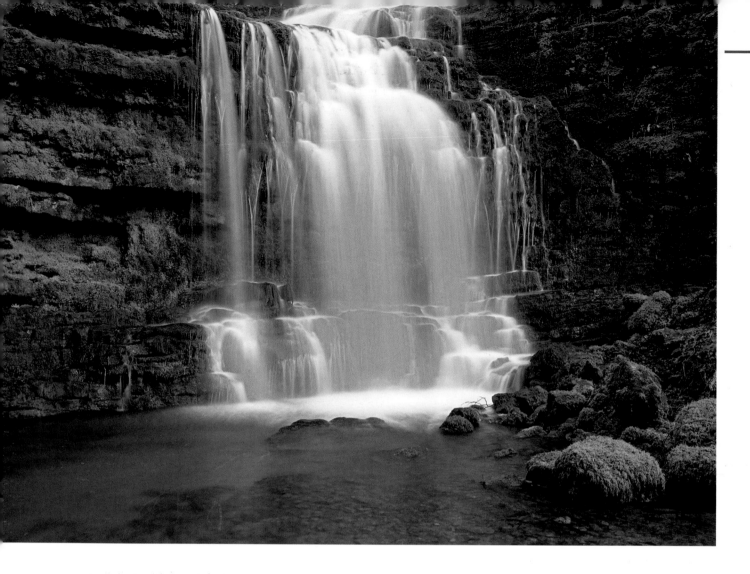

Neutral density filter

This is similar to a graduated filter except that it reduces the light evenly across the whole frame. These filters are most commonly manufactured as screw-on filters and act rather like a pair of sunglasses. A neutral density filter is used to reduce the amount of light reaching the sensor by absorbing the same amount of all the wavelengths; therefore it does not alter the colour in any way. It effectively reduces your ISO rating. Consequently, they are often used to simulate the effects of low-light photography when there is still quite a lot of light around.

For example, you might want to capture the blurring motion of the tide photographed over several seconds. However, your meter tells you that even if you use the smallest aperture, you will be required to use a shutter speed of 1/60 sec. By applying a neutral density filter – or perhaps several – you can substantially reduce this.

These filters have an overall grey appearance and on first inspection can be confused with a polarizing filter. They come in different densities.

- ND 2 filter – allows 50 per cent of the light to reach the sensor, reducing your speed by one stop.

Neutral density filters are useful when you want to reduce the amount of light reaching the sensor. In this shot of Scalebar Falls in Yorkshire in the north of England, I had to use a ND 4 filter, which effectively reduced the shutter speed from ¼ to 1 second.
Canon EOS 5D, 50mm lens, 1 sec at f/16, ISO 50

- ND 4 filter – allows 25 per cent of the light to reach the sensor, reducing your speed by two stops.
- ND 8 filter – allows 12.5 per cent of the light to reach the sensor, reducing your speed by four stops.

Providing you are not using an ultra-wide-angle lens, when you might experience vignetting, it is possible to stack your neutral density filters. You could put both an ND 4 and an ND 8 on at the same time, effectively reducing the speed by six stops. That can offer you considerable leeway.

Polarizing filter

This is likely to be one of the most expensive filters you buy, but it can perform several important functions. First, polarizing filters cut the reflection from shiny non-metallic surfaces, so they can remove the irritating

highlights that sometimes spoil botanical or other natural history shoots. A polarizing filter can be used to beef up saturation or just to increase contrast. It is most widely used by landscape photographers to intensify a blue sky; note that it works at its full potential only when the lens is pointing at 90 degrees from the sun. The effects can be dramatic, particularly if there are some white clouds present. Finally, a polarizing filter can also be used to remove unwanted reflections from still water.

There are two types of polarizing filters: linear and circular. The linear ones were cheaper to manufacture and worked well on older SLR cameras. They can, however, cause problems with the metering and focusing of modern DSLRs. For these you need a circular polarizer that is designed to work with the camera's exposure and autofocus systems.

Although a polarizing filter offers many benefits, there are also some drawbacks. The purpose of this filter is to reduce the amount of light reaching the sensor. Therefore expect to lose between two and three stops when using one. This could mean the difference between handholding your camera and putting it onto a tripod. Furthermore, there are frequent occasions when the polarizing effects are just too strong, resulting in an unnaturally dark sky.

Polarizing filters are particularly tricky to use with wide-angle lenses, and this sometimes results in an uneven effect across the frame. As stated above, the polarizing effect is at its most dramatic when used at 90 degrees to the sun; however, this can also create a very uneven sky. This filter has its uses, but it does need to be employed with caution. Finally, a polarizing filter can also be used as a neutral density filter because by applying one you are effectively losing three stops.

Starburst filter

This is not a personal favourite – these filters have a reputation of being a bit tacky, as they were often used to disguise an otherwise uninteresting image. However, the starburst effect occurs naturally when using the smallest aperture. As with all things, it does have a place provided it is used with caution. The starburst effect works particularly well with small highlights of intense light; if these are restricted within the picture, a small number of starbursts can look quite appealing.

UV filter

Because we are able to create so many filter effects digitally it can be tempting to dispense with all filters, but one I would recommend that you never get rid of is the UV filter. Always buy a screw-on type each time you buy a new lens and, unless you have good reason for removing it, keep it on all the time. Remember that without any filter you are exposing the front element of your lens to dust and possible scratch damage. Relatively speaking, these filters are cheap, and while they have only a minimal effect on the image, they can serve to protect your very much more expensive lens.

The UV filter is designed to remove the bluish haze caused by particles in the atmosphere; by introducing a very gentle pinkish tint, the sky can appear cleaner. Sometimes it is important to remove it, particularly when you wish to add another filter such as a polarizer; otherwise you might experience some vignetting.

A polarizing filter is most commonly used for adding drama to blue skies, but it is also effective in removing unwanted reflections from still water, as in this shot of the chateau at Chambord in France's Loire Valley.
Canon EOS 5D, 24–105mm zoom lens, 4 sec at f/22, ISO 100

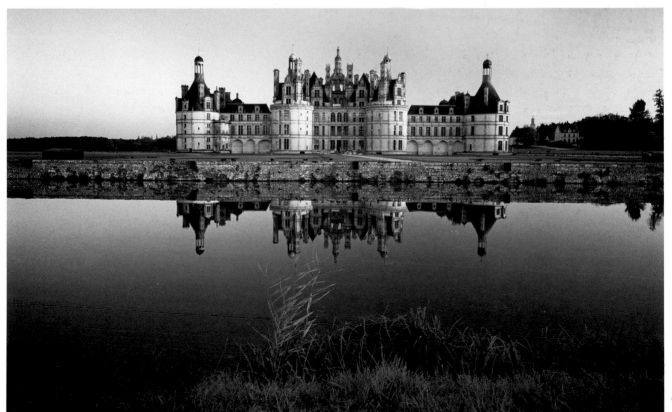

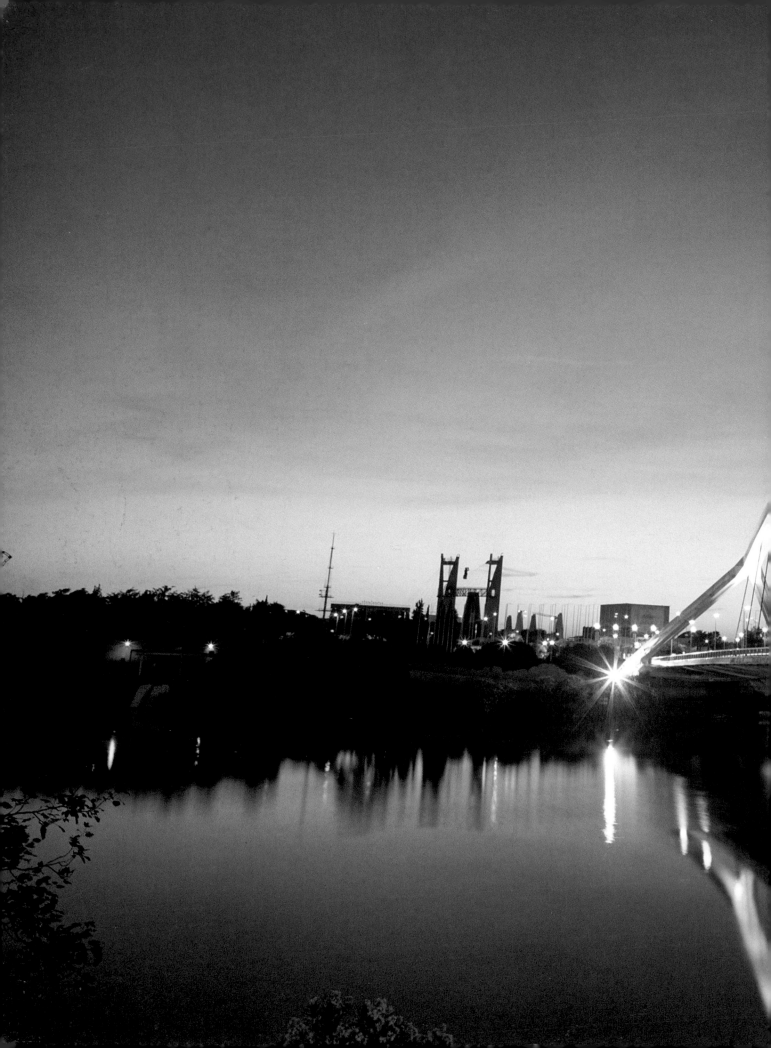

CHAPTER TWO
IN-CAMERA TECHNIQUES

USING THE HISTOGRAM

The histogram display is possibly the best feature of a DSLR camera for ensuring that we take well-exposed images time after time. When using film, particularly in low-light situations, I was always wondering whether I should have been exposing for the shadows or for the highlights. As I had nothing immediate to refer to, there was always some element of doubt; this has now been removed.

The general advice when shooting digitally is that we meter for the highlights and if necessary the shadow detail can be sorted post-production; however, with low-light photography it is just a bit more complicated. While the LCD is useful in terms of letting you see how well you have composed your image, it is notoriously unreliable in terms of illustrating whether you have exposed your image sufficiently well. What appears to be accurately exposed in low lighting will appear underexposed in normal light. It should also be noted that in low light the contrast range is greater than normal and a careful balance between the highlights and the shadows needs to be established.

The histogram display

This appears in the LCD, often together with the selected image. The histogram display will also offer an RGB display, which shows the colour saturation and tonal gradation of each of the channels (i.e. Red, Green and Blue). Having taken your photograph, checking the histogram is a far more reliable way of establishing the accuracy of the shot than merely referring to the image in the monitor.

What does the histogram show?

The histogram is presented as a graph, which indicates the distribution of the image's brightness level. The horizontal axis illustrates the spread of the tonal values, with the darkest appearing on the left and the lightest showing on the right. The vertical axis indicates how many pixels exist for each of the brightness levels. For example, if the graph appears to peak in the middle, then the histogram tells us that there is a high measure of midtones present in the image. If the histogram appears to bunch to the left

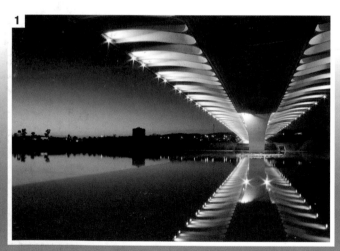

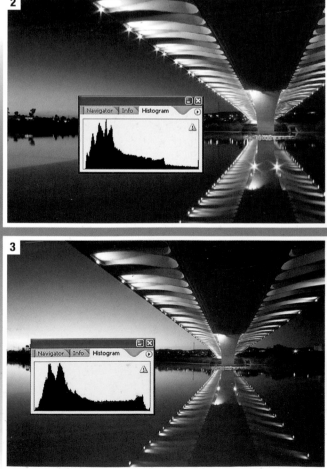

ONE This was a classic situation where, when I checked the camera's monitor in the low light, the image looked fine, but once I checked the histogram I realized that I risked losing too much shadow detail.

TWO By referring to the histogram, I could see that there was excessive bunching to the left, but more importantly the distribution of the lighter tones was poorly represented.

THREE With a one stop increase of exposure, the tonal spread has become more even; this is particularly evident in the lighter tones, which appear to have thickened in the graph. There is a marginal peak at the extreme right, which represents the bright lights. It would be very difficult to capture highlight detail in areas as bright as these.

FOUR The low-key character of this image has still been retained despite increasing the exposure by 1 stop. More importantly, the blocked-out shadow detail evident before has been opened up.
Canon EOS 5D, 20mm lens, 17 sec at f/22, ISO 100

the image will be dark; if it shows bunching to the right this suggests a high-key image. The danger is that if there are too many pixels on the left, it can indicate that important shadow detail has been lost. Conversely if there are too many pixels to the right, critical highlights are at risk.

What should the histogram show in low light?

While in normal light you should see an even distribution of pixels right across the full tonal range, most nighttime photography is low-key in nature; therefore you should expect to see the balance of pixels weighted to the left. If you increase the exposure not only are you likely to experience burnout of highlight detail, but the intrinsic character of the image can easily be lost. Conversely, you do not want too many pixels bunching on the left. The ideal tonal profile should show pixels represented across the full tonal range, but with the peaks appearing to the left of mid-way and then smoothly tapering down to the darkest point of the graph.

How do I resolve any problems?

Having examined the histogram, if you find that there is a good distribution across the full tonal range but that there is bunching to the right, you will encounter burnt-out highlights. To overcome this, either increase your shutter speed or close down your aperture by one stop. Either way you will reduce the exposure. On the other hand, if the histogram suggests that the shadows are blocking up, you need to increase your exposure by either reducing the shutter speed or by opening up your aperture by one stop.

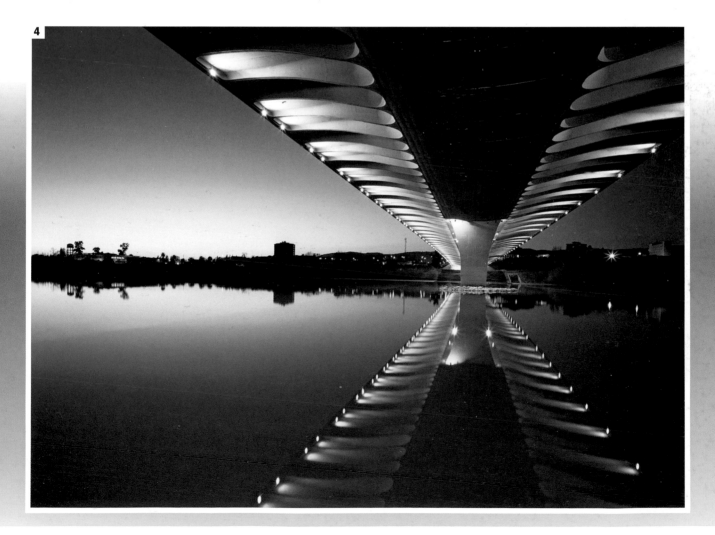

4

METERING FOR LOW LIGHT

Accurate metering is a prerequisite to producing excellent low-light images. This can be achieved in one of two ways: by using the camera's in-built metering system, or by using a handheld meter.

There is an erroneous belief that metering with a DSLR is less important than metering with a conventional SLR, as so much can now be corrected in Photoshop. This is misguided for two reasons: first because you are creating unnecessary work for yourself, but also because key highlight or shadow detail can be irretrievably lost by inaccurate exposure.

There has been a long-standing tradition, particularly when shooting colour negative, that one should always expose for the shadows; working digitally, we reverse that tradition and expose for the highlights. Generally, shadows can be retrieved but lost highlight detail is impossible to recover.

It is also important to appreciate what your meter is trying to read: all meters are aiming to establish a notional 18 per cent grey. This is the *average* tone required to produce an overall balanced exposure. This, of course, does not take into account the extremes at either end of the tonal spectrum. For example, as the metering system is trying to read everything as 18 per cent grey, it will tell you to underexpose a typical snow scene by two or three stops. Conversely, your metering system can easily convince you to overexpose, particularly in low light. It is important to understand what your light meter is telling you.

Using the camera's metering system

Most DSLRs have four metering modes (some of the more expensive ones offer more options). These four modes are:

- Auto exposure. This is good in most scenarios, but it can easily be fooled in backlit situations. It is also unreliable in low light, often showing a tendency to overexpose
- Multi-pattern or Evaluative. This is likely to be the most reliable metering system in your camera. It takes numerous light readings from various parts of the frame (how many depends on the sophistication of your camera) and then averages them out
- Centre-weighted. This takes a reading from the centre of the frame. It works particularly well in conditions where contrast is a problem
- Spot. This is similar to centre-weighted metering except that a very narrow angle of view is chosen. This is particularly useful if you wish to make an assessment of the lightest and darkest parts of the frame.

Metering for the camera's dynamic range

When metering, we are trying to assess the best overall exposure, but there are likely to be other exposure alternatives that might produce a better image. By making the image lighter or darker than the norm, we may improve the aesthetics of the photograph. At the same time we do not want to risk burnt-out highlights or blocked-out shadows: understanding your camera's dynamic range is one way of avoiding this.

Metering in low light can be challenging, which is why I often opt to use a handheld meter. In this example, I sensed that the strong illumination on the highlights of the building could result in burnt-out detail. Therefore I elected to spot meter from one of the lighter parts of the building.
Canon EOS 5D, 24–105mm zoom lens, 12 sec at f/16, ISO 100

Start by photographing a grey card, and then changing each exposure by 1/3 EV, so that you have a complete range from total underexposure to total overexposure. This should establish an absolute range of complete black to complete white, which is likely to span around seven to eight stops. We will assume that you have a range of eight stops, which means that four represents the middle of your camera's dynamic range. If you photographed something that was of the same tone as the grey card, you could afford to increase the exposure by as much as three and a half stops while still retaining detail.

There may well be other parts of the image that are lighter than your selected area, which in such extremes would burn out, but in some aspects of low-light photography the lightest part could equate to just 18 per cent grey. It could be that you want to underexpose your image. Once you know your camera's dynamic range, you can do this with confidence because you know at what point you are likely to lose shadow detail.

Auto-exposure bracketing

This is a particularly useful facility that automatically fires off various frames simultaneously bracketed, so that in addition to the exposure you have opted for you also have further underexposed and overexposed frames. This facility is helpful if you are unsure about the lighting, or if you need to respond very quickly to a situation and want to cover various possible exposures.

Using a handheld meter

Some photographers ignore the camera's built-in metering system, preferring to use a handheld meter instead. Because they operate independently from the camera, they allow you to make light readings with far greater accuracy. It is possible to leave the camera on the tripod, but move in closer to take a light reading from a particular part of the subject. It is also important to remember that light readings from handheld meters do not take into account any filters you may have on the lens. This, of course, will have to be factored in.

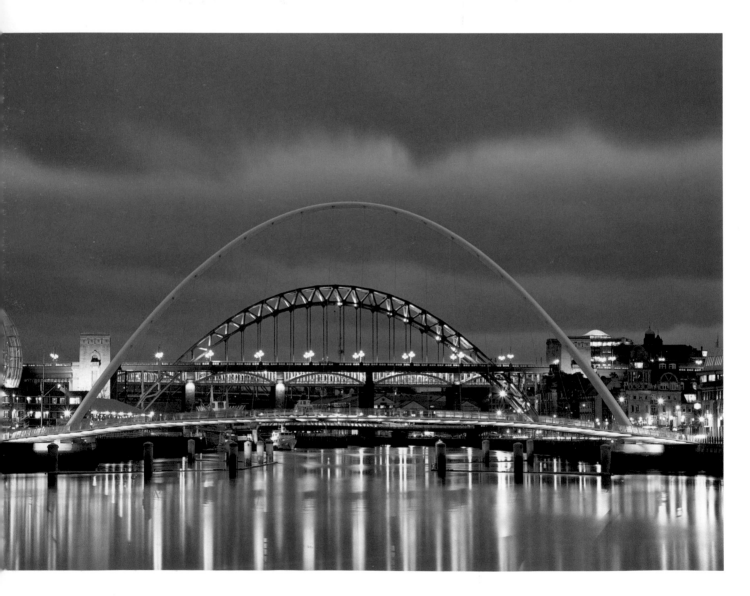

When encountering difficult low-light situations, handheld meters offer you the opportunity of making either a 'reflected' light reading (the light that is reflected from the area you wish to photograph) or an 'incident' light reading (a measurement of the source of the light). To take an incident light reading, it is necessary to fit a translucent cone over the meter cell and point the meter towards the camera. Reflected light readings work best when the contrast is reduced. In a landscape situation you are often best advised to point the meter towards the ground; however, it is important to remember the golden rule concerning digital, namely 'expose for the highlights'. If there is a significant disparity between the sky and the foreground, try taking a duplex reading instead.

A duplex reading is particularly useful in contrasty backlit lighting conditions. When reading the reflected light, the meter is likely to underexpose; by way of contrast, an incident light reading is likely to overexpose the highlights. The answer is to take two light readings – one a reflected

light reading and the second an incident light reading – and average out the two. Using a light meter in this way can be time-consuming, but with many low-light situations there should be some leeway.

BELOW LEFT An icon of northern Britain, the Tyne Bridge is a popular subject with many photographers. A high-contrast situation such as this can often fool the metering system. Fortunately, many cameras feature a useful auto-exposure bracketing facility.
Canon EOS 5D, 70–200mm zoom lens, 5 sec at f/16, ISO 200

BELOW It is important to remember that metering systems are designed to achieve a notional 18 per cent grey, and can easily be fooled in high-key situations such as this. I generally prefer to use a handheld meter in such circumstances.
Canon EOS 5D, 24–105mm zoom lens, 1/30 sec at f/22, ISO 50

OVERCOMING NOISE

It has long been assumed that while digital cameras are a match in most respects for the traditional film SLRs, they underperform when used in low-light situations. This notion may well have been justified with some of the earlier digital cameras, but as technology has improved, many of the initial problems have been overcome. A particular complaint was that when using a DSLR camera in low light, the incidence of noise (graininess) was substantially increased. With a new generation of DSLR cameras this should no longer apply, although there are still steps one should take in order to avoid the problem.

Reducing visible grain in camera

Many newer DSLRs now offer a noise reduction (NR) facility. If you are thinking of upgrading your camera this is one facility thta you ought to check. It will be available within the camera's menu, and should be applied when making exposures of one second or more. However, all good things come with a price. After the picture has been taken, the camera requires a processing period that equals the length of exposure, so you cannot take another picture until this procedure has been completed. With an exposure of 30 seconds that should not pose too great an inconvenience. However, with a five-minute exposure, possibly at a time when the lighting really is interesting, this can prove to be quite an impediment. The NR facility can also appear to slightly soften the image. You do, of course, have the option of switching off the NR facility.

What can you do if your camera does not have a NR facility?

All digital camera exposures longer than one second will increase grain, and as most low-light photography requires exposures of one second or more, then finding ways of reducing it must be considered. One way is to open up your aperture and thus obviate the need to use such a slow shutter speed; while this style of photography does have an appeal, you cannot allow the design of your photographs to be compromised in this way.

An alternative is to use a low ISO setting. The moment you make the decision to use a tripod, you may just as well opt for the slowest setting available. In many cases where you want to record light-trails, or perhaps capture the effect of slow-moving water, then using the slowest setting possible is a distinct advantage. Noise is rarely ever visible when you select an ISO setting of 50 or 100.

Problems of grain can also be caused by poor exposure; this will be evident in the shadow detail, particularly if you try to remedy the situation by an overuse of the Exposure slider. The rule of thumb is that you should always expose for the highlights, yet in low-light situations this could mean ending up with poorly exposed shadow detail. Getting that balance right is a challenge.

Reducing visible grain post-production

Increasingly, manufacturers are including a noise-cleaning facility within the Raw conversion package. However, if you decide to shoot JPEG then reducing noise can be achieved by using Photoshop – a Reduce Noise facility has been added to Elements 3, CS2 and all other subsequent editions. Go to Filter > Noise > Reduce Noise. When you are using this facility, zooming in on a key part of the image will help you to see precisely what changes are being made.

As with most things digital, you should exercise care when making changes to an image. If noise is visible at all, it is likely to be restricted to just certain parts of the image, particularly the sky. Noise can also appear in shadow detail, particularly if it has been significantly adjusted. Make a selection, then apply the Noise Reduction filter just to those areas that appear to be affected; in this way you can retain most of the original data. Possibly the best method for making this kind of selection is to use the Color Range tool.

Noise Reduction filter

Noise can appear in any image where an exposure of more than one second has been used, particularly if a moderately fast ISO setting has been selected. If your camera does not have a NR facility, then using the Noise Reduction filter in Photoshop can solve the problem. As noise is usually most evident in skies, apply the filter selectively.

Reduce Noise

OK
Cancel
☑ Preview

◉ Basic ○ Advanced

Settings: Default

Strength: 4

Preserve Details: 80 %

Reduce Color Noise: 45 %

Sharpen Details: 30 %

☐ Remove JPEG Artifact

□ 100% ⊞

ONE If your camera does not have a NR facility or perhaps it was not convenient to use it at the time, excessive noise can appear, particularly in blank areas such as skies. If your camera does not have a NR facility, the Noise Reduction filter in Photoshop can solve the problem.

TWO Using Navigator, carefully monitor what effect the Noise Reduction filter is having on the image.

THREE Noise can appear in any image where an exposure of more than 1 second has been used, particularly with a moderately fast ISO setting. *Canon EOS 5D, 20mm lens, 5 sec at f/22, ISO 100*

USING FLASH AND FILL-IN FLASH

The subject of flash could almost make a subject for a book in its own right, as there are so many exciting techniques to explore. However, from the standpoint of low-light photography, we shall consider just a few of these.

Fill-in flash

This is an interesting technique that can be used when you wish to balance the lighting of the foreground with the background. If your camera has a built-in flash unit it should serve the purpose well in most situations. If you need to apply a little more control, then you might find that using an independent flashgun offers more flexibility.

When using fill-in flash it is important that the light from the flash does not overwhelm the foreground. This can be controlled in one of two ways.

Method one

Make a normal light reading and set the camera to make a correct exposure for the ambient light. Then, set the fill-in flash to give a burst of light, giving either a one- or two-stop underexposure. For example, if your ambient light reading suggests using an aperture of f/11, consider setting the flash to f/16 or even f/22. This will marginally overexpose the foreground, but it should remain well within acceptable boundaries. If, however, you use a flash reading, which is the same as the camera exposure, not only will the image appear overexposed, but the shadows will appear as bright as the directly lit areas and any sense of modelling will be lost.

tip

Ideally, you should try to obtain a flashgun that can also work off camera.

Producing an image like this shot of the ancient stones at Avebury in Wiltshire, England, is surprisingly easy if you get your timing right. I had to wait for the sun to go down sufficiently to allow me a 2-minute exposure. With the shutter speed set to Bulb and the White Balance on Daylight, I was able to use the flashgun off-camera to illuminate each of the stones in turn. To make sure you don't appear in the image, it helps to wear dark clothing and to keep moving. Have your flashgun fully charged, as you cannot waste precious seconds waiting for it to recharge after each flash. The metering was taken directly off the landscape, as there was no need to factor in the stones at this stage. The light trails to the extreme right were created by passing vehicles; I elected not to crop them as they introduce a disquieting quality that adds to the image.
Canon EOS 5D, 20mm lens, 2 min at f/22, ISO 100

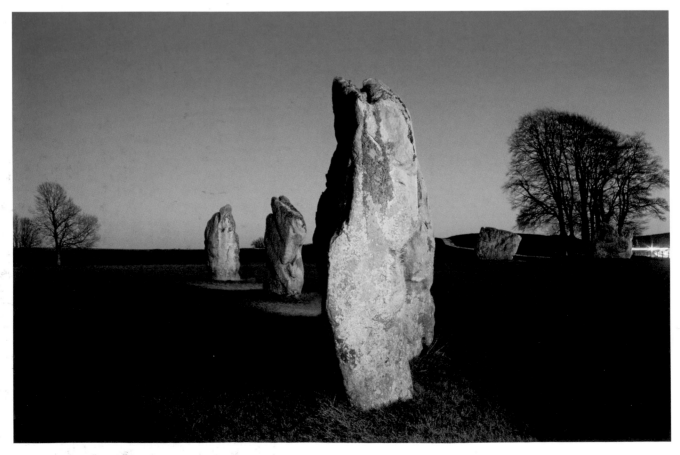

Method two

Make a light reading of the ambient light and set both the camera and the flash accordingly. But before firing the flash, place a diffuser over the flash head, which will reduce the amount of light it fires by one stop. This also has the advantage of producing a much softer light. If you do not have a diffuser, then try using a tissue as it gives much the same result. Either way, the effective strength of the flash will be reduced by one stop.

Combining flash with a slow shutter speed

This is another useful technique that can be used when you want to photograph a moving figure set against a background; it offers an interesting combination of stillness and movement. It necessitates handholding the camera for a relatively long exposure and firing off the flash at some point within it. The final result will be governed first by the strength of the flash relative to the available light, but also to the extent the camera is moved. The technique involves taking a light reading then halving the aperture. So, if your meter reading suggests an exposure of two seconds at f/8, make it f/11 instead, and then set your flashgun to the same modified reading. In this way, you should be able to balance out the light sources. The lowest practical speed you can use is 1/4 sec; the flash will freeze the movement, while the extended exposure will create the sense of movement. The results can be stunning.

TOP LEFT **Interesting effects can be achieved when combining flash together with a slow shutter speed. In this example, as I used a shutter speed of 1/2 sec, the burst of flash has captured only part of the action. This kind of work can be hit and miss, so you need to take lots of shots.** *Canon EOS 5D, 24–105mm zoom lens, 1/2 sec at f16, ISO 400*

BOTTOM LEFT **Night is the best time to paint with flash. In this example, the sun had set at least 45 minutes before, which gave me time to apply various bursts using a hammerhead flashgun. I particularly like the way the flash has frozen parts of the parasols, while the breeze has caused other parts to appear blurred.** *Canon EOS 5D, 24–105mm zoom lens, 34 sec at f16, ISO 100*

BELOW **It is often assumed that good portraits cannot be taken after dark, but by selecting an interestingly lit location and applying a little fill-in flash, night can be changed into day. Use your largest aperture if you want to try this.** *Canon EOS 40D, 17–85mm zoom lens, 1/5 sec at f/5.6, ISO 800*

Bouncing flash

This is a technique that works particularly well in small, poorly lit interiors. It involves bouncing the flash off an adjacent wall or off the ceiling in order to produce a soft, even light throughout the room. This works best when using either a white ceiling or wall; if the surface is too dark, much of the bounced light will be absorbed. If the camera is on a tripod, try to estimate the distance between the camera and the surface you wish to use, and then double it. This then becomes the distance for which you need to set your flash. Once you have established an aperture reading for that distance, open the aperture by one stop to take into account the additional light created by the flash.

Painting with flash

This is best achieved in a dark situation that requires a lengthy timed exposure. This should be perfect nighttime photography. Ideally, your calculated exposure period should be at least 30 seconds to give you time to make multiple flashes with the flashgun. An exposure of two minutes is much easier to handle. If you are having difficulty getting the exposure to 30 seconds, consider reducing the ISO setting and closing down the aperture. With your camera mounted on a tripod, make a light reading, select the required aperture and then set the shutter to Bulb ('B'). Pre-focus the camera before you start.

With the camera set to 'B' and the shutter locked open you are now able to move around using the flashgun to illuminate any part you want. You will not appear in the photograph as long as you keep moving. When firing off the flash, try to keep it as weak as possible; the exposure has been calculated for 30 seconds or more, so each time you add flash you are increasing the overall exposure of the image. Never point the flash back at the camera; in fact, each time you fire, try to shield the flashgun from the camera so that the source of the flash cannot be seen in the final image. Try rehearsing the procedure before you finally commit yourself to test whether it can be achieved in the allocated time. Moreover, it is important to try this with freshly charged batteries, as you may need to fire the flashgun in rapid succession.

As the quality of light produced by flash most closely replicates daylight, select the Daylight WB. However, as I have repeated now several times, shooting in Raw will always give you further options. Once you have taken your shots you are then in a better position to decide which WB option best fits.

If the ambient light does not give you sufficient time to make the multiple flashes you require, one thing you can do is to blend various layers in Photoshop. Providing that you have kept your camera on a tripod, you could make various separate exposures with each file showing a different part of the image illuminated by the flash. Once you have all the required layers, all you then need do is combine and blend your images in Photoshop. This technique is very similar to one covered in the final chapter (see pp. 140–141).

Start by opening all the images in Photoshop. Select one to be the Background layer. Then, using the Move tool and while holding down Shift, drag the each of the other images over it in turn. If you look in the Layers dialog, each of the layers will appear, one stacked over the other. If you then activate each of the layers that appear above the Background layer and select Lighten from the Blending mode, the lightest part (i.e., the part that was flashed) will appear through the other layers. In this way, all the areas that have been flashed will appear in the final composite.

ABOVE RIGHT Don't feel that you always need to use a sophisticated flash unit; these Spanish fruit sellers were illuminated with the camera's built-in flash.
Canon EOS 40D, 17–85mm zoom lens, 1/30 sec at f/8, ISO 400

RIGHT With the camera set to 'B' I was able to apply various bursts of flash onto this observational tower, although it was important to shield the flashgun from the camera when doing so. The white blob in the sky is a crescent moon, which has blurred due to the lengthy exposure.
Canon EOS 5D, 24–105mm zoom lens, 5 min at f/11, ISO 100

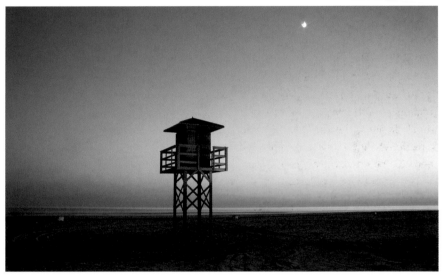

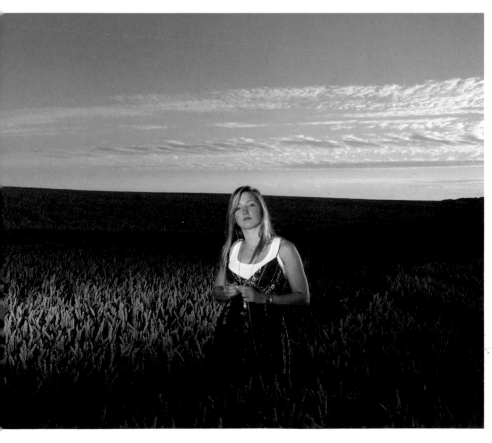

LEFT This appealing image has an almost timeless quality. It could have been taken on any decade and in any continent. Photographed in evening light, I took a light reading from the landscape and then deliberately underexposed by 1 stop, but set the flashgun to counterbalance this.
Canon EOS 40D, 17–85mm zoom lens, 1/30 sec at f/16, ISO 100

FAR LEFT When handheld, flash can be applied selectively to create strange, almost theatrical effects. Being able to refer to the camera's LCD in such situations can prove particularly helpful.
Canon EOS 5D, 20mm lens, 6 sec at f/22, ISO 100

USING UNCONVENTIONAL LIGHTING

When photographing in low light, it is important to understand that illumination from any source, no matter how unconventional, can prove useful. In addition to the ambient light we can use other controlled lighting sources such as flashguns, as we discussed in the previous four pages. But it is also possible to use less conventional light sources such as torches, lamps or even your car headlights.

Using car headlights

I must confess, I discovered this technique rather by accident. There have been several occasions while driving around that I have spotted interesting locations that looked good in the full glare of my headlights. However, as soon as I parked and turned the lights off, that magic seemed to disappear. I considered using a flashgun but the one I had with me simply would not have been powerful enough for the task in hand.

One can easily assume that car headlights are a very crude mechanism for illuminating potential sites – and of course, when compared to a sophisticated flashgun, there is no contest – but nevertheless there are things you can do to control the lighting.

- First, you have the option of using dipped or full beam. This not only allows you to regulate the strength of the light source, but also gives you some control, albeit small, over the angle of the lighting.
- Second, by moving the vehicle either closer or further away, you have some control over the intensity of the light source.
- Third, particularly if you are using a fairly lengthy exposure of two minutes or more, you should be able to move the vehicle in order to illuminate the subject from a variety of directions. It is critical in such manoeuvres that you ensure the headlights never shine directly at the camera.
- Finally, there is no requirement to use the car headlights for the full duration of the exposure. It may be that just a short blast of light is all that is required.

Metering is not particularly difficult, as all you are trying to achieve is a balance between the lighter part of the image – the sky, for example – and the area illuminated by the headlights. Before setting up the camera on the tripod, illuminate the intended area and take a light reading. By comparing the illuminated area with the non-illuminated area, you can get a good assessment of what will be required.

Potential problems

The quality of the lighting can be harsh, but it is excellent for picking out textural detail. It is a good idea to keep the engine running, particularly if you are using the main beam for an extended period. Strictly speaking this is against the law, so you may need to get some help from a friend. Because of the low angle of the light source, it is very easy for your own shadow or your tripod to appear in the image, so do check carefully prior to making the exposure.

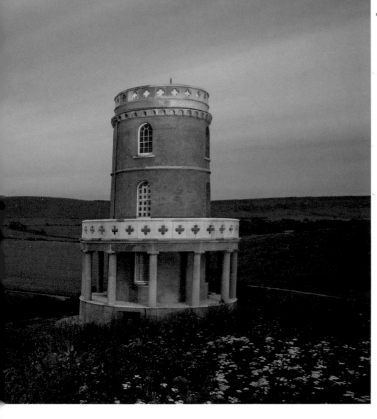

Using a torch

When compared to a dedicated flashgun, a torch is a primitive piece of equipment. However, there are occasions, albeit limited, when using a torch has distinct advantages. As the light can be applied cumulatively, it is possible to exercise considerable subtlety. When using flash, the light emitted blankets the entire subject, but when you are using a torch you are able to shine the light selectively. By moving nearer or further away from the subject, another layer of control can be introduced. But even from a purely practical standpoint, using a torch has several advantages. First, torches are both cheap and accessible and are the sort of thing that most motorists would normally keep in their glove compartment. Second, they come in several strengths and can be appropriately used in a variety of situations. While I would never suggest that torches can always be used as a substitute for a flashgun, there have been numerous occasions when I have successfully used one when I have forgotten to bring a flash unit.

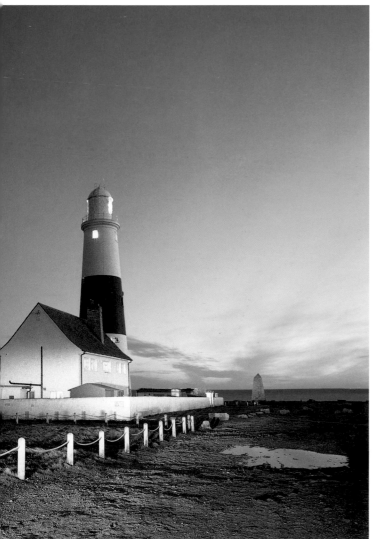

ABOVE LEFT I photographed Clavell Tower, overlooking Kimmeridge Bay in Dorset, England, well after sundown by illuminating the tower with a large handheld torch. It is important to keep the torch moving in order to avoid hotspots.
Canon EOS 5D, 24–105mm zoom lens, 6 min at f/22, ISO 100

LEFT I had just finished photographing this lighthouse at Portland in Dorset, England; my gear was packed and I was ready to go. It was only when I turned on my car headlights that I realized there was still another picture to be taken. The sky was near-perfect and the lighthouse was generating its own light; only the foreground required additional illumination, which the headlights provided. I took a two-minute exposure, making sure that my own shadow did not appear in frame. I tried to direct the headlights so they illuminated the small white fence in the foreground, which served as a useful lead-in line. Edward Hopper's wonderful painting 'Lighthouse at Two Lights' was in my mind as I took this photograph. He frequently painted early in the morning or late in the day, when the low sunlight cast shadows across the landscape.
Canon EOS 5D, 24–105mm zoom lens, 2 min at f/16, ISO 100

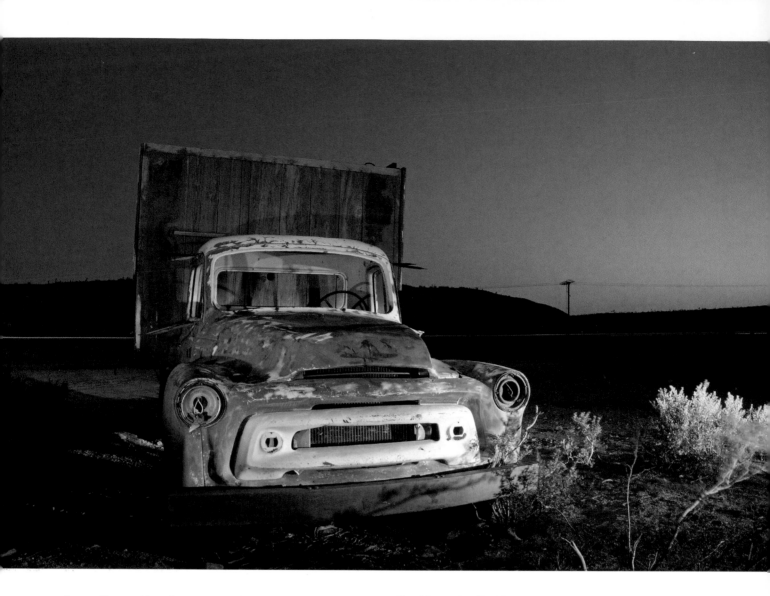

Generally speaking, the strength of light coming from a torch will not match that of a medium-sized flashgun, but that can be used to your advantage. The light from the torch can be used to add light gradually, and this does introduce a reasonable element of control. The best way to think about it is that you are *painting with light*. The effect will be to introduce elements of daylight into night and it will be rather like brushing in detail.

When shining the light, it is important to keep it moving, otherwise you risk creating hotspots. It also helps to think about the direction of the light. If you shine the torch from directly behind the camera, the subject will appear flat, but if you decide to work from either side of the subject, you will introduce a stronger sense of modelling.

When working away from the camera, you must take care never to shine the torch directly at it. It is also important to be realistic about what you can reasonably illuminate. Although some torches can be effective for quite a distance, the strength of the light will fall off incrementally. Try to restrict yourself to bushes, small buildings or vehicles. If you try something bigger such as a tree, try mentally dividing it up and then start the process of methodically illuminating

To achieve a shot like this it is important to position your own vehicle carefully; this determines how the headlights affect the final image. For this example, I arrived well before sundown so that I could experiment with various vantage points. The thin red horizontal line in the background is a light trail created by a passing vehicle.
Canon EOS 5D, 24–105mm zoom lens, 2 min at f/11, ISO 100

tip

Once you get into the mindset of photographing in unusual lighting situations, you quickly appreciate how open and flexible this can become. A low-light landscape becomes your palette and you can choose to paint any area with light.

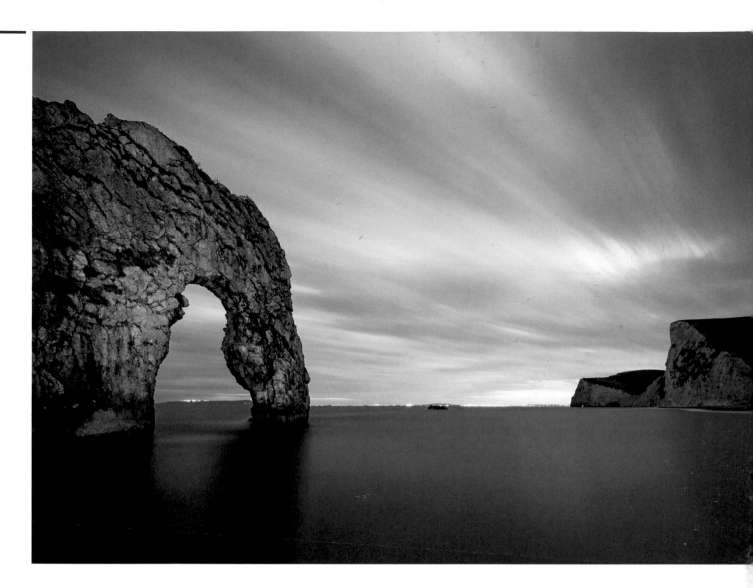

each part, starting at the top and working downwards. Even if you have only a small torch to hand, it can be used to lighten some tiny but important element of detail in the foreground. If you have never tried anything like this before, a quick glance at your LCD will no doubt reassure you. In most circumstances I find using the Daylight White Balance setting the best option.

Flashgun filters and lighting gels

Prior to the development of DSLR cameras, flash manufacturers would often supply flashguns with filters. These were used to counteract the cast created by artificial lighting such as fluorescent or tungsten. As most photographers now shoot digitally, they have stopped offering these filters as they have largely become redundant. This is a bit of a shame, as they can create wonderful special effects. They would often come in sets offering blue, green, amber and magenta attachments, which you placed over the head of the flashgun. Although these filters were designed to counter colour casts, they can of course be used to create one. If you are unable to get hold of these flashgun filters, try buying an older-style flashgun on an auction site; most are going very cheaply. An alternative option is to attach customized theatrical lighting gels over the flash.

This is a shot of Durdle Door in Dorset, England, a wonderful location in a World Heritage Site. The major risks when metering for a feature such as this in low light are ending up with a silhouetted foreground or a completely burnt-out sky. By metering for the sky but using a large handheld torch to illuminate the foreground you should be able to balance these extremes. This shot required an exposure of 5 minutes, which gave me time to methodically 'paint in' the stack.
Canon EOS 5D, 20mm lens, 5 min at f/16, ISO 200

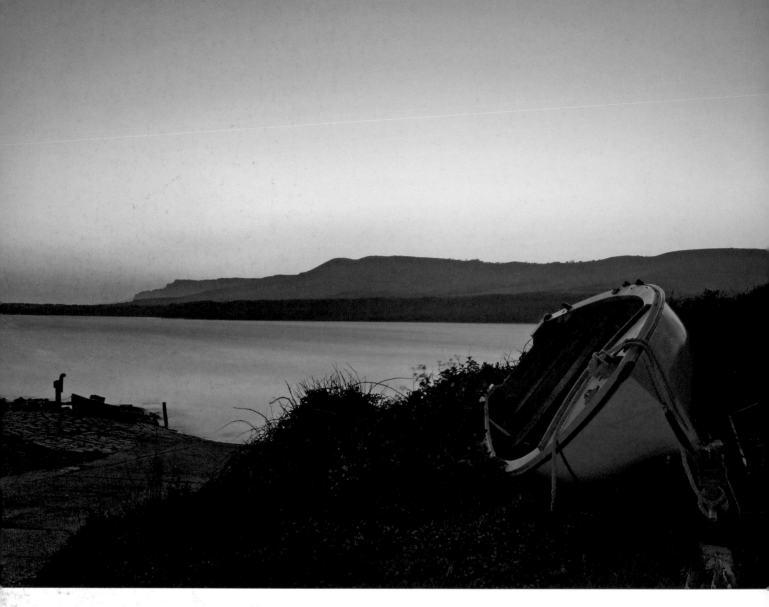

Select the right scenario

The main purpose of this technique is to illustrate a simple feature within
the landscape such as a tree, small building or possibly an abandoned vehicle.
For the best visual impact, select an open landscape – ideally with an interesting
night sky. I find that it is easier to take these shots in the evening rather than
at pre-dawn, as you will have more time to play with. Wait until your light meter
tells you that you have at least two minutes of exposure time (I prefer to have
between five and ten minutes available). You will need to set the camera to 'B'
(Bulb) mode and then take two light readings, one of the sky and another of the
land. When making your final light-reading assessment, the bias should be for
the sky. Select the object you wish to work on, then use your flashgun off-camera
with one of the colour gels over the head to illuminate one side or the other.
Having completed this, place a different coloured gel over the flash head and try
flashing the subject from an entirely different angle.

 If you are able to get inside the subject, try creating an inner glow. As the
ambient light will provide part of the illumination, and the various bursts of flash
will have an accumulative action, reduce the strength of the flash accordingly.
It is better to use too little flash than too much.

**Photographed 45 minutes after sunset,
I needed to give this an overall
exposure of 2 minutes. This gave me
plenty of time to apply two small bursts
of light using the flashgun off-camera,
with a red lighting gel attached. It was
important to ensure that the flashgun
was shielded from the camera while
this was being done.**
*Canon EOS 5D, 20mm lens, 2 min at f/16,
ISO 100*

Precautions to take

- Try never to direct the flash at the camera. I normally aim to get to my location before the light starts to disappear and rehearse the potential flash angles I might wish to use.

- Don't stay stationary in front of the camera for too long. If you can find a location from where you can fire off the flash while out of view of the camera, all the better.

- If you intend to try out different gels, make sure that you are organized. It is difficult to see what colour gel you are placing over the flash head in subdued light, so have a system. If you use a small torch, shield it from the camera's view.

- Generally I recommend using the camera's NR facility, but with such lengthy exposures and with the light disappearing fast, this might be an occasion when it would be wiser to switch it off. This gives you a chance to review what you have shot. If necessary, you still have sufficient time to retake the image. Cleaning up noise can be done easily either in your Raw Conversion dialog or in Photoshop.

This pillbox is one of the remnants of World War II that still litter the beaches of the UK. Photographed an hour after sunset, this required an exposure of 14 minutes. This gave me plenty of time to direct several bursts of flash at the subject, some with a red filter and some with a green one. The result is both theatrical and surreal.
Canon EOS 5D, 20mm lens, 14 min at f/22, ISO 100

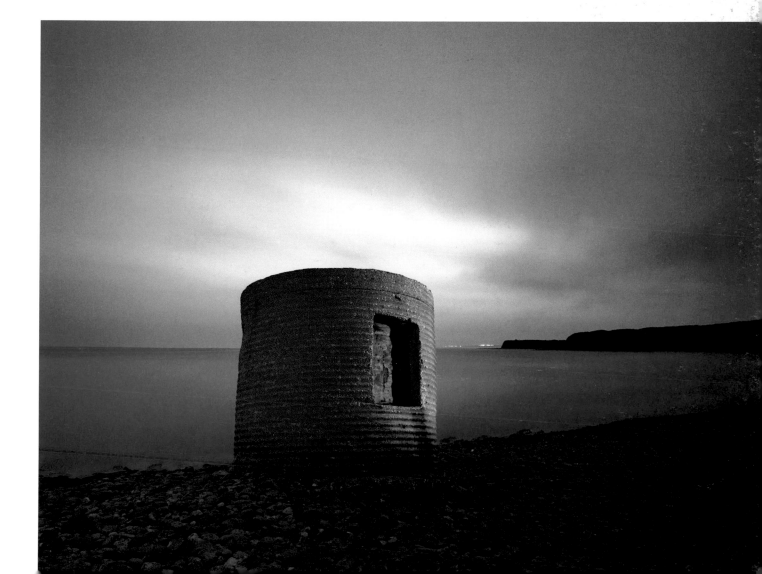

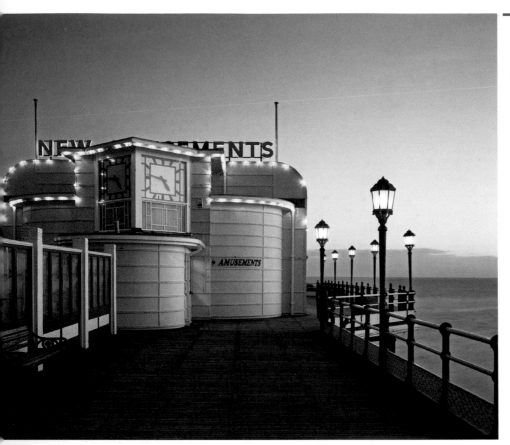

LEFT This shot was taken on the pier at Worthing, on the south coast of England, late in the year just as the sun was going down. I was drawn to the illuminated art-deco structure at the end of the pier. Had I relied entirely on the LCD, I could easily have convinced myself that this image could not have been improved.
Canon EOS 5D, 50mm lens, 2 sec at f/22, ISO 100

BELOW LEFT This shot was taken about 20 minutes later (as indicated by the clock on the building). Whether this is considered better or worse than the example above is a matter of personal judgment, but having an alternative always helps.
(Photograph: Eva Worobiec)
Canon EOS 40D, 17–85mm lens, 184 sec at f/11, ISO 200

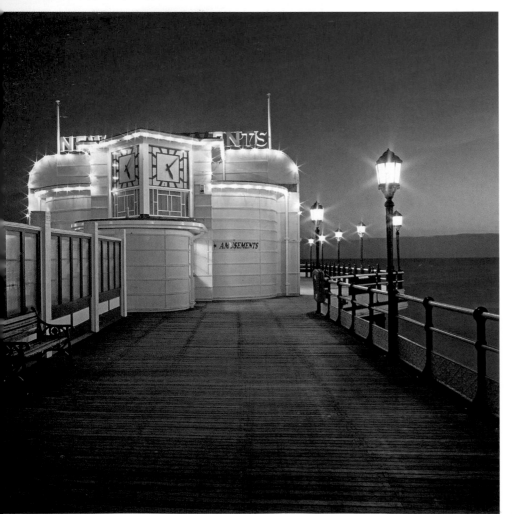

RIGHT I was attracted to the quiet evening light of this wonderful Cretan harbour. The lighthouse was illuminated and the street light in the foreground had just come on.
Canon EOS 5D, 24–105mm zoom lens, 33 sec at f/16, ISO 100

FAR RIGHT As I was packing up my gear and preparing to leave, I turned round and found that, quite unpredictably, the harbour wall was also illuminated at night. Even when you think you have got your shot in the bag, it is worth hanging on in case something special turns up unexpectedly.
Canon EOS 5D, 24–105mm zoom lens, 50 sec at f/16, ISO 100

A MATTER OF WHEN

When you are photographing in low light, your window of opportunity can be quite limited. Therefore it is important to exploit lighting situations as they present themselves. The most difficult times to predict are dawn and dusk; the lighting will be dependent on the weather conditions, the time of the year or even the latitude; for example, the sun rises and falls much more quickly the nearer the location is to the equator.

In photography we will all try to achieve different things. However, most of us will try to establish some measure of balance between the highlight and shadow detail. There will be critical moments, particularly at sunrise and at sunset, when the contrast between the foreground and sky is too great. Learning to anticipate the moment when everything falls into tonal balance is part of the art of low-light and night photography.

It was said that film is cheap, but shooting digitally is even cheaper. Therefore, if you are worried that cannot accurately judge the critical moment, take several different exposures and review them later in the comfort of your home. I often find that the best shots are taken at the end of a session.

Be prepared to bracket, as most DSLR cameras have an exposure level increments facility; this is designed to help you overcome the tricky lighting conditions that low-light photography often presents. All too often, inexperienced photographers check the LCD monitor and believe that they have made a reasonable capture and feel there is little more to be achieved. First, do not over-rely on the monitor: it is only when you get your image onto the computer that you are really able to assess its worth. Second, although you may have captured a really good shot, this should not prevent you from creating an even better one.

Often when photographing potentially interesting locations, it is worth arriving before the lighting is at its best. Anticipating the direction of the sun, or working out what other sources of illumination are likely to come into play, can help you make decisions well in advance. For example, if I see an interesting motel, I might look to see if there are any signs of neon around. If there are, I will ask the owner whether they come on at night, and at what time. Historic buildings are often lit up at night, but not always. Getting to your location early gives you time to ask a passing local.

It is also important to allow for the unpredictable, which is why photographing in low light can be so exciting. When making a long exposure, figures or vehicles will move into frame quite unpredictably. Don't regard this as a problem; when you eventually review your capture, these might turn out to be the best pictures.

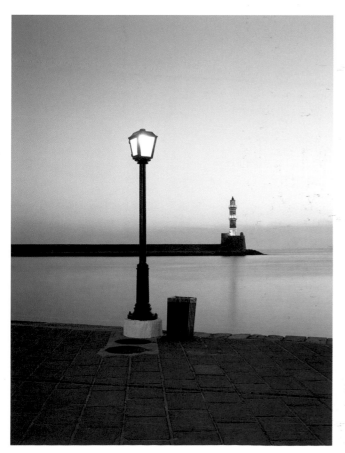

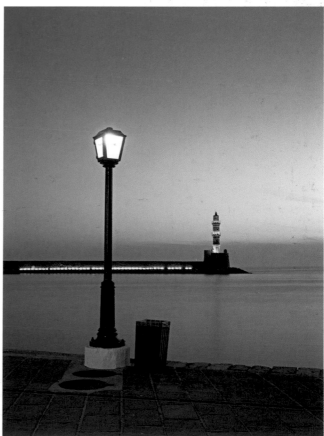

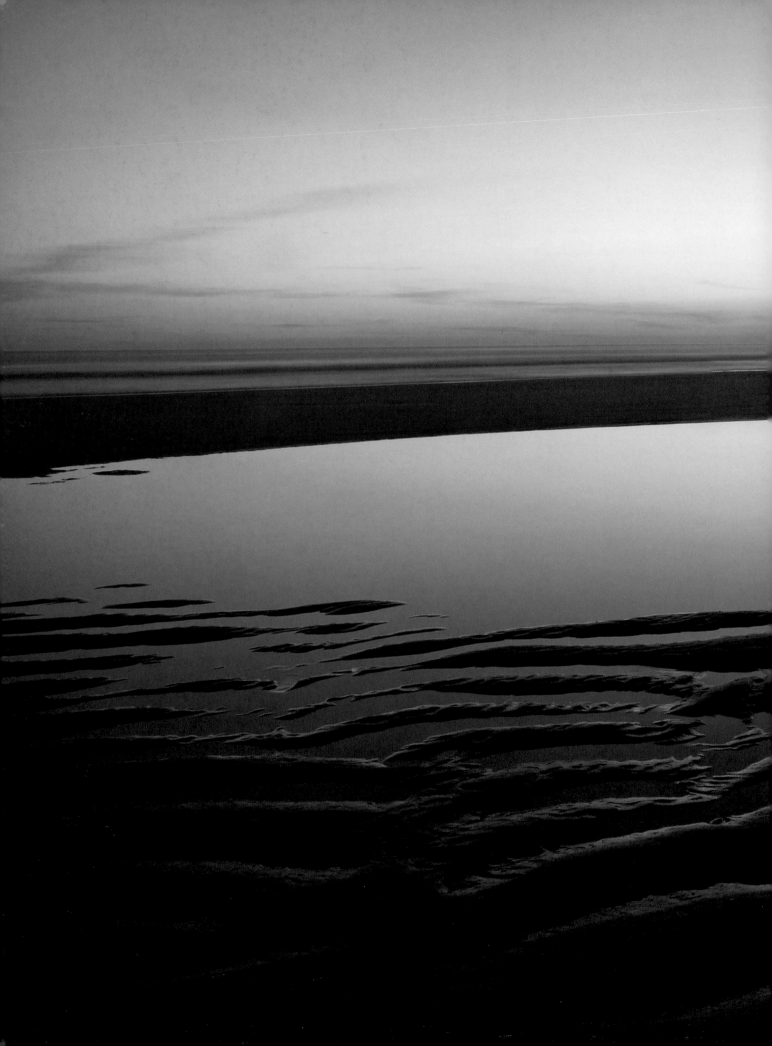

CHAPTER THREE
LOW-LIGHT SITUATIONS

THE QUALITY OF LIGHT

Ask any professional photographer and they will tell you that the secret of a successful photograph, particularly when shooting outside, is the quality of light. Most good landscapes are captured either at dawn or at dusk, although an increasing number of photographers recognize that great shots can also be captured at night.

LIGHT AT DUSK

It is perhaps a reflection of sleeping habits, but most amateur photographers are more inclined to photograph at sunset than they are at sunrise. That is not to detract from the wonderful quality of light one can expect to experience at this enchanting time of the day. It is sometimes easy to confuse the two periods, but there are important yet subtle differences between them.

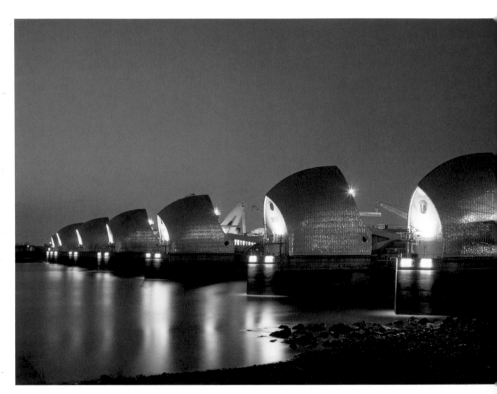

When compared to sunrise there is still an enormous amount of light at sunset. Therefore the main problem is balancing the exposure for both the sky and the foreground. This is where a graduated neutral density filter proves useful (see pp. 24–25). There is also a very noticeable disparity in the intensity of light at dusk between the east and west. In the west, the light is still extremely bright, but a more subtle quality of light can often be seen in the east. Also, by comparison to the dawn light, evening light is much warmer.

In common with the light we see at dawn, expect to see the colours of the sun reflected in clouds; often these can be so visually compelling they become the major focus of the image. As with dawn light, when the sky is seen without the sun the light becomes softer as contrast is reduced and shadows begin to weaken. Once the sun has set and throughout the period of twilight, the colours become

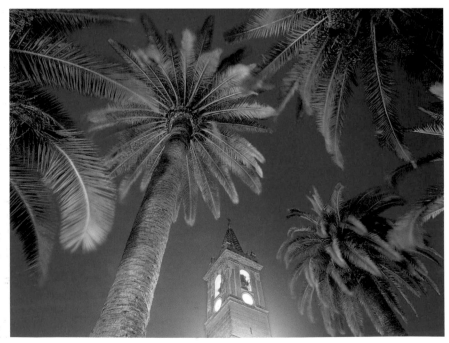

noticeably warmer. This is a phenomenon known as 'purple light' and is caused by the light from the blue end of the spectrum being reflected back into the sky. As the sun sinks even further below the horizon, one can often see an interesting afterglow of violet or pink; this might last for just a few minutes. While mists are a common feature with dawn light, there is no such luck at dusk. As the land has warmed up in the course of the day, there is no temperature inversion to create the right conditions for mist. Although fog can occur after dusk, particularly during the winter, this occurs only after the sun has gone down.

The temptation is always to face west, but the eastern sky certainly has something to offer. At twilight, the grey-blue band that appears over the horizon is the Earth's shadow.

This occurs just after sunset and rises to 6 degrees before it starts to fade. It is visible in the east because it marks the boundary between the illuminated and the non-illuminated parts of the atmosphere. When looking at the Earth's shadow, notice the red-orange-yellow band just above it that is created by the sun's rays shining into the sky, which then reflects the light downwards. This is a phenomenon known as 'counter twilight'.

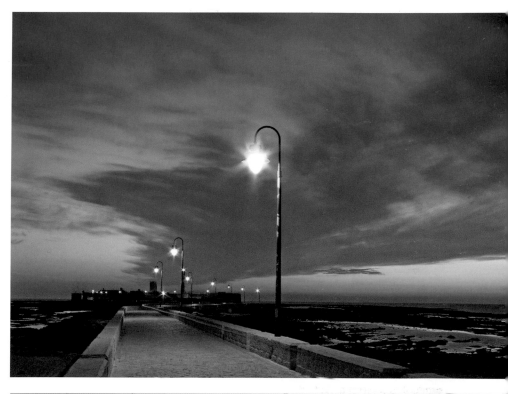

LEFT Dusk is probably the time of day when the sky makes its greatest changes. Once the sun has set, the colours become warmer and a phenomenon known as 'purple light' becomes evident. This is caused by the light from the blue end of the spectrum being reflected back into the sky. This proved an ideal time to photograph the intriguing Thames Barrier in London.
Canon EOS 40D, 17–85mm zoom lens, 2 min at f/16, ISO 100

BELOW LEFT There are probably more photographs taken at evening light than virtually any other time of day, but in truth it really can be a special time to take photographs.
Canon EOS 5D, 24–105mm zoom lens, 8 sec at f/11, ISO 100

ABOVE RIGHT When photographing in low light, you should always be prepared to embrace the unexpected. As I was photographing this causeway, a motorcyclist sped by, leaving a characteristic light trail in his wake. I think this adds to the picture.
Canon EOS 5D, 20mm lens, 16 sec at f/22, ISO 100

RIGHT Photographing close to the Mojave Desert in California, I was surprised at how quickly dusk turned to night. In a matter of minutes the beautiful warmth of the evening sky had given way to an inky blackness. You need to act quickly in such situations or your limited window of opportunity is squandered.
Canon EOS 40D, 17–85mm zoom lens, 4 sec at f/10, ISO 200

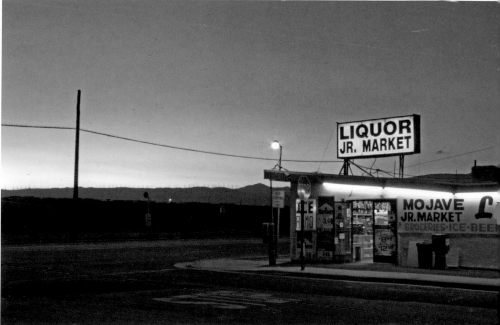

NIGHT PHOTOGRAPHY

Photographing at night certainly poses a challenge: theoretically there is no available light, although in reality that is not the case. It is extremely rare to experience total blackout, and most of us are able to walk home quite safely at night once our eyes become adjusted. This is because there is always a source of illumination somewhere. Away from any built-up environment, it could be that the only light source is the moon, but this is a rare occurrence. Even in rural areas of the developed world it can be hard to escape the orange glow of some near-by conurbation.

Our usual experiences of night lighting involve artificial lighting, and that can be both a curse and a blessing. The biggest problem is that artificial lighting greatly increases contrast, which some camera sensors find difficult to cope with. Moreover, deciding which White Balance

BELOW This is the Millennium Bridge linking Gateshead with Newcastle in northern England. At night the bridge was still being used by countless pedestrians. However, as I needed an exposure of nearly four minutes, they fail to appear in the image.
Canon EOS 5D, 20mm lens, 221 sec at f/22, ISO 100

option to use can also pose problems. My own view on this is that we should not always be aiming to achieve colours commensurate with daylight; instead we should learn to appreciate the bizarre and surreal colours that can be achieved at night. There are other practical problems to overcome. The very long exposures often required at night can encourage flare, particularly from adjacent brightly illuminated objects. With very long exposures of 30 minutes or more, the camera's viewfinder can start leaking light.

Getting an accurate light reading at night

This is the main reason why some photographers are reluctant to try serious night photography. They use their meter and, as it indicates that it is unable to give a reading, they give up, believing that their camera cannot operate at night. It is important to appreciate that a light meter can be fooled into giving you any exposure you want irrespective of the conditions. Most built-in camera meters will give an exposure of up to 30 seconds. However, if the aperture is set for f/16 it might not be able to give you a reading for that aperture. Simply keep opening the aperture until the meter gives you a light reading, which may be as low as f/2.8. But you don't want to use an aperture of f/2.8, you want f/16; to calculate this, double the length of the exposure for each f-stop you close down the aperture. For example, if your meter tells you that you need 30 seconds at f/2.8, then it is also telling you that you need a one-minute exposure at f/4,

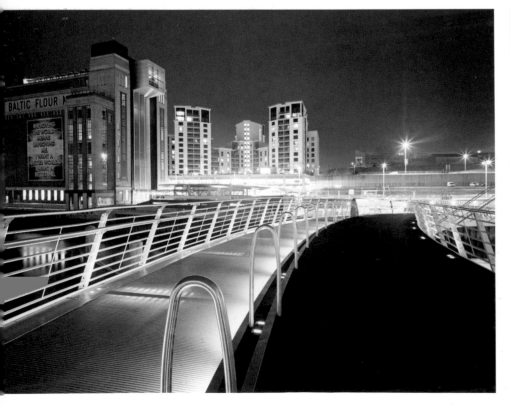

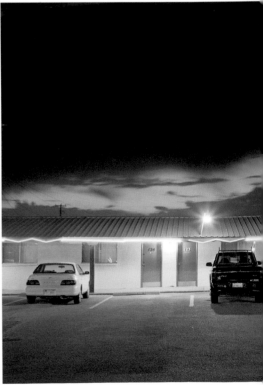

a two-minute exposure at f/5.6 and a four-minute exposure at f/8 and so on. On that basis it does not take a genius to work out that you will require a 16-minute exposure at f/16. In some very dark situations, it might be that you cannot get a light reading even with the camera set to the slowest speed with the widest aperture. Your next option is to increase the ISO rating. For example, while you may have opted to use an ISO of just 100, by increasing this to 1600 you are effectively increasing the speed by four stops. If we go back to our original calculation, let's assume that we are able to get a reading of only f/2.8 at 30 seconds when the ISO rating is set at 1600. If we still wish to use a rating of 100, then the effective exposure will need to increase by a further four stops, which requires an exposure of one hour.

Photographing landscape at night

In theory, if you expose for long enough then you will always get a picture, although it may not necessarily be the image you want. The best time to take a night shot is between 40 minutes and one hour after sunset. If you are facing west, there will still be some perceptible light in the sky; this offers a wonderful deep blue, particularly on a clear night. If you are photographing a landscape well away from any large town late at night then your only source of light may be the moon, and this can be surprisingly effective. Remember, you do not need to include the moon in your shot in order to take advantage of its illumination. In fact, you are advised

not to, as it will be far too bright relative to the rest of the landscape. Moreover, if you require an exposure of more than just a few seconds, it will appear blurred because of the rotation of the earth. Even on an overcast night, when any illumination from the moon has been blocked, it should be possible to take an effective shot, although the results will lack contrast and appear overwhelmingly blue. If you try this, aim to include a small element of illumination either from a distant building or perhaps a passing vehicle; this feature can offer a contrast to the overall blueness. A landscape in snow can prove a particularly rewarding subject to photograph at night, as the snow has the capacity to reflect the available light, revealing interesting detail.

BELOW LEFT Contrast is one of the biggest problems when photographing an urban area at night. It helps to select a location where the illumination is subdued.
Canon EOS 5D, 24–105mm zoom lens, 190 sec at f/16, ISO 100

BELOW Many of the older parts of cities offer wonderful photographic opportunities at night; Newcastle's Tyne Bridge is an excellent example. Try to keep an eye on the passing traffic to ensure that the headlights do not shine directly at the camera during the exposure.
Canon EOS 5D, 70–200mm zoom lens, 84 sec at f/22, ISO 400

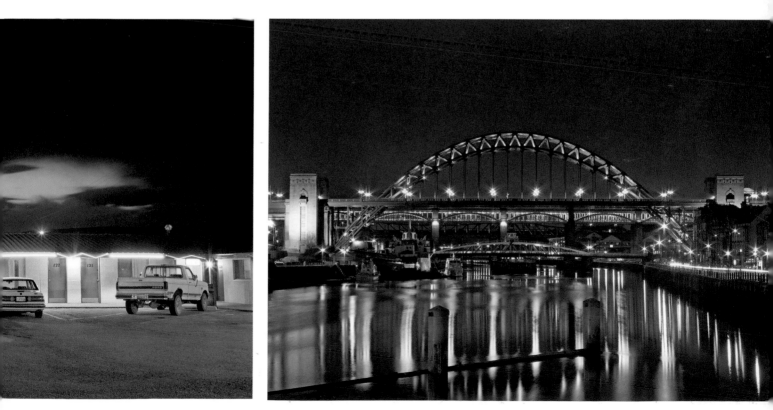

Photographing the built environment at night

Large conurbations offer excellent opportunities for night photography, as there will always be some source of artificial lighting. The main problem is assessing the light source and using the appropriate White Balance. Cities can be particularly appealing at night shortly after rain when the pavements are reflected in the city lights. Getting an accurate meter reading can sometimes be difficult due to contrast, so aim to spot-meter off some area of mid-grey. When compared to photographing a landscape at night, the exposures required for cities tend to be short. Consequently, you should be able to check whether you have made an accurate exposure in the LCD.

Photographing the moon

This is quite an easy task, partly because the moon is large in the sky, and is also fairly bright. A full moon can easily be shot handheld. The example illustrated on pp. 58–59 was taken at 1/160 sec at f/6.3 with an ISO setting of 400. I used a 200mm zoom.

The main problem you face is matching the exposure of the moon with the rest of the shot, which often requires a longer exposure. Clearly there is a balance to be found. If you expose for a full moon, you are unlikely to get a good all-round exposure, but if you expose for the full frame, the moon will appear burnt-out and blurred because of the Earth's movement. The best solution is to take a shot of the moon independent of the scene and then take a second shot and meter for the landscape. Merging the two files is a simple task. This has several advantages: first, it is often very difficult to catch the moon in its full splendour rising over an interesting landscape. However, unless you are using a particularly powerful long-angle lens, the moon in isolation rarely makes an interesting subject in its own right. Second, while most landscapes often look interesting when photographed at night, the sky by contrast appears featureless; by importing a moon you will be able to introduce an added dimension to the image.

Night offers us wonderful opportunities, when even mundane features assume a strange beauty. This road junction, a short distance from my home, took on an eerie glow when photographed in a thin winter fog. It would have been too dangerous to attempt to take this shot in daytime. *Canon EOS 5D, 24–105mm zoom lens, 32 sec at f/11, ISO 200 32 sec at f/11, ISO 200*

This was shot about an hour after sunset, when there was no visible source of light. But even on an overcast night, when any illumination from the moon has been blocked, it was still possible to capture an effective image. This shot required an exposure of 25 minutes.
Canon EOS 5D, 24–105mm zoom lens, 25 min at f/11, ISO 100

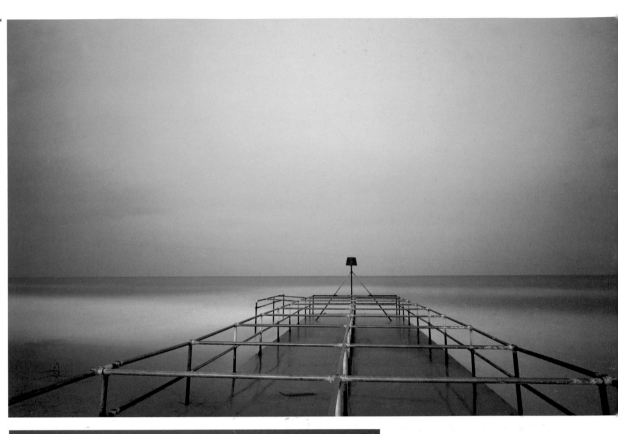

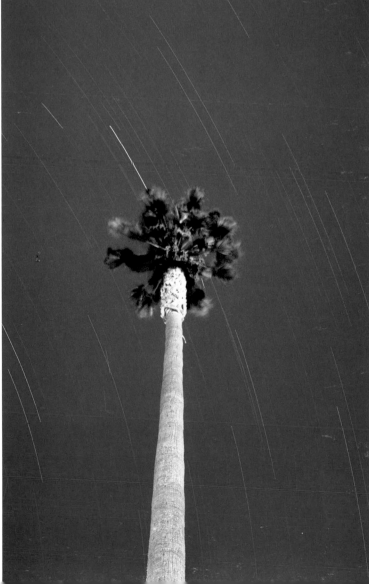

Even the simplest subject can appear interesting at night. Although the palm tree was slightly illuminated by a distant light, most of the illumination came from the moon. Requiring an exposure of nearly an hour, some blurring was inevitable in this shot, but that just adds to the atmosphere.
Canon EOS 5D, 24–105mm zoom lens, 55 min at f/8, ISO 200

Blending an image of a moon and a night landscape in Photoshop

Blending two files is simple in Photoshop. First call up the image without the moon and make this your Background layer. Then call up the image with the correctly exposed moon and simply drag this layer over the Background layer. Having called up the Layers palette, apply Lighten from the Blending Mode. The moon might not be in the perfect position, but by using the Move tool you are able to reposition it to best advantage. Once you are happy with the outcome, flatten and save. This technique is identical to the principle of intensifying light trails, which is discussed more fully in the final chapter (see pp. 140–141).

Photographing stars

This is a specialized area of photography that is demanding in terms of time and care, but the outcome can be fascinating. Because of the Earth's rotation, if you point your camera up into the night sky, the stars will appear like light trails.

To get the best results, you may need to expose your camera for up to six hours or more; you need to consider whether you really want to do this. Moreover, you will need to have a spare battery to hand, as exposures of this length will drain the battery's power.

To photograph stars, follow these steps:

- choose a very clear night. It is often best to try this method in winter, not just because the nights are longer, but because air pollution is less evident at this time of year
- work with a sturdy tripod. As exposures will last for hours, not minutes, it is important that your tripod does not move. Think carefully about where you place your tripod; ideally it should be somewhere sheltered from gusts of wind
- use a standard or slightly long-angle lens. A wide-angle lens will not show this technique to best effect
- in order to reduce the exposure time, be prepared to use a moderately fast ISO setting. Try 400
- switch off the autofocus and use manual instead. If you set to autofocus, your lens will start 'hunting'
- set your exposure to 'B' and select a reasonably large aperture. Make sure your lens is set to infinity
- star trails on their own are fairly unexciting, but can appear more interesting when counterbalanced with another attractive feature. The problem is that each might require a different exposure. Using star trails within a composite is one way around the problem.

ONE Photographing landscape at night can prove rewarding, sometimes revealing unusual lighting effects. However, you are often left with a featureless black sky.
Canon EOS 40D, 24–105mm zoom lens, 7 min at f/16, ISO 200

TWO Capturing the moon digitally can be surprisingly easy. The intensity of the light from the full moon allowed me to handhold this shot. It is important to ensure that the remaining part of the image is completely black so you can achieve a faultless blend between the moon and the Background layer.
Canon EOS 5D, 70–200mm zoom lens, 1/60 sec at f/6.3, ISO 400

THREE Using Photoshop, blending the moon layer with the Background layer is easy. It is sometimes tempting to import a particularly large moon into the background, but this can often look unnecessarily surreal. While the moon layer is active, it is simple to resize the moon using Transform so that it looks both plausible and aesthetically pleasing.

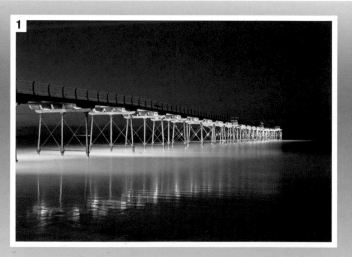

Photographing firework displays

From a photography standpoint, large organized events supervised by skilled technicians offer the best shows. You also have the choice of photographing fireworks in the winter or against the deep blue of a summer's evening. I prefer the latter.

Irrespective of the season, try an ISO rating of 100 with an aperture of f/16. Take a light reading from the sky to establish a suitable shutter speed, but then reduce it by a quarter. This ensures that you obtain a rich, dark sky. If in doubt, start with a 15-second exposure if photographing in summer, and one minute in winter. A quick check in the LCD should allay any doubts.

While I have suggested that you use the camera's NR facility for most low-light situations, make sure it is turned off when photographing fireworks. With the time required to process each image, excellent photographic opportunities will pass you by. If you have selected an ISO rating of 100, the incidence of noise should be greatly reduced.

Try experimenting with a range of focal lengths. Sometimes a wide-angle shot can be appropriate, while long-angle lenses work best on other occasions. This is when a medium zoom lens can prove useful.

As you watch the display, you will notice lulls and crescendos. Obviously, you will want to capture the peak moments. One way of achieving this is to use a small piece of black card to cover the lens while there are lulls in the display and then to remove it once the display becomes exciting again. Needless to say, you will need to deduct that period of time from your timed exposure. Most firework displays finish with a grand finale, so it is important to anticipate when this is likely to happen.

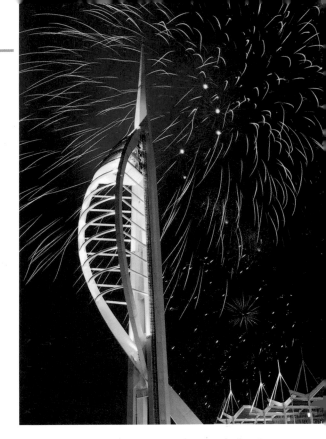

The Spinnaker Tower in Portsmouth, England, is a wonderful structure to photograph at any time, but is particularly appealing when set against a firework display.
Canon EOS 5D, 24–105mm zoom lens, 15 sec at f/11, ISO 50

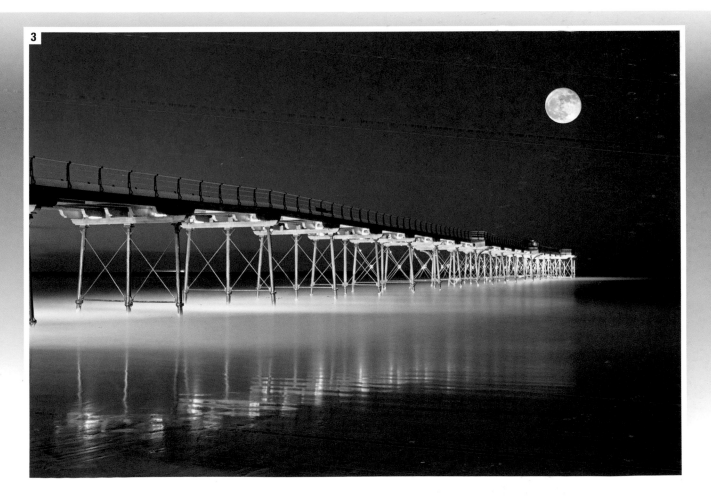

LIGHT AT DAWN

Early morning can be a particularly rewarding time to take photographs and, in my experience, is not too often shared by other photographers. It is a period that can be flamboyantly dramatic or quietly lyrical. Often dawn offers the best lighting, even if the rest of the day might prove to be wretched.

At 6am the burly driver of this truck was just about to set off. Fortunately, I persuaded him to get out of his cab and let me take this shot of his wonderful vehicle against the emerging dawn. I suspect he was too sleepy to refuse!
Canon EOS 40D, 17–85mm zoom lens, 1/3 sec at f/10, ISO 200

Part of the appeal of shooting at dawn is the aura of tranquility. Traffic has not started to hit the roads, families are only just beginning to stir, and there is a distinct lack of bustle and activity. That sense of stillness seems also to apply to the wind. Even when gusts are predicted they seem rarely to start until well after sunrise.

The pre-dawn light offers you only a limited window of opportunity, particularly when photographing landscape, so it is well worth checking out potential locations the previous day. Not only should you establish the best viewing point, but also consider simple practicalities such as where can you safely park. Waste just 20 minutes and you will be surprised just how quickly the light comes up. Be realistic about how long it will take you to get to your location, remembering that you will be driving in the dark. Plan for the unpredictable; this is the time of day that you are most likely to experience mists, and these can occur at virtually any time of the year.

Dawn can be divided into two periods, before sunrise and at sunrise. They are dramatically different:

- before sunrise, the quality of light will be cool and virtually shadowless. The colours will be muted or blue and can assume almost monochromatic qualities. This time can offer wonderful skies, particularly if there is a scattering of clouds, as the emerging sun projects light upwards. In a more urban environment, artificial lights or street lighting offer interesting challenges.
- at sunrise, the quality of light changes dramatically. Colours appear very warm, showing an orange/red bias. The sun has the capacity to penetrate through the atmosphere, creating strong and dramatic shadows, which by way of contrast have a distinct blue bias. As orange and blue appear opposite on the colour wheel, the results can be stunning.

I spotted this wonderful urban location the previous day and guessed that it might offer rich pickings at dawn. I arrived about 40 minutes before daybreak and took several shots as the sun gradually emerged. This one was taken at 6am; I was surprised by how busy the area had become by that time.
Canon EOS 5D, 50mm lens, 10 sec at f/16, ISO 100

By turning my back to the emerging sun, I was able to see the first rays of the day reflected off the chrome exterior of this fabulous American diner. Taken in the summer months, it was still too early for the first customers of the day.
Canon EOS 40D, 17–85mm zoom lens, 2 sec at f/13, ISO 100

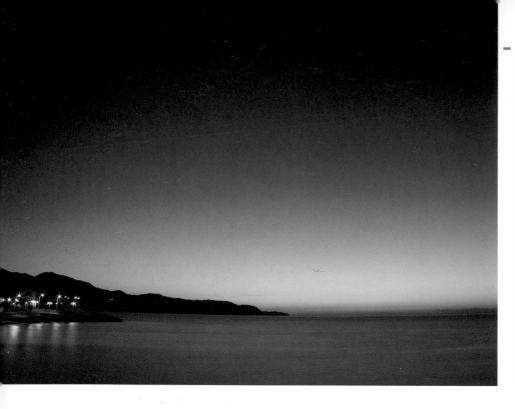

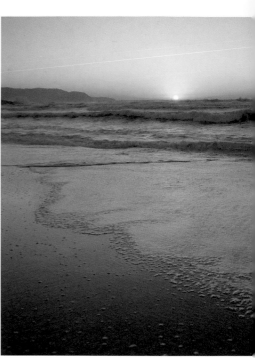

SUNRISE AND SUNSET

There are few spectacles that quite match the beauty of a dramatic sunrise or sunset; the low angle of the sun bathes everything in a warm theatrical light, which seems to pick out every element of detail. It is, however, surprisingly difficult to photograph the perfect sunrise or sunset.

The main problem is contrast, particularly if you wish to include a foreground. If you expose for the foreground then the sky will appear too bright, but if you meter for the sky the foreground will appear underexposed. One solution is to make two light readings, one of the sky and one of the foreground and then average out the two. If the contrast is still too great the sun may just be too bright in the sky. As a simple rule of thumb, I will photograph the sun only if I can comfortably look at it without having to squint my eyes. If the sun is any brighter than this, you are going beyond the camera's dynamic range. In this case, you should consider excluding the sun altogether. One solution is to wait for the sun to briefly disappear behind a cloud. Alternatively, you may wish to take two separate exposures, one for the sky and one for the foreground and then blend the two separate files post-camera (see pp. 130–131). Another simple solution is to use a graduated filter.

ABOVE At the point when the sun rises, the sky shows a red/orange bias, while the shadows retain a strong blue cast.
Canon EOS 5D, 24–105mm zoom lens 1 sec at f18

ABOVE LEFT Taken about 40 minutes before sunrise, the sky reveals a wonderful colour gradation from orange through to blue.
Canon EOS 5D, 24–105mm zoom lens 42 sec at f8

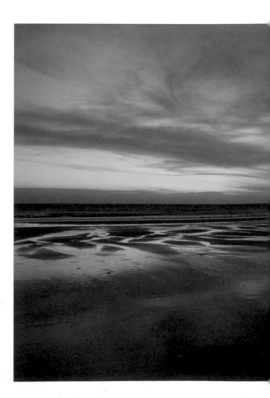

RIGHT A useful way of countering contrast is to let the sun disappear behind a veil of cloud. While some of the intensity of the colour might be lost, the camera is much more capable of recording the full range of tones. (Photograph by Eva Worobiec)
Canon EOS 40D, 17–85mm zoom, 2 sec at F11 ISO 100

FAR RIGHT Photographing a sunset or sunrise can be enhanced by including a simple silhouette.
Canon EOS 40D, 17–85mm zoom lens, 1/15 sec at f/16, ISO 100

What do I meter for?

Your main problem is overexposure. One of the key characteristics of a successful sunrise or sunset image is a creamy smoothness of the tones, particularly in the lightest areas. However, when working digitally, this can easily be replaced with unsightly demarcated blocks of yellow and white. It is far better to underexpose.

If you opt to use the camera's metering system, don't choose the auto setting as it will very easily be fooled. Try the Partial metering mode and take a light reading off the sky. Alternatively, you may wish to use a handheld meter.

There are some other factors to consider to help you get a more successful shot:

- shoot Raw. This way you are using a wider range of tones, which are more capable of capturing the subtle nuances of highlight detail that can otherwise be lost
- select the lowest ISO setting available. Once again, this is one way of ensuring that all the subtle detail is captured
- in most circumstances, select the Daylight White Balance
- bearing in mind how tricky exposure can be in high-contrast situations, be prepared to bracket your exposures. Assessing the results in strong light can be very difficult, but being able to select the correct exposure once you have downloaded the images is an advantage
- as a guideline, expose for the highlights. It is easy to lighten shadow detail afterwards in Photoshop, but there is little you can do with burnt-out highlights.

Making further adjustments in the Raw dialog

While some of you must wonder why I keep urging you to shoot Raw, it does allow you to make many important adjustments non-destructively. First, all Raw Conversion dialogs have a saturation slider, which allows you to pump up the saturation. Be prepared to apply this, but keep a careful eye on the highlights otherwise you risk losing subtle detail. Most Raw dialogs offer a facility for adjusting the white light balance. By increasing the colour temperature, the result will be the same as if you had taken the shot through a warm-up filter. If you decide that you would prefer to shoot in JPEG, select the Cloudy white light preset.

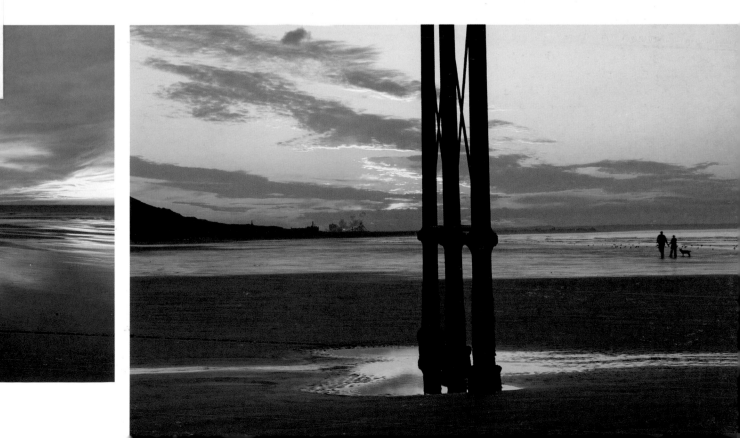

CROSSOVER LIGHTING

Crossover lighting is a term to describe the lighting situation when an illuminated building or structure matches that of the sky. It is a style of photography that is possibly best exemplified by the American photographer Joel Meyerowitz.

Carrying out this technique requires making very accurate light meter readings, which are usually best achieved using a handheld light meter. The aim is to arrive at an exposure whereby the sky and the foreground are the same. As the illuminated foreground is likely to remain constant and the sky is either becoming progressively darker (in the evening) or progressively lighter (at dawn), take your initial reading from the foreground and then keep taking further light readings from the sky until both parts are the same. Once you arrive at that point, take your shot. If everything turns out well, the result should be a perfect balance. It is a personal thing, but the images that can be achieved in

this kind of lighting can be quite spectacularly beautiful; moreover, you should not need to make any further adjustments in-camera or post-production.

This kind of perfection comes at a price, as your window of opportunity is likely to be very small; with a clear sky, expect no more than five minutes. I would normally use an exposure of about 30 seconds at f/16 when using an ISO of 100. While I would always recommend that you use your Noise Reduction facility, given the time it takes to process the image, you are likely to get in only two or three good shots at best. Planning your composition well in advance will be even more important. Your choice of White Balance will be governed by the proportion of sky relative to the foreground, although as changes to the sky are generally easier to make than to illuminated buildings, I would normally select one that matches the light source for the foreground. I should just mention how very reliable the Auto WB setting can be in these situations.

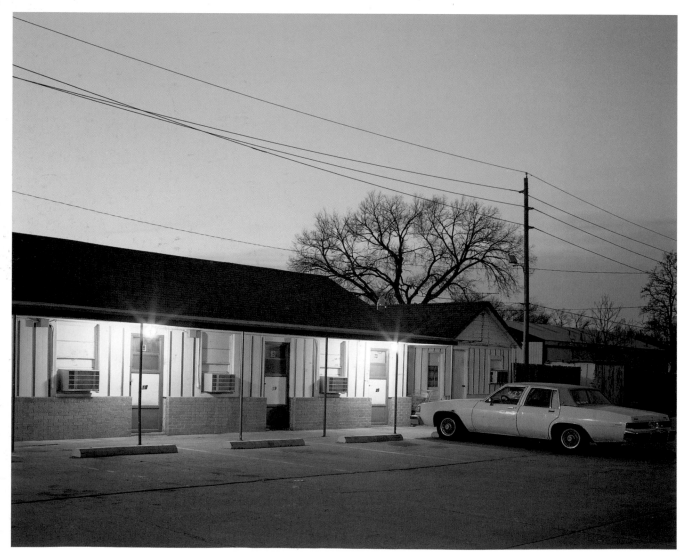

RIGHT With crossover lighting, you are trying to achieve a perfect balance of exposure between the sky and the illuminated building. Photographed any earlier, the lighting would appear insipid, but photographed much later and the sky would be reduced to an inky black. Generally, the best results can be obtained about 20 minutes after sunset.
Canon EOS 40D, 24–105mm zoom lens, 35 sec at f/18, ISO 100

BELOW LEFT You can achieve a wonderful balance in terms of exposure with crossover lighting and it can also create magnificent contrasts. The difference between the warm colours of the motel and the coolness of the night sky is the most visually arresting feature of this image.
Canon EOS 40D, 17–85mm zoom lens, 1/15 sec at f/16, ISO 100

BELOW RIGHT Even the most mundane of subjects can appear visually stunning when photographed in rich crossover lighting. Had I observed this scene an hour earlier, I doubt that I would have given it a second glance.
Canon EOS 5D, 50mm lens, 22 sec at f/22, ISO 100

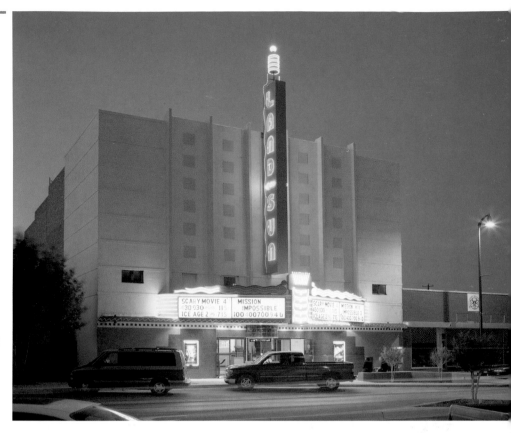

tip

Use a handheld meter to establish that the foreground and the sky are in balance; alternatively, use the spot-metering facility. In any difficult lighting situation, set the camera to Manual mode: you, not the camera, are in control.

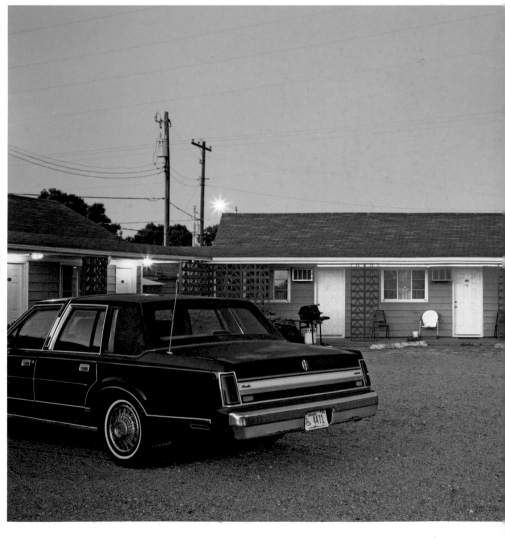

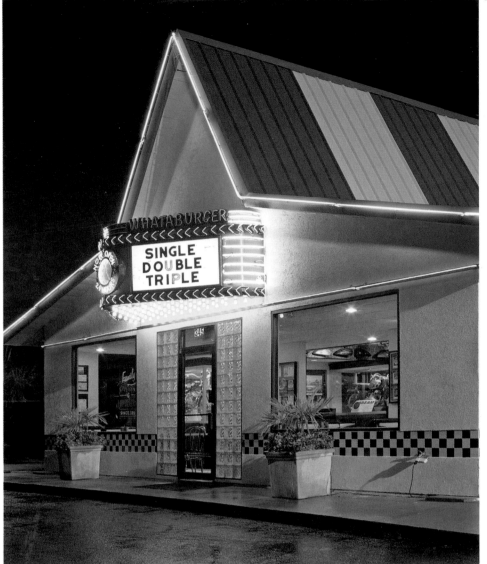

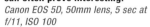

Because I used an exposure of 5 seconds or more, the rain in this image appears invisible, as it was moving too quickly to register. Reflections on rain-washed surfaces, particularly in an urban environment, can often prove interesting.
Canon EOS 5D, 50mm lens, 5 sec at f/11, ISO 100

Ordinary situations can be dramatically transformed in rain, particularly at night. This was the view from outside my motel just before sunrise, as I sheltered under the eaves of the building. Captured with a long-angle lens, the neon lighting reflected on wet tarmac produces some wonderful abstract elements.
Canon EOS 5D, 70–200mm zoom lens, 7 sec at f/22, ISO 400

PHOTOGRAPHING IN POOR WEATHER

This is something of a misnomer, because as far as I am concerned, there is no such thing as poor weather. Perhaps an issue not appreciated by all photographers is that inclement conditions can offer some of the most exciting photographic opportunities. It does, of course, help if you understand different weather conditions and are able to predict them. If I am planning to travel to an interesting location I always take the trouble of getting an up-to-date weather forecast before I leave to make the most of the circumstances.

Mist and fog

Possibly one of the few weather conditions that all photographers wish to experience from time to time, if only because of its beautiful ethereal qualities, is mist and fog. Predicting when this might occur is somewhat difficult. While mist and fog most commonly appear in autumn and winter, they may also occur after rainfall at night during any season. Mist and fog may also occur when the climatic conditions give rise to a phenomenon known as temperature inversion, when cold air is trapped over warm air.

The effects of mist and fog, particularly at sunrise, can be especially appealing. The lighting conditions are characteristically soft and diffused, often creating gentle pastel hues. Scenes that in normal daylight might appear visually discordant are toned down to gentle and subdued monochromatic hues. Because the light is scattered the contrast is similarly considerably reduced.

Exposure in such lighting conditions can prove problematic, but metering for the highlights is usually the best policy. If you are using a handheld meter, take an incident light reading. Dense fog can be notoriously difficult to expose for, so if necessary take a reading off the back of your hand and then increase the exposure by half to one stop. It may also be worth bracketing your exposures when trying to create shots in such demanding lighting conditions.

Rain

While many photographers are prepared to chance their arm with fog, far fewer are prepared to photograph in rain. It is not just that they are reluctant to get wet, but water can produce problems with cameras and lenses. Not surprisingly, therefore, few photographers are prepared to shoot when it is raining. This is a pity, as rain offers wonderful

Early-morning mists can create some of the most beautifully ethereal conditions for taking photographs. The main problem is getting the right exposure. If you are using a handheld meter, take an incident light reading. Alternatively, you might consider bracketing.
Canon EOS 40D, 24–105mm zoom lens, 1/20 sec at f/16, ISO 100

tip

Be prepared to use an umbrella. Not only will it keep you dry, it will keep your lens dry as well. If your camera is attached to a tripod, this is easily done.

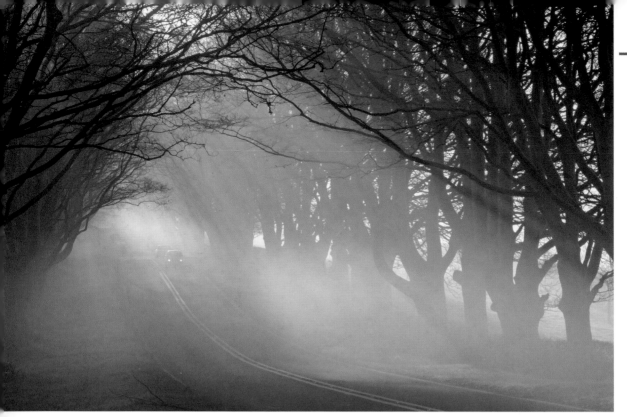

Fog can produce some remarkably beautiful conditions, but it often dissipates shortly after sunrise so you need to rise early to capture it.
Canon EOS 5D, 70–200mm zoom lens, 1/30 sec at f/22, ISO 400

photographic opportunities. Despite the reduced light, colours can appear rich and intense in the rain, which can be especially flattering to landscape. Because of the lack of shadows, forms often appear more rounded. After rain, look for reflections on rain-washed surfaces. These can be interesting at night, especially within an urban environment.

If you are photographing rain, find somewhere to shelter, for example under a tree or in a doorway. With a good zoom lens, you should be able to get into where the action is. At 1/60 sec you should be able to capture the movement of rain, but at lower shutter speeds the rain will record as a

blur. During exposures of one second or more, any movement from the rain completely disappears.

It is important to protect your camera when working in wet conditions. Modern DSLRs are well-sealed and can be safely exposed to some rain, but excessive moisture may still do some damage. If you are unable to shelter your camera, try making an impromptu cover out of a clear plastic bag. This will allow you to continue using the camera without it getting wet. Always protect the lens with a simple UV filter, and if necessary dry it with a dust-free cloth after each exposure.

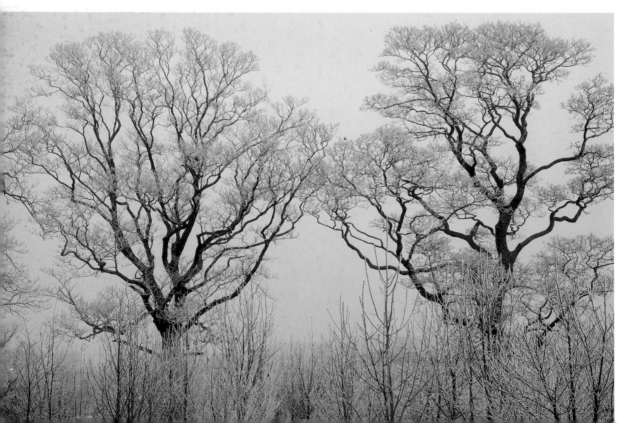

Hoar frost transforms the most mundane landscape, creating an eerily beautiful monochromatic scene. Here, the temperature the night before had dipped to −9°C (15.8°F). Try to keep your camera out of the cold for as long as possible in such severe conditions.
Canon EOS 5D, 70–200mm zoom lens, 1/30 sec at f/18, ISO 200

Storms

Storms can occur at any time of the year and can offer fabulous photographic opportunities, particularly if you are in a situation where you are able to isolate the threatening clouds relative to the landscape. Flat open landscape or the coast can often provide an excellent location for this type of photography. When taking a light reading – which you should take off the clouds – the meter will be aiming for a middle grey, which might not be sufficient to express the dark brooding atmosphere you are witnessing. If you wish to retain that dramatic sense of foreboding, try underexposing by up to one stop.

Snow

Snow transforms the land to a high-key monochromatic scene, and is an excellent medium for reflecting adjacent strong colours, particularly in low light. When photographing snow, you will encounter a blue cast in the shadows; this can be overcome by using an 81A or an 81B warm-up filter.

Exposing for snow can be difficult, as the reflected light from the snow can easily fool your light meter. Your meter will always give you a reading for 18 per cent grey, which means that in daytime you are likely to underexpose by at least two stops. In very low light, your camera's meter reading is likely to be more accurate. Even then, to avoid underexposure, take an incident light reading and then overexpose by half a stop.

Frost

Frost is very common on winter mornings, but less evident in the evening, so if you are prepared to get up early, the effects of frost are there to be photographed. They occur on clear still nights when all the heat has evaporated from the land. The air just above the ground needs to fall below freezing, which is why early morning often produces the best examples. Predicting them is quite easy, as they are most likely to occur during high pressure or when the previous day has experienced clear skies. Frost has a wonderful capacity for rendering the most ordinary plant life into something truly magical. The colours you get occupy the blue end of the colour spectrum and, as with snowy scenes, the images produced possess a wonderful monochromatic quality.

Problems with extreme cold

Aside from the discomfort, there are problems with photographing in temperatures of –6.5°C (20°F) and below. Most DSLRs work well in cold conditions; however, batteries begin to fail below this temperature. The first signs are that the shutter speeds begin to slow down, which of course will impact on the exposure. In such conditions, try to keep your camera as warm as possible; keep it inside the car for as long as you can, avoid using power-sapping accessories such as motor drivers, and even consider switching the autofocus to manual.

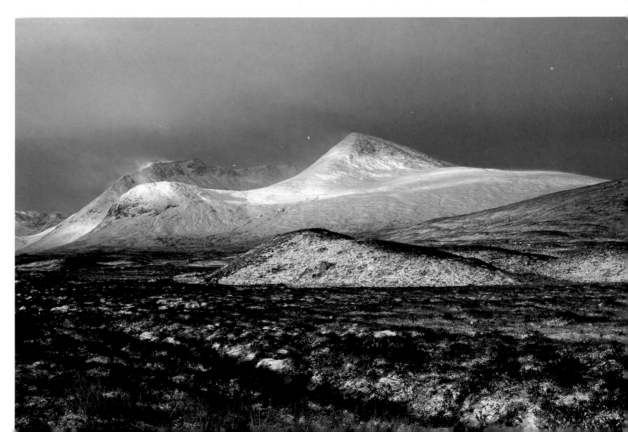

Winter scenes pose major challenges because of the low sun. If you want to retain maximum depth of field while using a slow ISO rating, you will need to work with a tripod. (Photograph: Eva Worobiec)
Canon EOS 5D, 50mm lens, 1/30 sec at f/11, ISO 100

UP T
DOORS 630

THE VISUAL APPEAL OF NEON

Neon is one of the most rewarding subjects to photograph in low light. Even today it continues to be a feature of many businesses in Europe and the US, although today's pallid displays are no match for the extravagance of America in the 1940s, 50s and 60s when neon dominated the urban landscape. As motels, diners, restaurants and petrol stations vied for trade, neon was shamelessly used to lure in custom. As its popularity grew, it could be seen on virtually all commercial buildings. That flamboyant display of swirling plasma was a cultural statement that seemed to set America apart from the rest of the world. Those of you who are fans of the cult movie *American Graffiti* will undoubtedly appreciate the brassy indulgence of this mid-twentieth-century phenomenon, although if you were to travel through large parts of the US today, you may be disappointed. Many of these wonderful cultural icons have disappeared, and those that survive need to be photographed, if only for posterity.

ABOVE Some neon can be particularly ornate and offers wonderful opportunities for abstract photography, as this example illustrates.
Canon EOS 5D, 70–200mm zoom lens, 2 sec at f/16, ISO 50

TOP FAR LEFT Really great shots can be captured by getting up close to neon. Wonderful old examples such as this are becoming increasingly rare. Selecting the correct White Balance can pose problems; in this example I selected Daylight, as an incorrectly balanced sky would have been more noticeable.
Canon EOS 40D, 17–85mm zoom lens, 6 sec at f/16, ISO 100

BOTTOM FAR LEFT As the popularity of neon grew in the 1940s and 50s, architects were expected to take it into account when drafting out their designs.
Canon EOS 5D, 70–200mm zoom lens, 1 sec at f/14, ISO 200

LEFT The silhouetted traffic lights introduce an extra element to this image. This is a case where a long-angle lens can prove useful.
Canon EOS 5D, 70–200mm zoom lens, 2 sec at f/11, ISO 100

While it is always desirable to photograph neon within its context, this might not be possible for a variety of reasons. For instance, many examples are so intricately ostentatious that they are best photographed against a much simpler background. A colourful dawn or evening sky can provide a wonderful foil for neon, although in reality most are rarely displayed in early morning. If you are able to catch neon at the point when the light is fading and the lighting has just come on, you will be rewarded with some stunning images.

The source of lighting is complex, particularly if you are photographing neon set against a dramatic sky. Once again, you need to establish some sense of balance. While we can be more forgiving of colour aberrations in something as artificial as neon, it is very easy to spot when the colours in the sky look wrong. Therefore, it might be more sensible to set the White Balance to accommodate the sky. As the neon is likely to be the lightest part of the image, expose for the highlights. Many interesting locations may have displays with one or two burnt-out tubes; accept this as rakish charm rather than regarding it as a flaw. Finally, make sure that you take a long-angle zoom so you can get in close.

LANDSCAPE IN LOW LIGHT

One of the most popular subjects for photography are landscapes. Good landscapes are available to us all, and they offer us the opportunity to impose our own creative outlook. The quality of light is the defining element when shooting landscape images.

LANDSCAPE AT DUSK

This is possibly the most popular and most photographed aspect of landscape photography, so forgive me if I appear to be stating the obvious here. Photographing landscape at the end of the day is considerably more convenient than shooting at dawn. First you are able to travel to your location in daylight, and second, you should be able to predict with reasonable accuracy what the lighting conditions are likely to be.

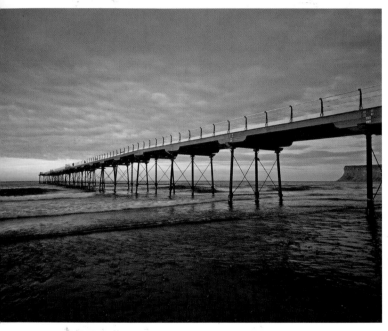

Sometimes some of the best lighting conditions appear at the end of an overcast day. The low evening sun peeps out below the clouds and picks out key elements within the picture.
Canon EOS 5D, 20mm lens, 1 sec at f/22, ISO 100

It is always sound practice to arrive at your location early, even if you are familiar with it. An hour spent checking out every possible viewpoint before the lighting becomes interesting is time well spent. But it is important to remain open-minded; lighting can be notoriously unpredictable and sometimes it requires a quick change of plan.

Photographing into the setting sun does cause problems. While the rim lighting it creates can be seductive, you are likely to encounter too much contrast. Allow the sun to disappear behind thin cloud or slightly change your viewpoint so that it is obscured by a tree or other distant object. The normal convention when shooting digitally is to expose for the highlights, but in these circumstances the contrast will be too great. Use a graduated neutral density filter to balance out the exposure, otherwise the sky will look too washed out.

The features of the landscape should govern many of your decisions, but often I find when photographing at dusk, just as the sun is setting, that facing away from the sun secures the best results. Not only is the contrast more containable, but the eastern sky can reveal a delicate range of hues.

When at home don't always assume that because the sky is overcast there is no chance of any dramatic lighting. If you notice even a slight break, it is worth getting to your location; often the setting sun can appear through the clouds to produce some awesome and theatrical light shows.

Most landscapes are best photographed using the smallest aperture. This ensures that everything from the foreground to the horizon is in sharp focus. This, of course, means that you must use a slow shutter speed and a tripod.

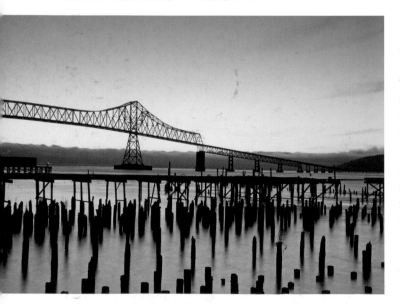

Facing the late evening sky, I was able to capture this beautifully silhouetted bridge at Astoria in Oregon together with the remnants of a derelict pier. With an exposure of 4 seconds, the movement of the water is transformed into an ethereal mist.
Canon EOS 5D, 20mm lens, 4 sec at f/16, ISO 100

My opinion is that the landscape becomes more interesting just after the sun has disappeared below the horizon. Sunsets after a sunny day can reveal an afterglow that can last around 40 minutes, and this can act as a fabulous foil for your landscape. The counter to that of course is that the land lacks an obvious source of light. In these situations, look for elements that might reflect what remaining light there is and use these as a feature. Also, be prepared to use flash. Obviously it would be impossible to illuminate the entire landscape, but if you are using a wide-angle lens and have found some interesting feature in the foreground, a discreet bit of fill-in flash can often work wonders, particularly if it is used off-camera. Quickly review your shot in the LCD; if you have overdone it, try using the flash on a weaker setting. Alternatively, you could try using a small torch to paint in some of the close-up detail.

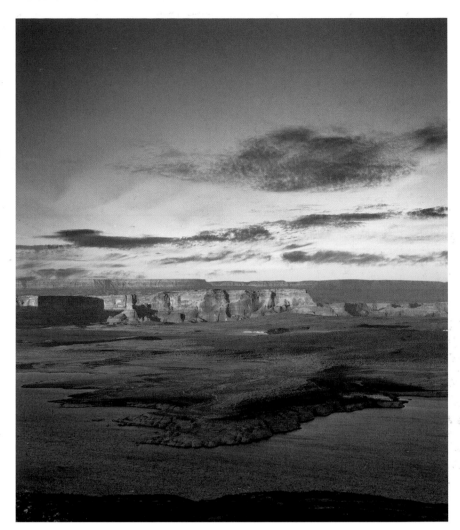

ABOVE RIGHT I encountered a particularly beautiful sunset while photographing on the shores of Lake Mead in Arizona. I decided to turn my back to the setting sun. This can often offer some of the best landscape opportunities – not only are you likely to come upon more interesting skies, but you will also experience a better balance between the sky and foreground.
Canon EOS 5D, 50mm lens, 1/2 sec at f/16, ISO 100

RIGHT Some of the best lighting conditions can appear at the end of an overcast day. In this shot of Chania Harbour in Crete, the low evening sun peeped below the clouds to create some dramatic lighting.
Canon EOS 5D, 70–200mm zoom lens, 17 sec at f/22, ISO 100

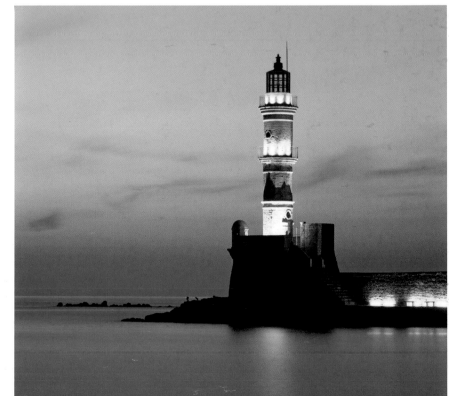

LANDSCAPE AT DAWN

As a reluctant early riser, I must confess that this is the aspect of landscape photography I find most challenging. It often requires a night car journey in order to get to the location on time. Having to get up very early, particularly in the summer months, does not appeal to everyone, but if you can be bothered the results can be stunning. If you are going to go to all that effort, it is imperative to check the weather forecast the previous day (although, as I have found to my cost, this is no guarantee).

It is important to be able to anticipate where the sun will rise as this will have an important bearing on the success of your trip. If it is an important shot, visit the area in daylight, checking out all the potential viewing points. If you are not familiar with the area or you are staying some distance from your location, make a realistic assessment of how long your journey will take, as there is little point arriving half an hour after sunrise.

The landscape just before sunrise can be a particularly appealing time to take photographs. While there are likely to be superb colours in the sky, the landscape will remain muted, which creates a wonderful tonal balance. The colours one gets at dawn certainly cannot compare with those one can expect to see in the middle of the day; my concern is that too many inexperienced photographers unnecessarily filter out the dawn cast in order to achieve something more neutral. When compared to shooting on film, the digital photographer has considerable scope for making changes, but sometimes the image is best left untouched. What the camera captures might not be precisely what you saw, but establishing what is 'real' is extremely subjective. My own view is that one should assess each image individually. If there is an obvious colour cast and it offends, only then should you change it.

BELOW LEFT The period just before sunrise can produce some beautiful lighting conditions, as this shot of Bryce Canyon, Utah demonstrates. The sky begins to reveal the warmth of the emerging sun, which is then reflected back into the land. Often when photographing landscape I need to use a filter to balance the sky with the foreground, but at this time of day filters are rarely required.
Canon EOS 5D, 70–200mm zoom lens, 2 sec at f/13, ISO 100

BELOW The moment the sun appears, it picks out the beautiful sandstone cliffs on the far-distant horizon. In these situations you have just minutes to play with before the sun rises sufficiently high and the entire landscape emerges into daylight.
Canon EOS 5D, 70–200mm zoom lens, 2 sec at f/13, ISO 100

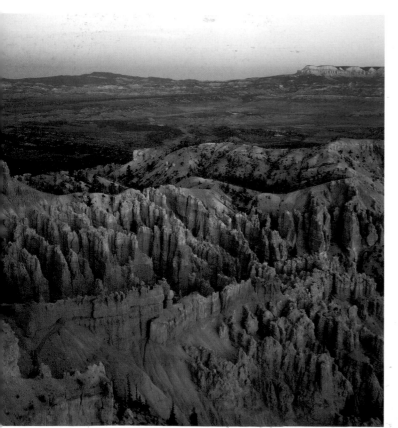

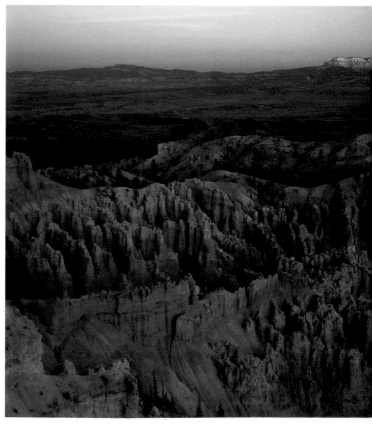

This shot was taken with my back to the sun, just as it emerged over the horizon.
The colours in the sky opposite the sun can be particularly attractive at this wonderful time of the day. Even a mundane roadsign can appear magical in such rich lighting.
Canon EOS 5D, 50mm lens, 2 sec at f/18, ISO 100

One of the great delights of photographing pre-dawn is that you are able to take something as simple as the in-coming tide and it will assume almost numinous qualities. It is also worth noting that the lighting is much colder than at dusk.
Canon EOS 40D, 17–85mm zoom lens, 35 sec at f/16, ISO 100

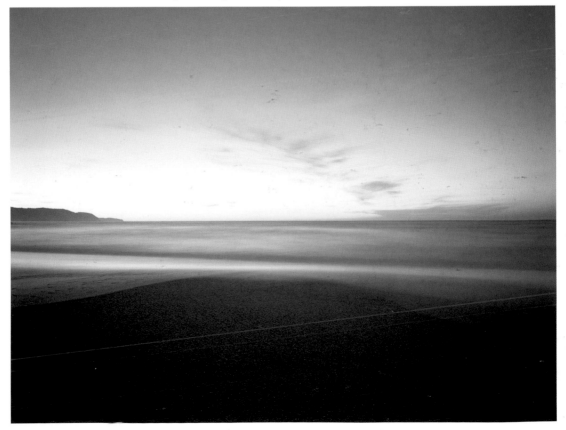

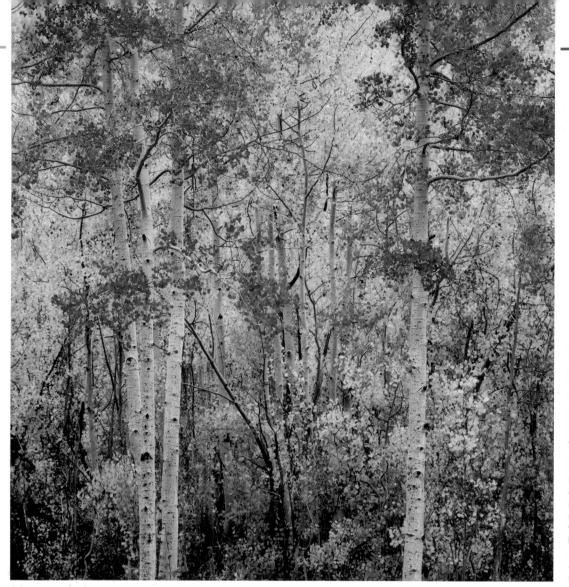

Many photographers underestimate how little light can be available in dense woodland even in the middle of the day, particularly if the sky is overcast. But if you arrive prepared with a tripod, there are rich pickings to be had. I often find the most saturated colours can be captured immediately after rainfall. This image was shot with a long-angle lens.
Canon EOS 5D, 24–105mm lens, 1/2 sec at f/16, ISO 100

LANDSCAPE IN POOR LIGHT

It is often assumed that low-light landscape photography refers to that period of time just after sunset and just before sunrise, but there are countless landscape locations where one can expect to see greatly reduced light even in the middle of the day. The most obvious example of this is in woodland. Often I would wander through our local forest and, while I had no problems photographing it from the edge, the moment I started to penetrate deep into the undergrowth, the lighting was so bad that I was unable to take a handheld shot. Ironically, the situation is often far worse in the summer, particularly among deciduous trees, as the thick foliage can block out most of the light.

The ambient lighting conditions are very important. On a very sunny day, a small amount of the light will get through irrespective of the thick overhead canopy, but this is not the kind of light that most of us would welcome. The result is

dappled sunlight, which can look very attractive, but is far too contrasty to photograph. Duller days are more conducive for this kind of work. Most landscape situations benefit from using a small aperture with a slow ISO to ensure that all the fine detail is captured; this necessitates using a slow shutter speed. Employing a slow shutter speed in a forest brings its own problems, most notably wind; if you want every leaf to appear pin-sharp, then it is important that there are no sudden breezes to spoil your picture. Fortunately, once you get well inside wooded areas, wind is greatly reduced.

Autumn can be a great time to photograph in deciduous woodland because of the interesting colour changes, but problems can be created by falling leaves, particularly when using an exposure of one second or more. Sometimes when confronted by a problem, it is worth making a virtue of it and deliberately using it as part of the image. The chaotic streaks created by falling leaves can often add an interesting dimension to the shot. Opt for either Shade or Cloudy when selecting your White Balance, particularly if you are shooting JPEG. When shooting in woodland it is sometimes suggested that you use a polarizing filter to cut out any reflections from the leaves. The only problem with this is that it will slow your

exposure by up to three stops, making the possibility of leaves or branches moving during an exposure even more likely. You need to balance the risks and then decide.

Dells, grottoes and canyons can also provide excellent opportunities for photography, but the amount of light penetrating these places is often greatly reduced. You should understand the source of light, as this can often produce a colour cast, particularly in the shadows. The other major problem is contrast, as the light will invariably come from a single restricted source. If you experience this, use a graduated neutral density filter to balance out the lighting.

BELOW RIGHT Interesting landscapes can be taken at times when others choose not to venture out. Photographed on a bleak winter's day, there seemed to be very little light around, which creates this wonderful monochromatic effect. While reducing the colour, the mist has also increased the sense of depth by exaggerating the tonal perspective.
Canon EOS 5D, 17–40mm lens, 1/4 sec at f/11, ISO 100

BOTTOM LEFT Photographers from around the world are attracted to these wonderful Arizona slot canyons. Sculpted out of red sandstone by occasional flash floods, they lie below the surface of the desert. As they are untouched by direct sunlight, the glowing orange and red is created by indirect sunlight bounced off the walls. Despite the appearance of light, this required a 30-second exposure.
(Photograph: Eva Worobiec)
Canon EOS 5D, 17–40mm lens, 30 sec at f/16, ISO 100

BELOW We are sometimes surprised by how long exposures need to be; in this case it was 4 seconds. While autumn trees are particularly photogenic, there is always a problem of leaves falling during the exposure. Shooting on a calm day helps.
(Photograph: Eva Worobiec)
Canon EOS 5D, 24–105mm lens, 4 sec at f/11, ISO 100

tip
If you experience a problem with contrast, use a graduated neutral density filter to balance out the lighting.

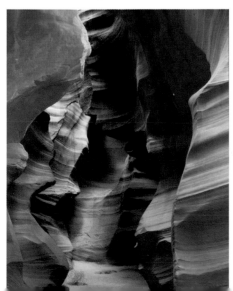

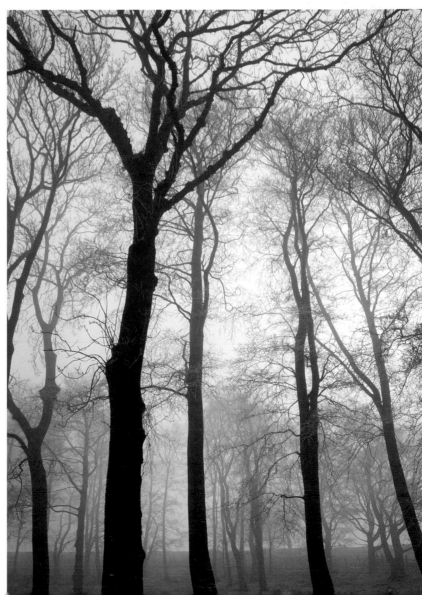

MOVING WATER

One of the fascinating aspects of photography is that it is capable of recording things that the eye just cannot register. At one end of the spectrum we cannot see a speeding bullet being fired out of a gun, but this tiny fraction in time can be 'frozen' with specialized high-speed photography. At the other extreme, the camera is capable of showing us a world that has been slowed down to such a degree that it is no longer recognizable. This is particularly evident when photographing moving water over an extended period of time.

tip

If you wish to retain a dramatic sky yet achieve the silky effect of moving water, reduce the exposure by adding either a neutral density or a polarizing filter.

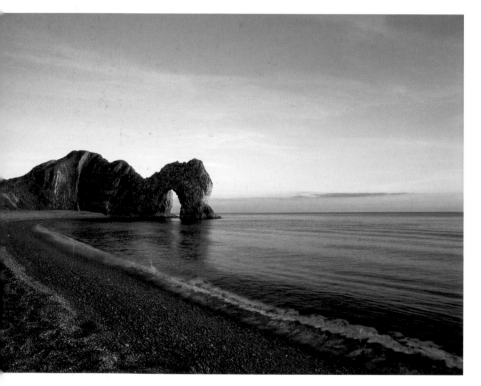

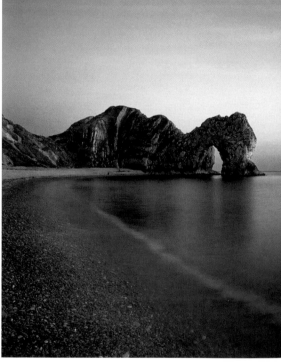

Ever since I started taking photographs more than 30 years ago, I have been fascinated by images featuring slow-moving water. The effects can be stunning. When using a slow shutter speed, the camera cannot capture the detail your eyes can normally see, but records instead the wonderful rhythms that the moving water creates. The potential for this kind of photography is endless. You can try photographing a fast-moving river, a babbling hillside stream or perhaps a waterfall. Living close to the coast, I often use the sea when I wish to practise this kind of photography. While each type of water has its own unique characteristics, they all offer wonderful creative opportunities, as the movement of water, irrespective of the source, produces an amazing silk-like and highly photogenic mistiness.

The velocity of the water determines the shutter speeds you need to create this exciting effect.

ABOVE LEFT Photographed in the evening just as the sun was setting at Durdle Door, Dorset, the lighting in the sky and on the headland was just about perfect. However, with a 2-second exposure, there is still too much detail in the moving tide.
Canon EOS 5D, 20mm lens, 2 sec at f/22, ISO 100

ABOVE Shot 15 minutes later, an exposure of 30 seconds was required, which creates an appealing and romantic effect. As this shot has been taken a short time after sunset, much of the rich detail of the sky has been retained. This kind of photography relies on balancing the quality of the sky with the movement of the water.
Canon EOS 5D, 20mm lens, 30 sec at f/22, ISO 100

At first sight, the large rock in the foreground of this scene on Portland in Dorset, England, looks as if it is illuminated by the last rays of the sun. In fact the sun had set 40 minutes earlier, and I had to give this shot a 20-minute exposure. I slightly increased the saturation in Photoshop.
Canon EOS 5D, 70–200mm zoom lens, 20 min at f/16, ISO 50

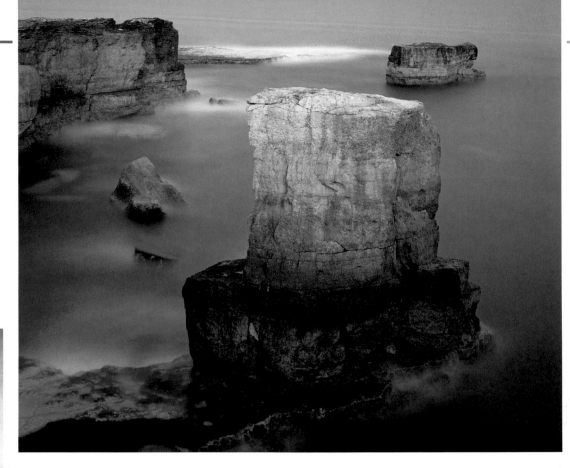

Relatively speaking, waterfalls display the fastest-moving water. This can be captured with speeds of between a quarter to one second. The main problem with photographing waterfalls is the spray, which can get onto the lens, particularly if there is a breeze. One solution is to fit a UV filter over the lens; this will need to be cleaned with a soft cloth after each exposure. Another solution is to use a long-angle lens.

Most waterfalls are located in valleys or dells where the lighting is limited. Therefore, with an ISO setting of 100, you should be able to get your shutter speed down. If, however, the light is too strong and you are not able to achieve the effects you are after, try fitting a neutral density filter. One problem that you will have difficulties in overcoming is strong directional sunlight. In these circumstances it will be impossible to get the shutter down to an acceptable speed, unless you use a very powerful neutral density filter; you are also likely to encounter excessive contrast.

RIGHT This shot was taken about 40 minutes after sunset. Images taken this late in the evening, particularly on an overcast day, are often characterized by an overall blueness. It often pays to include an illuminated feature in the distance. In this example, the lighthouse and the adjacent buildings provide an important focal point. This image, like the one above, was shot on Portland.
Canon EOS 5D, 24–105mm zoom lens, 5 min at f/16, ISO 100

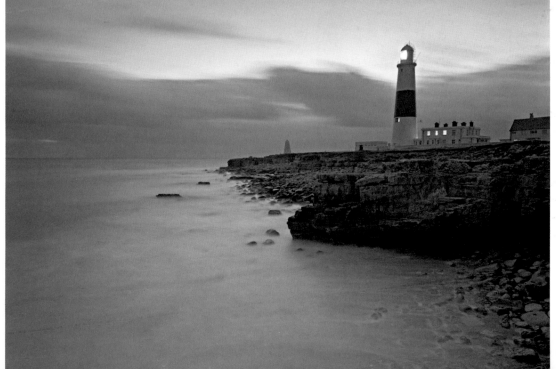

Rivers are not often used for this kind of photography, largely because the flow tends to be unspectacular. However, they can prove photogenic if shot before dawn or in the evening. When photographing water in low light you need some source of illumination, whether natural or artificial, otherwise the river can easily appear as a black and empty void. Unless you have a full moon, try photographing rivers as they pass through urban areas, as you are more likely to benefit from adjacent lighting.

The coast offers the most popular locations for this kind of photography. It should be noted that relative to a waterfall, the tide moves comparatively slowly. Even with a shutter speed of several seconds, much of the detail of the wave action can still be captured. As fairly lengthy exposures are required, it is best to photograph coastal scenes before dawn, or in the evening. Some of the best results can be achieved with exposures of between two and five minutes, which give the movement of the tide sufficient time to create a smooth or misty surface. When photographing in the evening, the best results are usually gained about 30 minutes after sunset, but often the best skies appear when there is still a little more light in the sky. Rather irritatingly, I have found that the most interesting skies can be captured ten minutes before sunrise or 15 minutes after sunset. In order to maximize the potential of both the sky and the moving tide, use either a polarizing filter or a neutral density filter and take the shot when the sky still retains detail. This allows you to exploit the light when the sky is in its full glory, but the reduced light getting through to the sensor requires that you use an exposure of at least two minutes. This way you get the best of both worlds.

RIGHT Because of the fast-flowing nature of waterfalls, you will be able to select a shutter speed that is sufficiently slow to create the distinctive silky gossamer effect that is the defining characteristic of this kind of photography. If you need to slow down your shutter speed, try using a neutral density filter.
Canon EOS 5D, 50mm lens, 1 sec at f/16, ISO 100

BELOW FAR RIGHT Photographing rivers at night in a rural setting can be difficult because of the lack of light (this is rarely a problem in an urban situation). While my eye was initially drawn to this beautifully illuminated chateau at Amboise in France's Loire Valley, I soon realized that it was the contrast between the relatively still water to the left and the more turbulent flow to the right that was of most interest.
Canon EOS 40D, 17–85mm zoom lens, 2 min at f/16, ISO 100

tip

Do not always assume that you need a dramatic sky to take successful shots of moving water. Even the dullest of skies will register as blue in low-light situations.

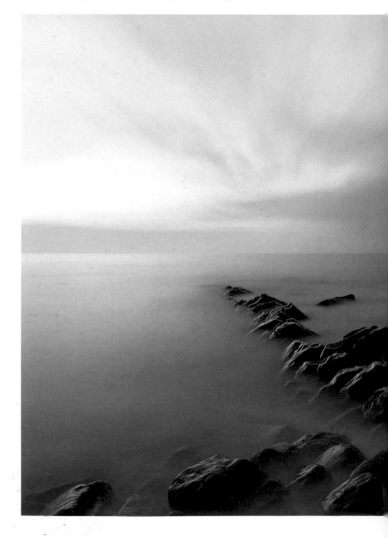

When I shot this image at Kimmeridge in Dorset, England, about 50 minutes after sunset, all the earlier colour had drained from the sky. It was so dark that I had difficulty seeing. However, once I had exposed my shot and checked it in the monitor, I was able to see details on the screen that had not been visible to the naked eye.
Canon EOS 5D, 20mm lens, 18 min at f/22, ISO 100

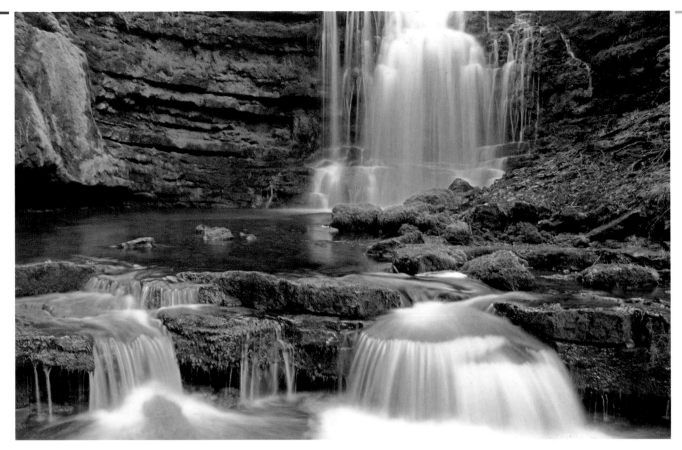

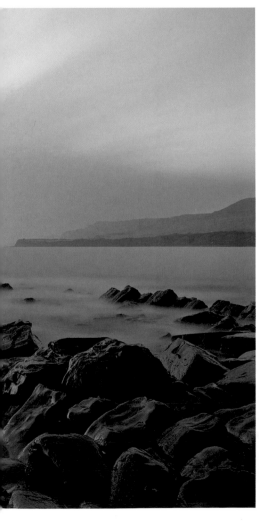

USING WATER AS A REFLECTOR

There can be few opportunities in photography more exciting than capturing a dramatic feature using a stretch of still water to create a mirror-image. When this does occur, we really need to make the most of the opportunity. The most likely examples can be found around prominent buildings. Increasingly, most countries are promoting their heritage, which often involves illuminating interesting or historical sites, if only for a short period of the evening. Try to arrive before the lights go on, giving you sufficient time to find an area of still water that you can use.

The urban environment offers excellent opportunities for photographing reflections. For example, shops and businesses often retain a lighting display long after the customers have left. If it has been raining, check out the smooth surfaces of pavements or piazzas, which can often provide a photographic bonanza. Puddles are terrific, if only because of the irregular shapes they create. Don't be too concerned about passing pedestrians; they can often help make the picture. If the required exposure is 15 seconds

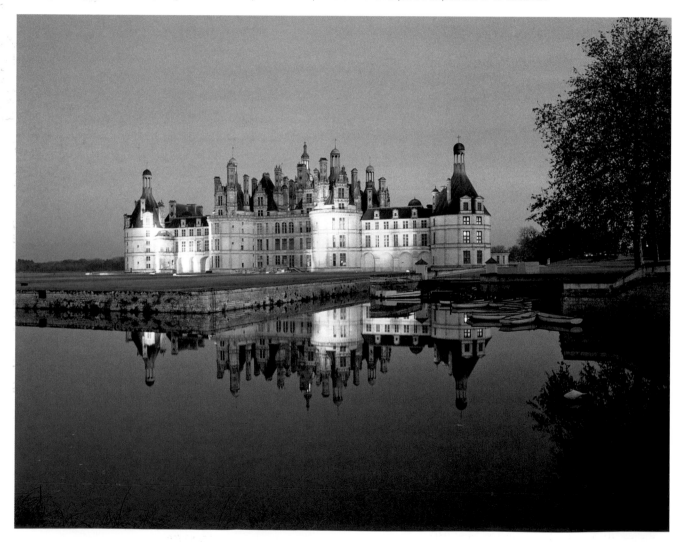

Despite an earlier breeze, the water quickly became still when the sun set. My main problem was a succession of rowers passing by, which meant a wait of 4 minutes before the water was sufficiently calm again. Once I had taken this shot, a large pike leaped out of the water, sending it back into turmoil. This is the famous chateau at Chambord, France.
Canon EOS 5D, 20mm lens, 5 sec at f/22, ISO 100

Brittany's Mont St Michel is one of the most impressive monuments in Europe. However, on this day, the wind was a problem. As the wind was blowing from right to left, I realized that if I could find a windbreak I should find relatively calm water; the mudbank to the right served the purpose perfectly. Another problem was that photographing from the estuary meant I was standing on soft mud. To prevent the camera and tripod sinking and causing blur during the lengthy exposure, I improvised a platform from a flattened-out cardboard carton.
Canon EOS 5D, 20mm lens, 47 sec at f/22, ISO 100

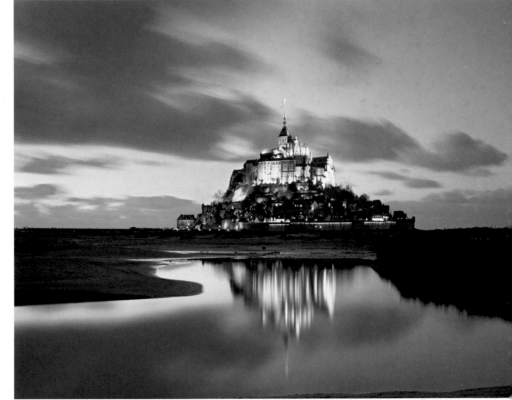

or more, then they are unlikely to appear in the shot anyway. Many urban situations offer ornamental pools or fountains, which again can provide an excellent source for reflections in low light.

Even a simple walk along the beach will offer tidal pools, which can act as a wonderful mirror to the emerging or disappearing sun. If you try this, use a wide-angle lens set to a small aperture in order to ensure that both the sky and the pool are fully in focus. Canals and calm stretches of rivers can also provide superb opportunities for this kind of photography. Don't restrict yourself to photographing just illuminated buildings.

What are the potential problems?

The biggest one is wind. It does not take much more than a gentle breeze to spoil the effect, but that should not deter you. Even on quite a gusty day, it is amazing how frequently the conditions calm down at sunset. Even if it does not, if you reconnoiter the area beforehand, you can often discover areas of still water that are sheltered from the wind.

It is important to get the metering right. The reflection is likely to be at least two stops darker than the source. By taking two light readings, one from the source and the other from the reflection, then averaging out the two readings, you should arrive at a good compromise. However, a better solution is to use a graduated neutral density filter, ensuring that the source is covered by the filter and the reflection is covered by the clear part.

Polarizing filters can be useful in these situations as they cut out the unwanted reflections in the water, but they come at a price. The drawback is that the filter effectively reduces your speed by three stops, which on an already long exposure could increase the risk that some movement will occur in the reflected water.

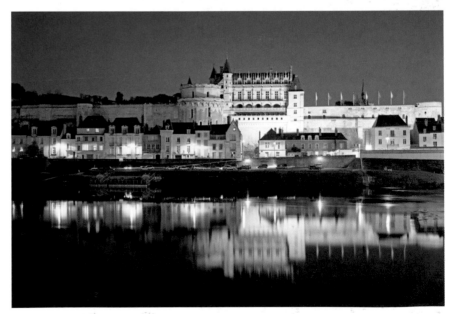

A quiet section of a river can offer creative opportunities for reflected images. Taken on the bank of the Loire in France, the reflection is surprisingly intact bearing in mind that this is a flowing river, and that the duration of the exposure was in excess of 2 minutes.
Canon EOS 40D, 17–85mm zoom lens, 94 sec at f/16, ISO 100

THE URBAN ENVIRONMENT

It is sometimes assumed that 'landscape' refers to wild or rural areas, away from towns and cities, but this is a somewhat romantic view; as many of you will be aware, many conurbations offer excellent photographic opportunities, particularly when photographed in low light.

CITIES AT NIGHT

I can vividly remember flying over London at night for the first time and being totally transfixed by the sheer beauty of the place. It ceased to look like a city but instead reminded me of a beautifully intricate abstract painting. When flying over a city in daylight it is difficult to evaluate where the important areas are, but at night the main routes and buildings are vividly illuminated. I was particularly fascinated by the movement of traffic, which created an interesting visual analogy; light from headlights and tail-lights seemed to symbolize the red and white blood corpuscles flowing through the arteries. Unfortunately, I was unable to take photographs at the time, but I nevertheless gained an important appreciation of just how photogenic our towns and cities can appear at night.

Photographing from a high vantage point has many advantages, not least because it offers you a panoramic view of the city; unfortunately, such vantage points are not always going to be available. There will be places that you know but if you are unfamiliar with the area consult a map; this should give you the information you need. Increasingly cities are building tall structures that are open to the public and make excellent viewing points.

When using exposures in excess of one minute, the travelling patterns of the community can be graphically illustrated, creating fabulous lines of colour. By the very nature of towns, the lighting is likely to be mixed; you need to exclude areas that are disproportionately bright. Try not to photograph roads that directly face the camera, otherwise the headlights may create unwanted flare.

If you are lucky enough to find a location overlooking a built-up area, get there in sufficient time to find the best viewing point. Often when photographing from higher locations, you are subject to strong winds, so you are more likely to be successful if you find a sheltered spot. Usually I find that I need to use a long-angle zoom, so finding a sheltered viewing point is critical.

If you are travelling abroad, particularly around the Mediterranean, you will encounter numerous smaller towns clustered around hilltops. Historically, communities built their houses on the least fertile land, which often meant on

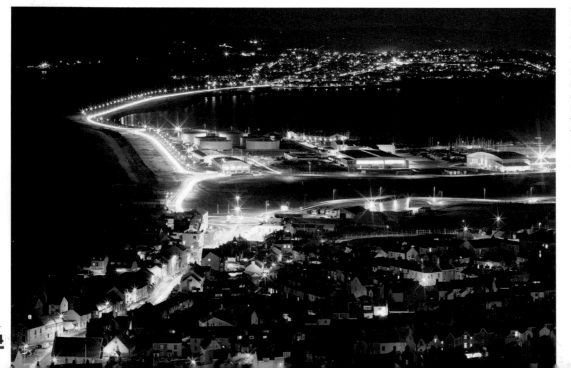

This was taken in Portland, Dorset at around 5pm on a winter's evening, at the start of the rush-hour. Caught during an exposure of over a minute, the light trails highlight the important thoroughfares.
Canon EOS 40D, 17–85mm zoom lens, 72 sec at f/22, ISO 200

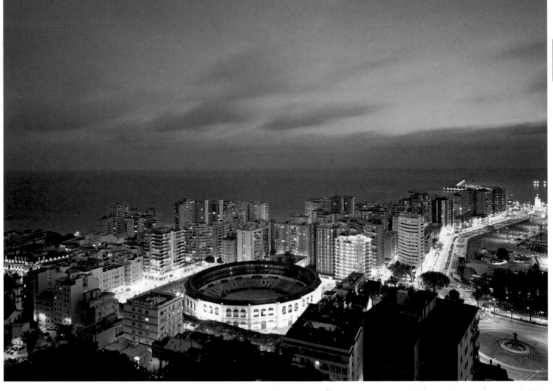

This is the port of the beautiful city of Malaga in Spain. As we drove in we could see an old castle situated on a hill overlooking the port and realized that this would make an excellent vantage point. If you are unfamiliar with an area, arrive early so you have plenty of time to decide where the best photographic venues are.
Canon EOS 5D, 20mm lens, 7 sec at f/11, ISO 100

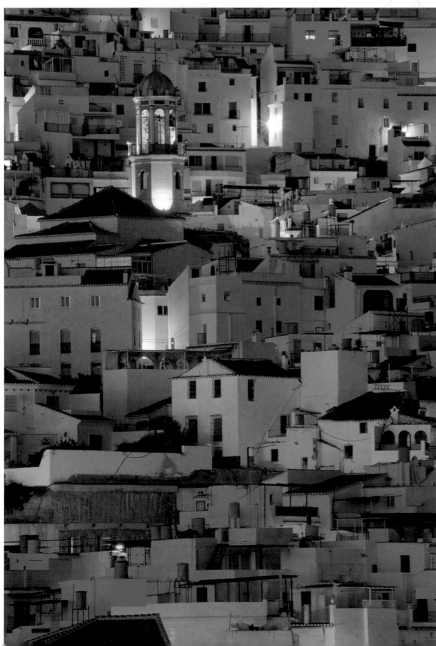

high rocky outcrops – which of course can present interesting photographic opportunities.

Deciding which White Balance setting to use is a problem because there are likely to be many conflicting light sources. If you wish to include the surrounding landscape in the shot, that can simply add to the problem. I would suggest that the Auto WB works well in most circumstances. Finally, don't feel that you cannot get right inside a town or city in order to get a great shot. Try and select a busy part where there is a lot of activity. The main shopping street or perhaps the station might offer what you are after.

The lighting is often mixed in urban situations. In addition to the ambient evening light there are buildings illuminated by both tungsten and fluorescent lighting. In taking this photo of Competa, Southern Spain, I selected the Auto White Balance setting and then reviewed the results in the Raw dialog. The final decision is often governed by aesthetics.
(Photograph: Eva Worobiec)
Canon EOS 5D, 70–200mm zoom lens, 12 sec at f/8, ISO 200

THE CONCRETE JUNGLE

An element of photography that many of us are inclined to ignore are those areas within large towns or cities that are sometimes disparagingly referred to as 'the concrete jungle'. This is a term made popular in the 1960s and 70s, influenced strongly by Bob Marley's song *Concrete Jungle*, which demonizes certain areas of the city with their proliferation of tower blocks and tenements.

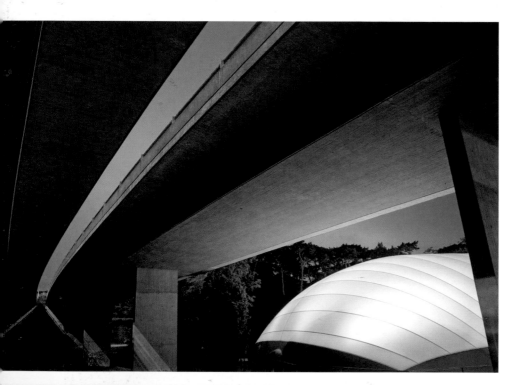

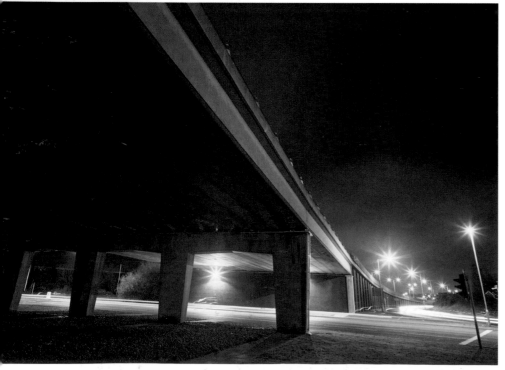

Undoubtedly there are negative aspects to the concrete jungle, but there are many elements of urban environments that are worth exploring. Often the heart of the city is littered with curious shops and businesses that will be obscurely lit, either internally or by some adjacent lighting. As adults, many of us are too dependent on our cars; if we simply parked and tried walking instead, we would immediately encounter a network of subways that we probably did not know existed. Even in the daytime, these strange subterranean underpasses can make intriguing pictures. Increasingly, more and more cities are constructing urban motorways. These create fascinating intersections and overpasses that are eerily lit at night. Despite the low light, if you are able to include a figure or two, it can greatly add interest (or possibly even menace) to your photograph.

You will not want to be burdened with too much equipment. While I would always recommend that you take your tripod, try limiting your lenses to just a single wide-angle zoom. The dynamic

ABOVE LEFT Motorway bridges can create fascinating abstract scenarios. The illuminated structure to the right is an indoor tennis court, but in this context it looks much more alien. *Canon EOS 40D, 17–85mm zoom lens, 6 sec at f/16, ISO 100*

LEFT Inner-city freeways are designed for the car, not human beings and can appear intimidating, particularly at night. Bathed in a hostile orange light, the only signs of human presence are the light trails from vehicles passing by. In order to create a sense of drama, the concrete jungle is best photographed during an early-evening fog on a winter's day. *Canon EOS 5D, 20mm lens, 48 sec at f/16, ISO 400*

quality of the architecture seems to suit this focal range.

In order to create a sense of drama, the concrete jungle is best photographed during foggy weather. This has the advantage of softening the harsh street lighting and creating a slightly eerie atmosphere. It is also worth trying photographing after rain, as the strange lighting effects are reflected in the puddles that form on pavements.

Often the lighting can be low and unpredictable; consequently, the autofocus system is inclined to 'hunt'. Try switching to Manual. While the metering system in most cameras works well in most situations, this may be a good time to use a handheld light meter if you have one. If you want to use the camera's metering system, try setting it to centre-weighted; this will most reliably deal with the backlighting you are likely to encounter. Finally, be prepared to use the full range of ISO settings. In this way, while you can use a slower speed to capture the passing car trails, you are also able to switch to something much faster in order to grab an interesting figure or two.

ABOVE RIGHT Photographs such as this are far better done without using a tripod. In this example I increased the ISO rating to 800 and tried hand-holding the camera. *Canon EOS 5D, 24–105mm zoom lens, 1/2 sec at f/16, ISO 800*

RIGHT Small shops and businesses trapped by the network of inner-city motorways offer wonderful photographic opportunities. This old established fast-food outlet in Salina, Kansas, continues to thrive, selling up to 3,000 hamburgers a day. *Canon EOS 5D, 70–200mm zoom lens, 1 sec at f/22, ISO 100*

ILLUMINATED BUILDINGS

Many amateurs assume that architectural photography lies within
the domain of applied photography and fail to recognize the potential
creative opportunities. With a little imagination, photographing
architecture can be as inspiring as any other branch of photography.

Traditional buildings

Many towns and cities are increasingly aware of their architectural heritage and
are going to great lengths to illuminate their interesting buildings, which, of course
offer wonderful photographic opportunities. As tourism expands, communities
want to show off their great buildings, but there is a downside to this. More
buildings are undergoing renovation, and while in the long term this can only be
good, it generates a plethora of cranes and scaffolding that makes photography
ever more difficult.

Successful low-light photography is largely about planning, and this certainly
applies when photographing buildings. Driving around our large towns and cities
will always prove challenging and often when photographing in low light we have
only a relatively small window of opportunity; therefore you can rarely fit in more
than a single location in a day. It is essential that you establish that the building
you want to shoot is illuminated at night. Check out the location in advance and
look for possible floodlights. If you are in doubt, ask a local, as there is little point
in hanging around if it is not lit up.

If you are new to an area and not too sure whether a particular town or city
offers any potentially interesting opportunities, it is worth consulting the local
tourist office. Most communities are keen to promote their local sites and will
offer you all the help that you want. Research on the internet can be particularly
useful in this respect.

As with most aspects of photography, timing is critical. If you intend to include
the sky in your image, then capturing the building in crossover lighting will prove
advantageous. If so, then your window of opportunity will be restricted to just 15
minutes. If you don't want to include the sky, you can be more flexible, but you
should nevertheless try to ensure that the contrast between the source of lighting
and the architectural detail is not too great.

Other hazards

When photographing illuminated buildings, watch out for light straying from
adjacent buildings or near-by street lamps. This will become particularly
noticeable if you are making very long timed exposures; therefore, always
use a lens hood.

If you want to include the entire building in your shot, this will require using
a wide-angle lens, particularly if you are photographing in an older part of town.
If you are shooting at ground level, this will inevitably lead to converging verticals.
Occasionally this can look quite dynamic, but often it does distract the eye.
We consider how to resolve converging verticals in Chapter 4 (see pp. 124–125).

Unless you are an expert, assessing the nature of the source of illumination
can often prove difficult. Therefore judging the correct White Balance might
prove tricky. If you decide to shoot JPEG, check your monitor after each shot
and if necessary make further adjustments. If you shoot Raw, simply set the

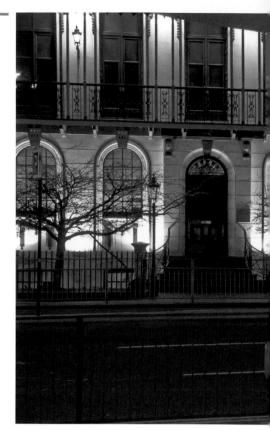

ABOVE If you decide to photograph a
building without including the sky, then
your window of opportunity is much wider.
It is still important to balance the source of
illumination and the architectural detail.
*Canon EOS 40D, 17–85mm zoom lens, 16 sec
at f/22, ISO 100*

ABOVE RIGHT Once nightfall descends,
there is little point in including the sky, but
many illuminated buildings still continue to
offer wonderful photographic opportunities.
Canon EOS 5D, 50mm lens, 4 sec at f/8, ISO 200

RIGHT England's Salisbury Cathedral is
an impressive building, but like many large
structures, it necessitates using a wide-angle
lens, which can lead to converging verticals.
While this could be regarded as a negative,
it can also be used for artistic effect.
Canon EOS 5D, 20mm lens, 27 sec at f/16, ISO 200

FAR RIGHT There was a 3-stop difference
in exposure between the lobby and the marquee
of this famous old theatre in Sacramento,
California. To resolve this issue, I took two
separate shots on a tripod and created an
HDR file later on.
*Canon EOS 40D, 17–85mm zoom lens, 1 sec
and 8 sec at f/11, ISO 100*

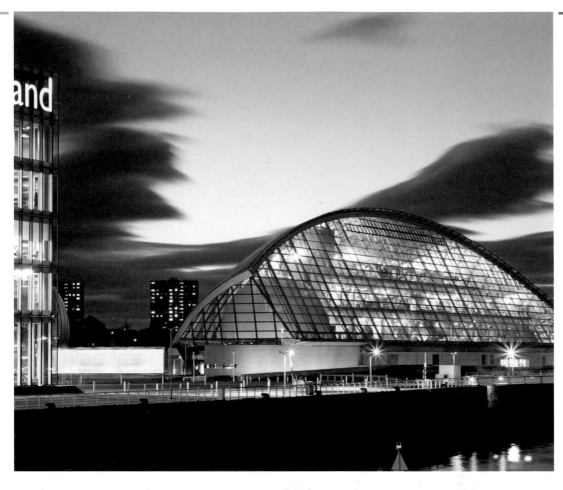

White Balance to Auto and make any necessary adjustments in the Camera Raw dialog.

Usually when photographing major buildings in built-up areas you will experience passing traffic; these of course will leave the inevitable light trails. Sometimes these can be used to enhance the image, but occasionally you may wish to exclude them from the photograph entirely. If so, when a vehicle drives by, use a piece of black card to cover the lens, then continue with the exposure once it has passed. With exposures of 30 seconds or more, this is easy to do.

Modernistic buildings

As many of our large cities are regenerating, newer and more architecturally impressive buildings are being constructed that provide numerous photographic opportunities. While modern architecture may have earned a poor reputation as a result of the excesses of the 1960s and 70s, most will agree that this new wave of building in many of our inner cities is proving to be an enormous asset. The passing of the millennium appears to

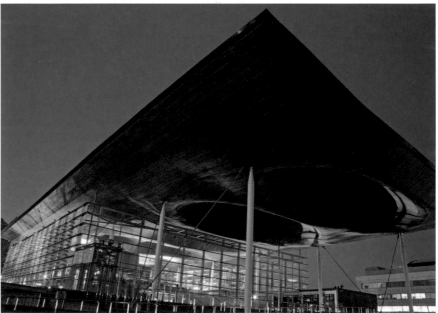

This is The Welsh Assembly Building in Cardiff. I arrived about 30 minutes before sunset, so decided to have a cup of coffee at a nearby restaurant. I asked the waitress whether the building was illuminated at night and she said it wasn't, so I decided to look for other opportunities. After a rather frustrating 45 minutes, I passed by this building again only to see it internally lit by both fluorescent and tungsten. What I should have asked her is 'does this building illuminate either from the outside or the inside?', as most modern buildings do.
Canon EOS 5D, 20mm lens, 194 sec at f/16, ISO 100

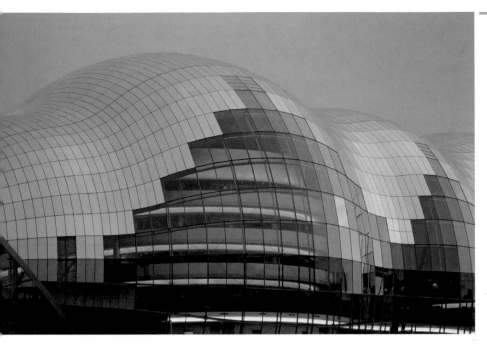

have been a particularly important spur in this development.

Selecting a suitable vantage point is the key to this kind of photography. Fortunately, many of these newer developments are located either within old established docklands or alongside rivers and canals. Either way, these offer excellent viewing areas. Using water as a foreground can greatly increase the impact of the image, and whether the water is fast-flowing or still, the effects at nighttime can be stunning. Try to exaggerate the effect by slowing down the exposure by either selecting the slowest ISO setting or by closing the aperture right down. Rivers need not be the only foil for this kind of photography; any reflective surface will do. If it has rained recently, then look for a puddle or use the wet paving stones or other suitable surfaces as a means for photographing reflections. The roof of a parked car or even the wing-mirror can also provide an interesting added dimension to this kind of photography. It is all a matter of being creative.

One aspect that many photographers find interesting is that, as many of these newer buildings are largely constructed from steel and glass, they appear illuminated from within. While they may not have the allure of historic structures, the light emanating from such buildings can be dazzling. From a technical standpoint, the lighting is often varied, which makes selecting the correct White Balance a bit more challenging, but the overall effect can still be wonderful. Most modern buildings are lit by fluorescent lighting, which creates a distinctive green cast. If you are photographing a close-up of the building and you wish to counter this, select the Fluorescent White Balance. From a personal viewpoint, I sometimes find this cast quite interesting, providing there are no figures included in the composition. If you wish to include the sky then I would select Auto or Daylight from the White Balance option.

It is so easy to get carried away by the success of your work, particularly if you are only checking it out on your LCD; however, be aware that they are not foolproof and often the image appears much brighter. Get into the habit of referring to the histogram as well, as this will provide you with far more reliable information.

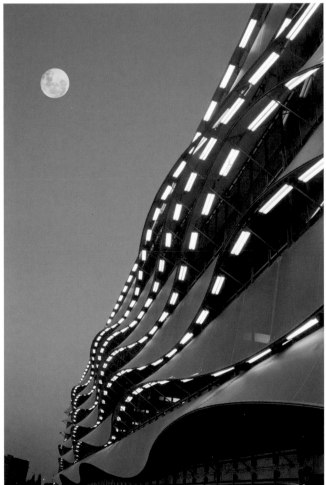

Many modern buildings are illuminated from within, often from a variety of sources that offer an interesting range of colours. This means that even a humble multi-storey car park can make a worthy subject when photographed at night.
Canon EOS 5D, 20mm lens, 4 sec at f/16, ISO 100 (for the shot without the moon)

RIGHT Large buildings are often illuminated both by sunlight and by interior illumination. This is the very impressive interior of Glasgow's Civic Hall. The contrast between the warm hues created by the interior lighting and the cool blues of daylight produces an aesthetically pleasing outcome. *Canon EOS 40D, 17–85mm zoom lens, 4 sec at f/22, ISO 100*

BELOW RIGHT In small, tight interiors you may need to use a wide-angle lens. This can create problems with distortion but these can quite easily be remedied in Photoshop. *Canon EOS 5D, 20mm lens, 2 sec at f/16, ISO 100*

INTERIORS

It is somewhat ironic that although most of us spend a large proportion of our lives indoors, few of us seem to take photographs of interiors; perhaps the answer is precisely because we do spend so much time indoors. Yet when I look at lifestyle magazines, I am struck by how beautifully some interiors can be photographed. It is almost as if the photographer sees the room as a blank canvas and then is able to use lighting to create a specific mood. There are, however, several important technical considerations that need to be taken into account.

Get permission

Wherever you decide to take your interior shot, you will more than likely be on private property; therefore you should always seek the permission of the owner. It may be that you are impressed by the home of a good friend, or perhaps you would prefer to photograph something more ambitious such as a theatre, a civic hall or a bowling alley. It helps to actively engage the owner; they may be prepared to alter the lighting so it best suits your needs. A promise of a print usually helps.

Dealing with colour casts

All lit rooms will potentially reveal a colour cast, but the extent of this will be governed by whether it is also illuminated by daylight. If photographed at night, the lighting source is likely to be either fluorescent or tungsten, which can be easily countered by selecting the appropriate White Balance preset. If there is a single light source, then there will not be a problem. However, often the light source is mixed, particularly in commercial buildings. But it should also be noted that not all colour casts are bad; do you necessarily want all interiors to look as if they have been shot in natural light? A cast becomes a problem when it is blatantly obvious, but a very subtle warming of the colours can occasionally be an advantage; it is matter of aesthetics. For example, a room that is partly illuminated by daylight and partly internally lit can offer an interesting mix of warm and cool. The same effect can be achieved by selectively flashing part of an internally illuminated room.

Lighting

The main problem is balancing the light, particularly when dealing with a large area. One solution is to place a bank of slave units throughout the room; these can be triggered by the master flash. Needless to say, if you use this method, it is important that the units are discreetly located. Another solution is to make numerous flashes with your flashgun, although this will depend on you being able to substantially increase the length of the exposure. If you decide to try this method, the first task is to select the lowest ISO setting. This not only slows down the exposure but will offer the finest detail. Then select the smallest aperture. If you are still getting an unacceptably high light reading, try reducing the light from outside by closing any blinds or curtains. Once the lighting has been greatly reduced, use your handheld flashgun to paint in the light. When using flash in this way, try to keep the lighting subtle, as it should be used only to reveal shadow detail.

BELOW LEFT Often large complex buildings such as theatres will have a variety of light sources, so opting for a single White Balance preset is not sufficient. Shooting Raw has many advantages because it gives you the option of making changes later in the process. You should ensure that those areas that should appear grey or white do so.
Canon EOS 5D, 20mm lens, 12 sec at f/11, ISO 100

BELOW This shot was taken while I was eating in a restaurant in San Francisco. Initially I was drawn to the neon outside, but then I noticed how the colours bled into the interior. The shot was handheld using a lens with an image stabilizer.
Canon EOS 40D, 17–85mm zoom lens, 1/13 sec at f/5, ISO 400

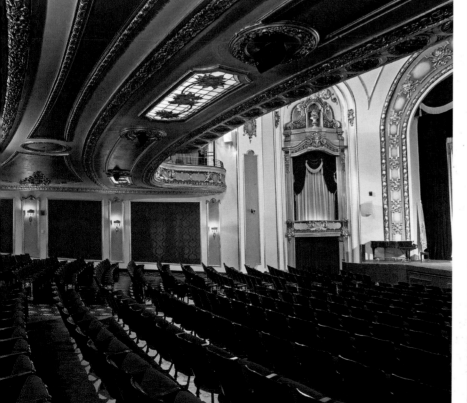

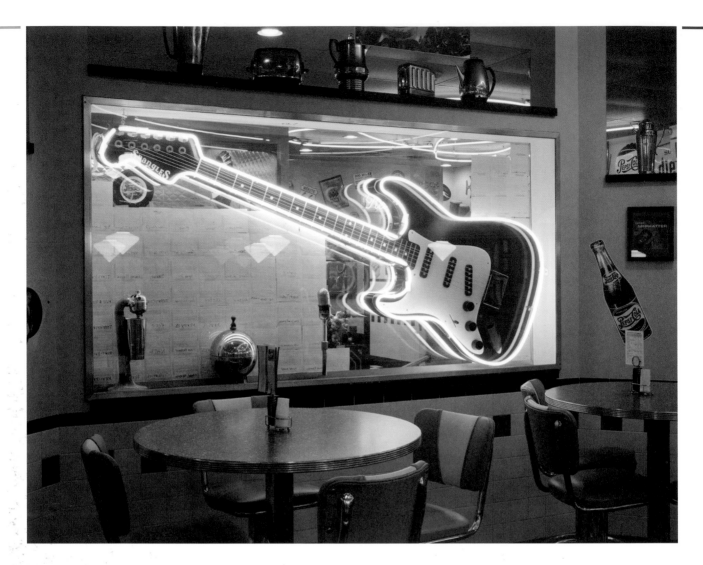

If the interior you intend to photograph is well lit
(it has roof panels for example, that let in daylight), then
no further illumination may be required; it may simply be
a matter of waiting until the lighting outside illuminates
the interior more evenly.

Photographing smaller rooms is considerably easier.
First you may consider using fill-in flash. Remember that
flash has the added bonus of rendering natural light
and will counter any cast create by the internal lighting.
The only problem with using direct flash is that it can create
unsightly shadows. You can try bouncing the flash instead,
although this of course requires using a flashgun that either
has a swivel head, or ideally can be operated off-camera.
The usual practice is to bounce the flash off the ceiling or
off an adjacent light wall. Another equally useful method is
to use a softbox attachment over the flash head; this will
greatly reduce the severity of the shadows.

What lens should I use?

Ideally you should use a standard or short telephoto lens,
but with smaller rooms that just is not practical. In order to
create a sense of space you will need to use a wide-angle
lens, although this will inevitably create distortion. The wider
the lens the more severe this is likely to be. Converging
verticals can be remedied in Photoshop; however, it helps
to minimize the problem in the first place. First, make sure
that there are no objects too close to the lens, otherwise the
distortion will become even more obvious. If you wish
to include a figure, try to place them slightly off-centre.
This also makes for a good composition. If you are
contemplating doing a lot of architectural work, then it might
be worth getting a shift lens, as this allows you to take a shot
of either an interior or an exterior free of distortions.

ABOVE To successfully photograph an interior it is important to get
the permission and ideally the full cooperation of the owner. It would
have been impossible to photograph this busy diner at certain times of
the day, but after speaking to the owner, I was invited to return when the
place was quieter.
Canon EOS 5D, 24–105mm zoom lens, 18 sec at f/16, ISO 100

RIGHT Sometimes it is the small details that catch your eye when
you are inside an interesting building. In this example, I was sitting
having a cup of coffee when I noticed the wonderful visual interplay
between the gold and blue.
Canon EOS 5D, 24–105mm zoom lens, 2 sec at f/16, ISO 100

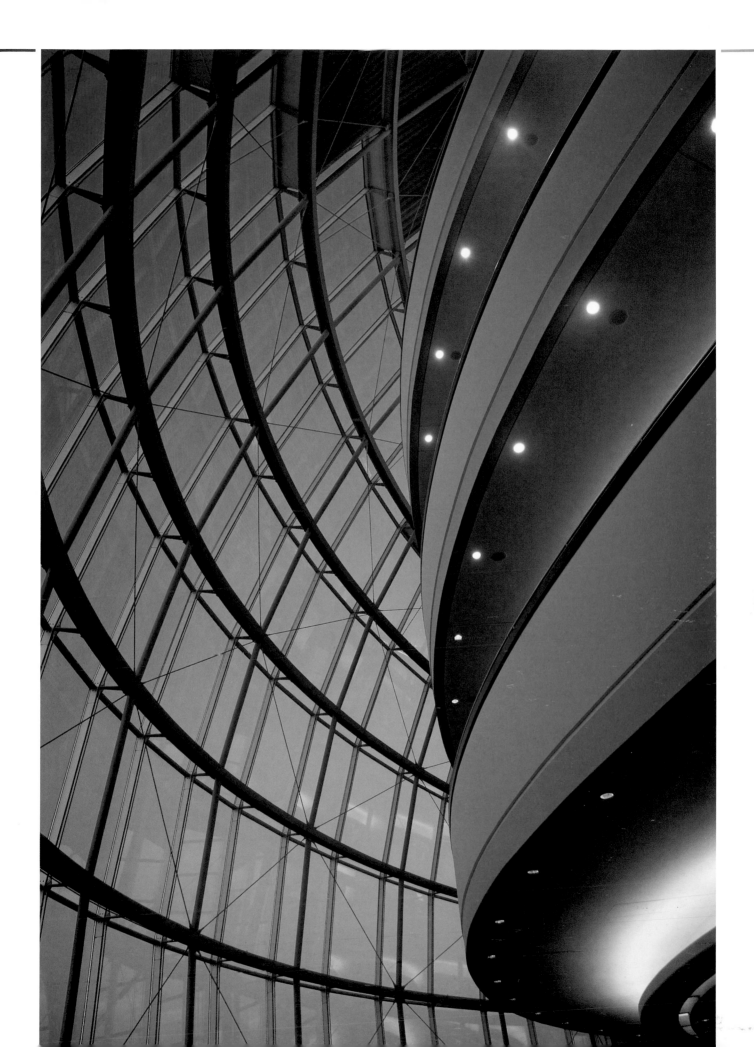

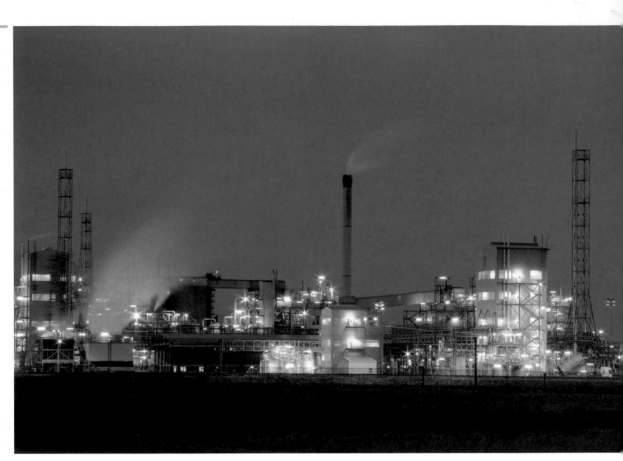

Photographed at night, industry can appear astonishingly beautiful, particularly when set against a deep blue sky. There had been a stiff breeze blowing from left to right, so I used my body as a windshield for the duration of the shot.
Canon EOS 5D, 70–200mm zoom lens, 30 sec at f/20, ISO 100

INDUSTRY

It is all too easy to take a disparaging view of industry, but it is worth noting that it still represents an important part of our economy. As a boy brought up in an industrial area, I can remember seeing enormous industrial complexes belching out carbon dioxide and every other polluting cocktail known to man; global warming was not an issue in those days. The smell at times could be overwhelming, but at night everything was paradoxically transformed into something strangely beautiful. Possibly looking at the scene with the eyes of a child, the flares and twinkling lights reminded me of Christmas.

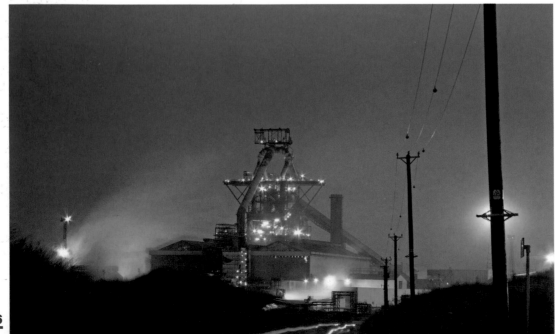

One of the problems of photographing at nighttime is flare from lights directly facing the camera. In this example, I was aware of an arc light to the extreme right of the image. I contained the problem by positioning the camera so that the light appears behind one of the telegraph poles. A vehicle went by during this exposure, which I think greatly enhanced the image. Celebrate the unexpected!
Canon EOS 5D, 70–200mm zoom lens, 112 sec at f/16,

One of the roles of photography is to unearth beauty, no matter how unpromising the subject matter, and industry certainly poses one of the greatest challenges in this regard. But if I needed to quote a single example of how a subject can be spectacularly changed at night, this would be it. With the sulphurous smoke and the fiery stacks illuminated by a heady mixture of tungsten and mercury vapour lighting, it is not difficult to imagine a scene out of Dante's *Inferno*. With the long exposures required for night photography, these billowing noxious gases are transformed into something visually quite stunning.

It cannot have escaped your notice that these traditional industries are steadily disappearing. Coal-mining, the steel industry and ship-building are all in decline. Even the mighty chemical industry is no longer the force it once was, so finding and photographing these awesome complexes has an even greater significance. Locating heavy industry is becoming harder. The problem is that although most heavy industrial complexes are visible from a distance, access to them is restricted. This is where a good map can prove so useful. Often there is a network of small roads or tracks that can take you much closer, offering you far better vantage points. But you do need to act responsibly. For commercial reasons, many of these complexes exercise high security and do not encourage photography. Some years ago, I had my film confiscated by a pair of zealous security guards who appeared from nowhere while I was photographing one well-known chemical complex. In fairness, they did explain that their major concern was possible industrial espionage.

It seems possible to obtain good images of industry at any time of the day or night; it is not normally governed by weather. To get the best shots, try using a long-angle lens, which will get you into the really interesting parts. Wait for an interesting plume of smoke to appear and try to use an exposure of at least thirty seconds to allow time for it to drift across the frame.

The swirling vapours and flares here resemble something out of Dante's 'Inferno'. I noticed that these flares and emissions were released at regular intervals; I simply had to wait.
Canon EOS 5D, 70–200mm zoom lens, 26 sec at f/16, ISO 100

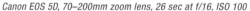

BRIDGES

If there is one photographic topic that seems to fare particularly well in low light then it has to be bridges. Photographed in daylight they can look commonplace, but seen in low light they are transformed. The one great advantage of photographing bridges is that they are so accessible. Most of us will live within easy travelling distance of at least one interesting structure. If you are a tourist, or you are a stranger to an area, then tracking down potentially interesting bridges is a comparatively easy task. Located by rivers and ravines, you do not have to be a rocket scientist to work out where they are; certainly they should be marked out on any half-decent map. If you are planning to travel to a new location, buying a guidebook of the area will also prove helpful.

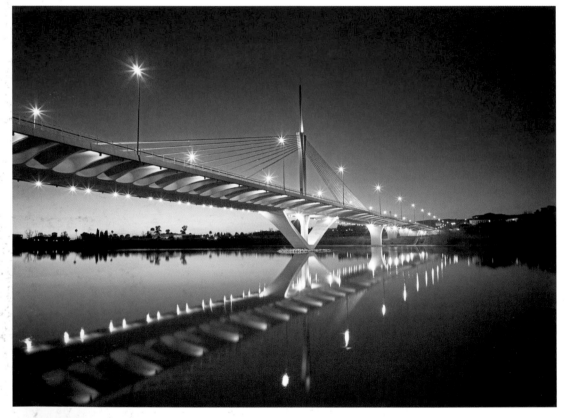

As most bridges are constructed to span a stretch of water, this can be used to create an interesting mirror effect. When I initially approached this bridge in Cordoba, Spain, the opposite side was wonderfully illuminated by the sun. Once the sun had set, it was better to shoot from this side as I was able to include the sunset.
Canon EOS 40D, 17–85mm zoom lens, 23 sec at f/16, ISO 100

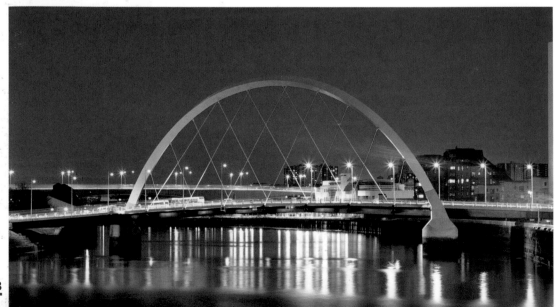

Many of our older cities are in the process of regenerating their ports and docklands, and this often involves creating visually stunning bridges. This excellent example, taken in Glasgow, was photographed from an adjacent footbridge further down-river.
Canon EOS 5D, 70–200mm zoom lens, 35 sec at f/22, ISO 200

There has been quite a rash of 'millennium' bridges and other structures, which offer excellent photographic opportunities. Some have been constructed as public walkways and, as they exclude traffic, they offer a fresh angle on the subject.

Many bridges are illuminated, but that need not be a problem. If they are not illuminated, try photographing them pre-dawn or just after the sun has set. From a distance most bridges can appear beautifully delicate, particularly if they are set against a dramatic sky. Those that carry traffic can be illuminated, if only partially, by the vehicles moving over them, and this can offer an interesting source of lighting. But increasingly often bridges are being lit at night because the authorities recognize that they are visually beautiful and that they are an important part of our heritage.

Getting an interesting vantage point is not difficult; there are often public footpaths adjacent to the river banks that offer great views. Sometimes you may wish to get nearer, but it is worth noting that some bridges and structures are situated on private land and you may need to get permission to photograph them. If you are standing on public land, then you are free to take photographs of whatever you want, but if you are on private land you can quite legitimately be asked to move on.

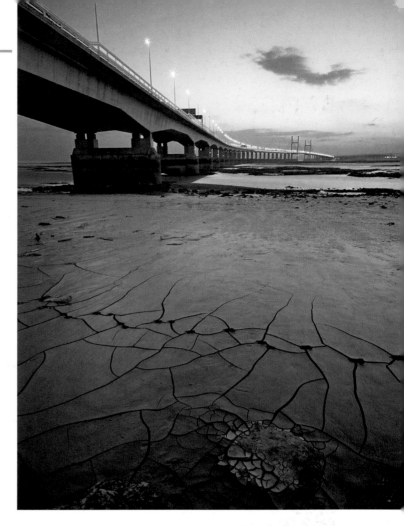

ABOVE RIGHT When viewed from a distance, England's Severn Bridge appears a particularly elegant structure. It is often best photographed in the early evening or just before dawn.
Canon EOS 5D, 20mm lens, 18 sec at f/16, ISO 100

RIGHT San Francisco's Golden Gate Bridge is probably one of the most photographed bridges in the world; I was hoping to do something different with this familiar image. Walking along the shore I realized there were several interesting rocks protruding from the water, so I used one of these as an added element.
Canon EOS 5D, 24–105mm zoom lens, 18 sec at f/16, ISO 100

tip
If the stretch of water you are photographing is tidal, do your research and find out whether the tide will be in or out prior to your trip.

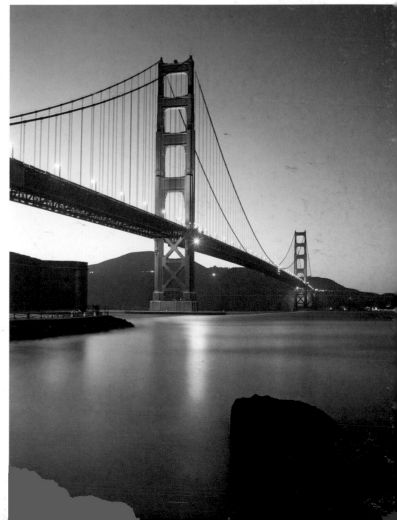

CAR TRAILS

One very popular technique that many photographers exploit in low light is car trails. With the shutter open for an extended period the lights from passing vehicles leave an interesting trail of light. This is definitely a technique that suits darker conditions otherwise the lights, particularly the tail lights, do not show up with sufficient clarity. It is never helpful to be too prescriptive, but generally when there is just a two-stop gap between the exposure of the sky and the foreground this marks a good time to start taking shots. If you need to speed this up, try using a polarizing filter, which should reduce your effective speed by three stops. For this technique to work at its best, you will require an extended exposure of at least one minute, although two minutes would be better.

Location

Once you start looking you should find numerous footbridges over busy motorways or dual carriageways that offer excellent vantage points for this kind of work. Some of these may be found within a large town or city. Once you have found your location, you will quickly appreciate that traffic often bunches to create interesting pulses of light. Obviously there is little point in starting your exposure when there are only a few vehicles passing. In order to get the best out of each exposure, be prepared to cover the lens each time there is a pause. If your wristwatch has a stop-watch facility, use it to ensure that you get a measured exposure. Personally I feel that light trails work best when they are used to support another element within the picture.

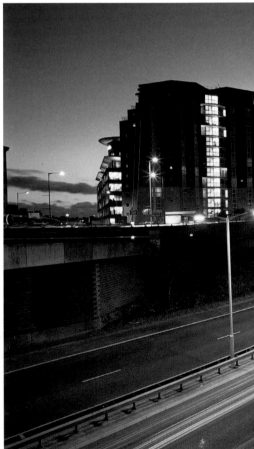

LEFT Car trails can be used to create an interesting abstract image. This location showed a good flow of traffic, and was at a point where traffic joins and leaves the carriageway. The sky contributed little to the image, so I cropped it out.
Canon EOS 5D, 24–105mm zoom lens, 2 min (using a piece of card to cover the lens when no traffic was passing) at f/16, ISO 100

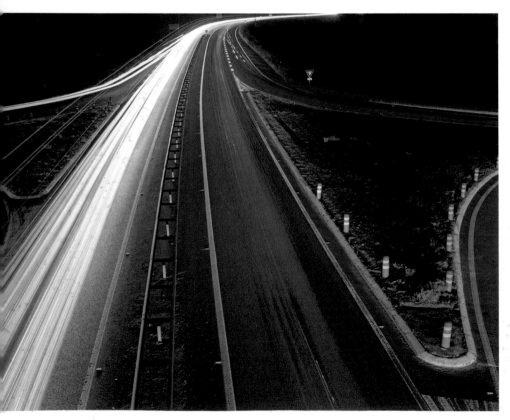

Setting up your camera

- Use the lowest ISO setting available. This will not only offer you the best available quality, but it will slow your camera down to allow for extended exposures.
- Set your camera to manual and pre-select an aperture of f/16. As it gets darker you may have problems focusing, so adjust the hyperfocal length, setting f/16 to infinity.
- Set the camera to 'B' (bulb). Some of your earlier shots will be less than 30 seconds but you don't want to be making changes as the light is disappearing. Most DSLRs allow you to count the exposure in the monitor.
- Switch off the autofocus. One of the big problems with autofocus lenses in very low light is that they starting 'hunting'. With the aperture and focusing already pre-set, there is no need for autofocus

tip

When using a piece of card to cover the lens in order to control parts of the exposure, simply count out the required exposure time ('one second, two seconds', and so on) and stop counting as you cover the lens.

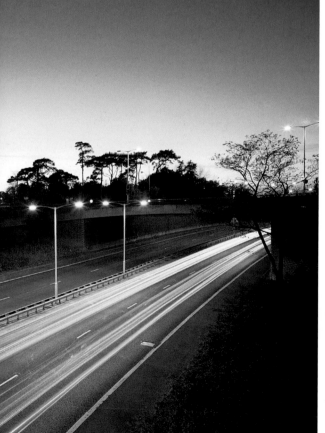

ABOVE This has been photographed from a vantage point within a large town. I personally feel that light trails are more interesting when they are used as a secondary element within the image. The strength of the trails is diminished by the ambient light coming from a variety of sources, but had the shot been taken later on much of the detail of the other areas would have been lost; a balance has to be struck.
Canon EOS 5D, 24–105mm lens, 54 sec at f/11, ISO 100

BELOW To capture the best light trails you need to be able to control them. In this example I was keen to ensure that there was a high percentage of tail lights. Whether headlights or tail lights pass will often be governed by traffic lights further down the road, so keeping an open eye clearly helps. But more importantly, by covering the lens with a piece of dark card as the headlights passed but removing it as the tail lights went by, I was able to control the light sources far better.
Canon EOS 5D, 24–105mm lens, 30 sec at f/16, ISO 100

Traditional cinemas with 1950s-style neon lighting are becoming increasingly rare, but this fabulous building in Eastland, Texas, is a particularly good example. Mixed lighting always poses a problem; do you expose for the interior or for the exterior? Because most of the neon can be seen outside the cinema, I decided to opt for a Daylight preset.
Canon EOS 5D, 50mm lens, 7 sec at f/22, ISO 100

Cinema owners also took great pride in their marquees, which were designed to lure in custom. Usually the best time to photograph them is in crossover lighting, but occasionally they can be successfully photographed at nighttime as well.
Canon EOS 5D, 20mm lens, 12 sec at f/16, ISO 100

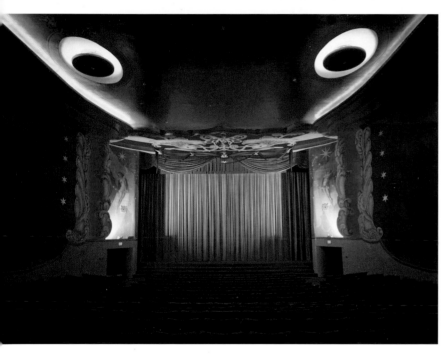

ABOVE The interiors of cinemas can be remarkably evocative places; certainly when I saw this excellent example it immediately brought to mind the musty smell of cigarettes and the plush red seating of the cinemas of my youth. The low-key lighting adds to the atmosphere.
Canon EOS 5D, 20mm lens, 34 sec at f/22, ISO 100

ABOVE LEFT Photographing the interiors of cinemas should be all about mood. I deliberately underexposed the image in order to conjure that moment of anticipation when the curtains open and the projected image suddenly appears on screen.
Canon EOS 5D, 24–105mm lens, 34 sec at f/16, ISO 100

LEFT As each cinema tried to out-do their rivals, many would be fabulously decorated with wonderful murals, as this truly impressive Californian cinema so graphically illustrates. Art Deco seems to have been the prevalent style of the time.
Canon EOS 5D, 24–105mm lens, 17 sec at f/16, ISO 100

RECREATIONAL LOCATIONS

We all lead complicated lives and, of course, setting aside time to take photographs is an important part of that. When we decide to go to a restaurant, visit the cinema or perhaps take the children to the fair, then quite understandably we tend to leave the camera at home. But these kinds of locations can offer truly fabulous photographic opportunities. Once you have identified them, these locations are best explored by revisiting them on your own.

Cinemas

Traditionally most cinemas were located in the centre of towns and cities, but with people's viewing habits changing, and many electing to watch movies at home, a lot of these historically significant building are disappearing, or they are relocating to out-of-town malls and are re-emerging as multiplexes.

It is of course still possible to come across some of these charming old cinemas, but they are becoming rarer. One of the best methods for tracking them down is to use the internet. Local websites will be posted, often including photographs taken by enthusiasts that give you a hint of what might be achieved.

Photographing the exterior

Not all cinemas are as extravagantly lit as they once were, largely because of the expense of replacing neon. Nevertheless, it is often surprising just how attractive many of the marquees can appear, particularly at night.

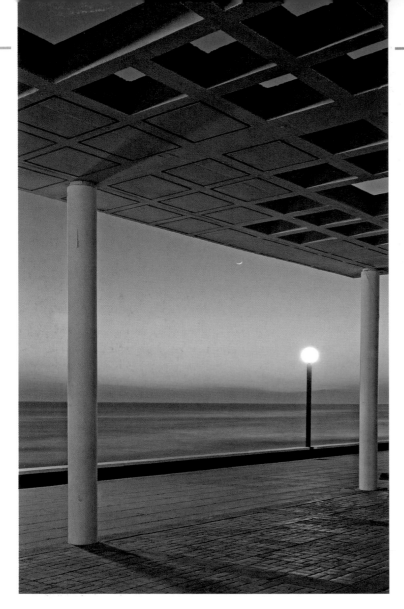

LEFT Seaside resorts can be appealing out of season, particularly at dawn or in the early evening when you are less likely to encounter crowds. There is often an attractive clarity of light in the winter months.
Canon EOS 5D, 20mm lens, 14 sec at f/16, ISO 200

BELOW Many British piers are in decline, but this one has been tastefully renovated. It is subtly illuminated, which makes it an ideal subject to photograph in low light.
Canon EOS 40D, 17–85mm zoom lens, 26 sec at f/16, ISO 100

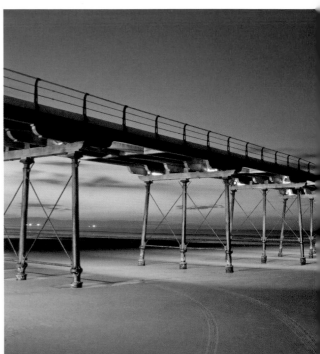

RIGHT The pier in Eastbourne in southern England is a wonderful Victorian edifice that has stood the test of time. The orange created by the artificial lighting presents a wonderful contrast against the blue of the night sky.
Canon EOS 5D, 70–200mm zoom lens, 8 sec at f/11, ISO 100

FAR RIGHT There is something uniquely charming about the typical British pier. Even 30 years ago, they were a common feature in many of our seaside resorts, but since then many have disappeared. This is Brighton's famous pier, which attracts thousands of roosting starlings as the sun goes down.
Canon EOS 5D, 70–200mm zoom lens, 1/8 sec at f/22, ISO 100

Generally, photographing cinemas works best in crossover light, at that point when the sky and the building are of the same intensity. With an ISO rating of 100 and using an aperture of f/16, anticipate an exposure of around 30 seconds. Remember that with exposures of that length, passing figures will appear as a blur, if they appear at all. It is a matter of personal choice, but in my opinion the blur created can often add to the image. Vehicles will sometimes pose a problem; if they are parked, there is little you can do, although you can change a problem into a virtue by including

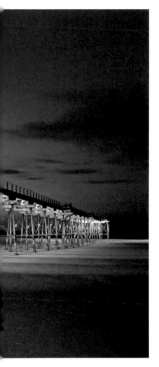

the reflections you see in cars in the image. Passing vehicles with their light trails can create the biggest problem, but once again it is a matter of deciding whether you wish to include them or not. If you don't, simply cover the lens as they pass by, then continue with your exposure.

Photographing any building in evening light will create difficulties because of the mixed lighting conditions. The problem is compounded because cinemas can often show a combination of lighting including sodium, fluorescent and tungsten. This is a problem when photographing any kind of building out-of-doors. First you need to establish what the dominant light source is and then decide whether you feel that the cast it creates will benefit or spoil the

image. Select the appropriate AWB setting and see what materializes. With an expected exposure of just 30 seconds, you will have plenty of time to re-take the shot with a different setting if that is what is needed.

Photographing interiors

Cinemas are complex places and they are illuminated by a variety of light sources. However, if you have the full cooperation of the owner, you should have some control over this. Atmosphere should always be at the heart of a good interior shot and sometimes a more dramatic outcome can be achieved by reducing certain lights. The rich and ornate detail within the auditorium is often worth photographing, although it is difficult to avoid making the screen the main focus of the photograph. If you are using an ISO setting of 100 at f/16, expect an exposure of two minutes or more. Incidentally, if the screen happens to be showing a movie while you are taking the shot, you can get some interesting blurred images recorded on the screen.

All interiors will potentially create a colour cast. It is important to work out the source of lighting, be it tungsten or fluorescent, and set the White Balance accordingly. Once again, problems can arise if there is a mixture. You might be able to ask the owners to turn off certain lights, although this could compromise your composition. Moreover, sometimes one source of light has the effect of countering the cast created by another. You will need to accept that there will be some limits to your control; the atmosphere created by the lighting should take precedence over the precise balance of the lighting source. In essence, what you are trying to achieve is an image where white areas appear

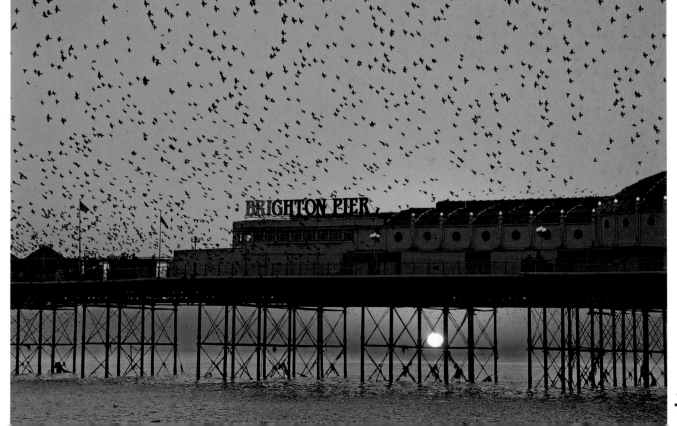

BELOW One of the interesting features of photographing fairs is that some of the rides will be moving while others are static; this creates an attractive contrast.
(Photograph: Eva Worobiec)
Canon EOS 5D, 24–105mm lens, 14 sec at f/16, ISO 100

BELOW RIGHT
Getting good photographic angles is never easy in a confined space with lots of other people milling around. Using a zoom helps in such situations.
Canon EOS 5D, 24–105mm lens, 8 sec at f/16, ISO 100

BELOW It is often assumed that you cannot photograph people unaware in low-lit situations. Here, by using a narrow depth of field with a moderately long-angle lens, I was able to discreetly photograph one of the assistants, who was busy with his phone at the time.
Canon EOS 5D, 24–105mm lens, 1 sec at f/11, ISO 400

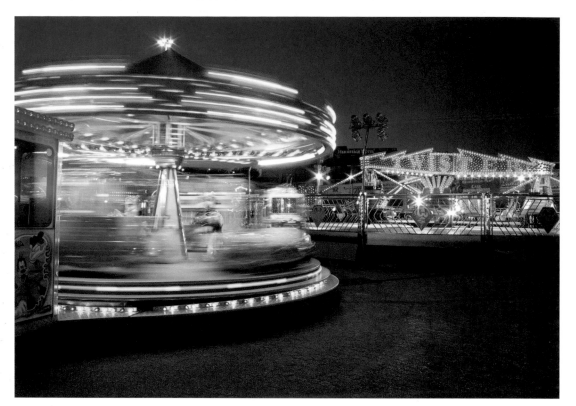

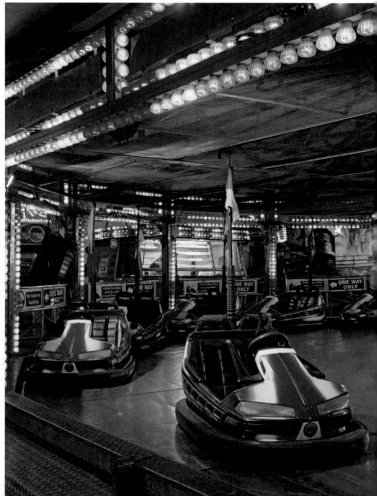

white and free of a colour cast. In most cases the AWB setting will suffice, but if you notice there is a problem after exposure, photograph a plain white object. If there is still a cast, use the camera's Custom White Balance facility to correct it. Finally, you can correct the White Balance in-camera after the shot has been taken. The most common casts are blue, amber, magenta and green. Many DSLRs have a setting that allows you to change any specific cast incrementally. Often this cast is most evident in the greys.

Seaside resorts

One of the great features of photographing coastal resorts is that interesting and often beautifully illuminated structures are likely to be positioned adjacent to or near the sea, which provides a very simple yet dramatic backdrop. Normally one of the major difficulties with photographing buildings is that neighbouring ones can often intrude, thereby compromising composition. By way of contrast, in many coastal resorts, the most opulent and flamboyant structures are likely to be situated in splendid isolation, which makes the task of photographing them far easier.

During the winter months, many of the resorts are relatively empty, while in the summer they will attract large crowds and present entirely different opportunities. As people are more relaxed when on holiday, they are far more accommodating should you wish to photograph them. And while you may not be guaranteed good weather, the lighting nearer the coast often has a luminescence that we do not experience inland.

There are one or two precautions you should take. Both sand and seawater are notoriously damaging to cameras, so you should take extra care when working near them. When changing lenses, try to ensure that you are sheltered from a sudden gust of wind, otherwise you risk getting sand in your camera. If you are able to get by with just a single zoom, then you should avoid this risk. Standing too close to the edge of the promenade can also invite sea spray, which can not only damage your camera, but your lens as well. If you are in an exposed area, keep your equipment covered until you really need it.

Photographing fairgrounds

Fairs and fairgrounds have long been a favourite with photographers, if only for the variety of photographic opportunities they offer. Moreover, they are easily accessible. While few fairs remain static, they do tend to return to the same locations on a regular basis. Most fairs operate during the summer months, although they can also be seen on special occasions throughout the year, particularly at Christmas and New Year.

From the standpoint of low-light photography, fairs seem not to kick off until dusk, when their flashing lights and gaudy neon are at their most appealing. As they try to cater for the full age range, most fairs do not get into the full swing until the early evening. Fairs by their very nature are busy places and are not ideal if you want to plan particular shots. There has to be an element of give and take; with long exposures, figures will inevitably stray across your frame, but with exposures of eight seconds or more, this should not pose a problem. Sometimes figures will stop and linger and there is not a lot you can do. But rather than get frustrated, check your LCD, because sometimes these unplanned intrusions can add a fresh dimension to the image.

Most fairs are tightly packed and getting a good angle is difficult. Take a medium-range zoom that will allow you to take both wide-angle and long-angle shots, as the one thing you do not want to do is to constantly be changing lenses. If you want to work discreetly, there are always corners you can retreat to, as most people are concerned with having a good time and will barely give you a second glance.

One of the great advantages of photographing fairs is that while most of them are outdoors, neither the ambient lighting nor the weather should pose significant problems. Many low-light situations require you to use a very specific window of opportunity, but when photographing fairs you can work for much longer, as the sky will rarely feature in the image.

One thing you will quickly appreciate is that photographic opportunities abound. First, some of the rides will be static while others will be moving and having an option really does help. You can choose to include figures or decide that you do not want them in. Certainly I would suggest that you experiment with as many aperture settings as possible, as the results can be interesting.

If you do want to capture figures, try using flash. In some situations, this can offend some people. However, within the context of a fairground, with its strobes and constantly flashing lights, your fill-in flash is likely to go unnoticed. The huge advantage of working digitally is that if someone is unhappy about you taking their photograph, you can show them the file, and if they are still unhappy, simply delete it from the memory card.

Finally, regardless of whether the fair has been set up on public or private land, it is a good idea to find out who is in charge of running it and have a quiet chat with the operator. In the same way as we might not appreciate strangers photographing our place of work, fairground workers might also be put out. Once you have explained the purpose of your photography, the overwhelming majority should prove more than supportive.

tip

Use a medium zoom lens in these situations. Often you will find yourself in a tightly packed place with lots of other people milling around. The last thing you need is to be constantly changing lenses.

THE URBAN ENVIRONMENT **107**

MAKING THE
ORDINARY
EXTRAORDINARY

There are certain photographic locations that virtually guarantee you great shots, but the real challenge comes when you try to photograph the prosaic and the mundane. I have long admired the work of the American photographer William Eggleston; he has a wonderful capacity to photograph commonplace subjects and yet, through his intimate understanding of colour and composition, he is able to present the ordinary as something quite extraordinary. Try photographing even the most familiar of places in low light and you will be surprised by how easily you can transform everyday scenes into something truly special.

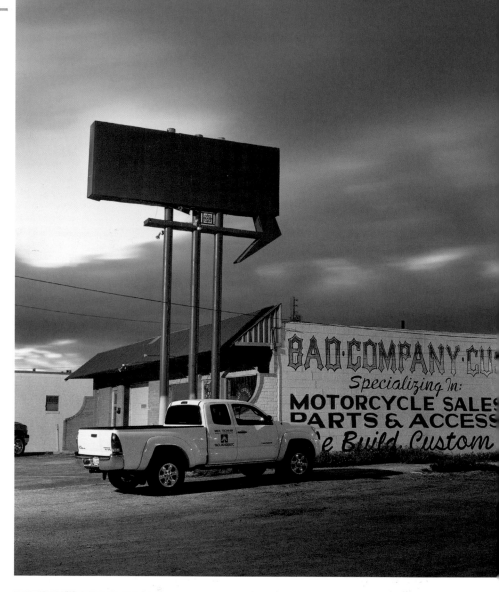

ABOVE RIGHT Seen before sunrise with the light coming from an adjacent building, this otherwise prosaic commercial building assumes very strong pictorial qualities. Part of the appeal is the rich orange and gold set against the newly emerging sky.
Canon EOS 5D, 50mm lens, 4 sec at f/16, ISO 200

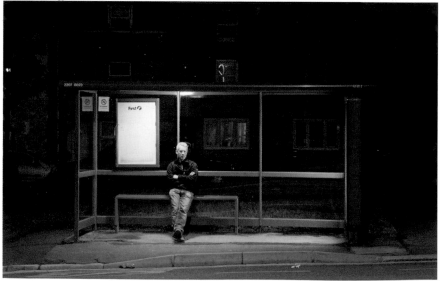

RIGHT There are few things as prosaic as someone patiently waiting for a bus, but when viewed at night, this figure appeared strangely sinister. It was inappropriate to use a tripod, so I quickly upped the ISO rating and shot this handheld.
Canon EOS 5D, 24–105mm lens, 1/15 sec at f/5.6, ISO 800

The secret is to visit these familiar locations at night. The real problem is that we all live very busy lives; we go to work, we travel home again, we make a meal, we maybe watch some TV and that tends to be the pattern for the day. We may be lucky enough to set a few days aside for photography, but unfortunately we convince ourselves that good photographs can only be taken outside of our normal experiences. Because our travel has become so familiar, it is difficult to see anything worth taking. But going to and from work can offer some wonderful photographic opportunities, particularly in the winter months when your journeys are made in the dark. Shops and businesses that you routinely pass can be fabulously changed by the interesting lighting that night offers. The wonderful artificial lighting we commonly experience in the winter months introduces an amazing theatrical quality to many familiar buildings.

Even the roads you travel on can be beautifully transformed at nighttime, particularly if there are interesting weather conditions such as rain or fog. The darkness simplifies the landscape and the lighting from your vehicle focuses only on the tarmac ahead. Use the situation as it presents itself; if there is a lot of traffic, the light trails they create can be used to good effect. You may prefer to return to the scene later in the evening and capture some of these places once they have become deserted. Locations that are normally busy in the day can appear eerily empty in the evening or at night.

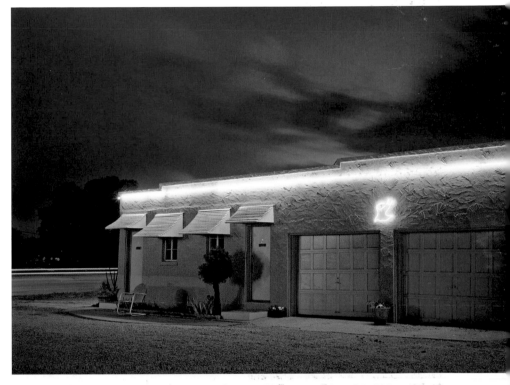

This was photographed at the back of a motel that I was staying at. As I went to get my car, I was struck by the richness of the colours set against the night sky.
Canon EOS 5D, 24–105mm lens, 27 sec at f/16, ISO 100

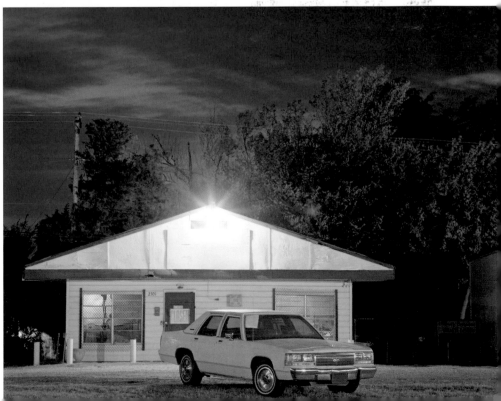

In the course of the day, I had passed this old Ford car on several occasions and in the full glare of daylight I had barely looked at it. But as soon as I saw it at night, I immediately recognized its strong visual appeal.
Canon EOS 5D, 50mm lens, 14 sec at f/11, ISO 400

PORTRAITS AND FIGURES

It is sometimes assumed that there are too many difficulties to overcome when photographing portraits or figures in low light, but in reality some of the most unusual shots can be taken when the lighting is reduced. Often it helps to think about the constraints and limitations and then try to make them work in your favour. Broadly speaking, the task can be divided into two categories: photographing portraits indoors and photographing them out-of-doors.

ABOVE It is surprising how sharp a portrait can be without using flash, even when using fairly long shutter speeds. In this example, I needed an exposure of 2 seconds, but because the subject had braced himself against the counter, there was no movement.
Canon EOS 5D, 24–105mm lens, 2 sec at f/8, ISO 400

PHOTOGRAPHING INDOORS

Usually our very first experience of taking photographs is of taking snaps of our friends and families. While we might try to take the odd indoor picture, we quickly learn that the camera cannot cope with such situations, and therefore tend to take most of our portraits outdoors. But are we dismissing some excellent photographic opportunities?

Using available light

Even when you are indoors there is often still quite a lot of available light, particularly in daytime, and it should be possible to handhold your camera without the need to use flash. Place the subject close to a window or an open door and, although you may be required to increase the ISO setting and open up the aperture, you should be able to take a decent portrait. The main problem is contrast. As the light will be coming from one source, you will encounter shadows. This can be flattering in some circumstances, but most portraits look best when photographed in soft light. If you are photographing your subject close to a window, there are two ways of softening it. First, if there is a net curtain available, use it to reduce the harshness of the light coming from outside. Second, by bouncing some of the light back towards the subject using a white reflector, you will be able to balance out the source so that the portrait appears

almost shadowless. If you do not have a reflector, a sheet of white card can be used to achieve virtually the same result.

Use fill-in flash

I am often amazed how well many amateur photographers cope with indoor portraiture merely by relying on the camera's fill-in flash; this may be achieved with just a modest compact. Simply by pointing and shooting, the camera can be relied upon to do a reasonably good job. More expensive DSLRs tend not to have a built-in flash unit, although you can buy small independent fill-in flash units that work extremely well. All cameras have a red-eye facility; this of course should be selected.

LEFT Most professional photographers take portraits indoors using sophisticated studio lighting. This has many advantages, not least that every aspect of the photograph remains within your control. *Canon EOS 40D, 17–85mm zoom lens, 1/60 sec at f/8, ISO 200*

RIGHT Using flash directly onto the subject can result in harsh shadows, but using the flash off-camera is one way of avoiding this. *Canon EOS 5D, 24–105mm lens, 1/60 sec at f/16, ISO 400*

RIGHT People's places of work can often provide excellent photographic opportunities. In this example, I decided to bounce the flash off the ceiling. *Canon EOS 5D, 17–40mm lens, 20 sec at f/16, ISO 100*

Also try to remember that as flash offers a natural light you should set your White Balance facility to Daylight. The one major problem with using an on-camera flash unit is that the lighting will be extremely flat. In most circumstances, it is much more flattering to a portrait if you are able introduce some element of modelling. The face is more complex than it might at first seem, and although the head is roughly spherical, it does comprise various planar surfaces that need to considered. Undoubtedly the most important features are the eyes, and it is vital that they are adequately lit.

Bouncing flash

Fill-in flash copes well with many situations, but the direction of the lighting will always be determined by the position of the camera. Sometimes you may wish to alter that, particularly if you want to introduce an element of modelling. Bouncing the flash off a ceiling, or perhaps an adjacent wall, will offer you more scope. There are several issues you need to consider. First, it is important that the surface you wish to bounce your light off is both smooth and pale in colour, otherwise it will absorb too much of the light. Second, you will need a more powerful flashgun. When calculating the distance of the flash, you need to consider the distance from the flash to the reflective surface and then add this to the distance from the reflective surface to the subject. Bouncing flash reduces the strength of

the light, as some of it will inevitably be absorbed. Therefore, when making your calculations you will need to open up the aperture by at least one stop.

Diffusing the flash

Most flashguns will come equipped with an optional diffuser head, which you attach to the flashgun if you want to soften the burst of light. If your flashgun does not have one, or perhaps you have lost it, a piece of tissue will do, which you can place over the head. This then allows you to aim the flash directly at the subject without it creating unsightly shadows. Once again, it is important that you open up your aperture by one stop.

Using the lens stabilizer

Increasingly often lenses are being made with stabilizers, which allow you to handhold your camera at very slow speeds. There are numerous occasions when you wish to take a shot without the subject becoming aware; in these circumstances flash can be quite intrusive. By selecting

a moderately high ISO setting and using a wide aperture, it should be possible to handhold a camera in many normal interior lit situations. As you are not using flash, you will need to consider the available light source and set the White Balance accordingly.

Blurring figures without flash

An interesting technique you may wish to try involves photographing an interior with the camera set on a tripod, using a moderately slow shutter speed of around half a second or less and then allowing figures to move into frame. For this to work you need to find a visually strong scenario; often operating from a high vantage point produces interesting results. With the camera focused on the background, allow figures to move in and out of frame. Once you think you have achieved an interesting balance, fire the shutter. This is the art of the unpredictable, but the real joy of working digitally is that you can take as many shots as you want and review your results later on.

PHOTOGRAPHING OUTDOORS

As I have already said, most portraits are photographed outside and usually quite successfully. Problems can arise, however, particularly in low-light situations or when there is a lot of contrast.

Photographing outdoors without flash

Some people might suggest that this is impossible because of the slow shutter speeds required, but do not underestimate what can be achieved if you have a stabilizer fitted to your lens. If you use a fast ISO and a wide aperture, it should be possible to handhold your camera and still capture a portrait in moderately low light. It is also worth considering how still some people can remain. For example, many of the great portraits taken in the nineteenth century were captured on very slow glass plates that sometimes required an exposure of several seconds and yet they were sharp. Be prepared to use the available light creatively. If you are in a well-lit urban area, you should be able to place your subject near to a brightly illuminated shop window or perhaps directly below street lighting and still be able to get a workable light reading. Once again, you will need to consider the light source and adjust your White Balance.

Photographing outdoors using flash

This can work, but it is a matter of balancing the light from the flash with the ambient light. For example, using flash to photograph a figure in an unlit landscape in the middle of the night might look a tad obvious. If you try taking the same shot at dusk or dawn when the strength of the ambient light is stronger, you will achieve a more rounded image. It is important that the two light sources are balanced. Ideally the aperture and speed of the camera should match the aperture setting and speed of the flash, but that rarely happens. One way around this is to use a slow shutter speed in conjunction with a burst of flash. In fact, very interesting effects can be created with this method. The important point is that you meter for the background but set the flash for the subject. This type of photography can look particularly effective when using a telephoto lens set to a wide aperture.

BELOW LEFT I was surprised how well this image turned out under the thundery sky. Using a flashgun off-camera, I directed the light to the right of the subject, which introduced an element of modelling.
Canon EOS 5D, 24–105mm lens, 1/60 sec at f/11, ISO 400

BELOW RIGHT Photographing a portrait outdoors can be particularly effective if a small amount of fill-in flash is used. The trick is to match the ambient lighting with the flash.
Canon EOS 40D, 17–85mm zoom lens, 1/60 sec at f/8, ISO 100

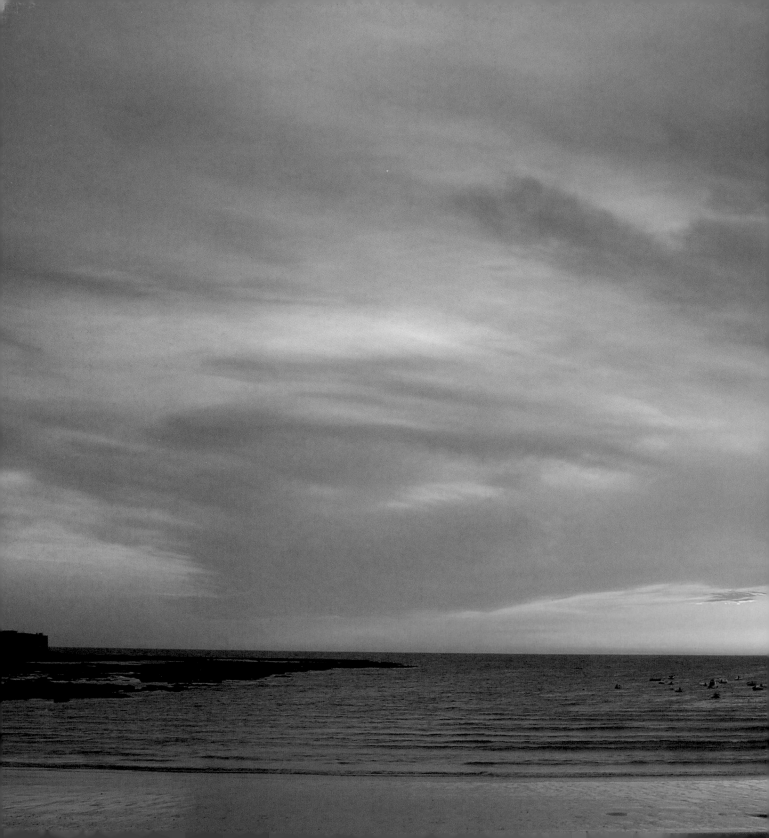

CHAPTER 4
POST-CAMERA PRODUCTION

USING THE RAW DIALOG BOX

A Raw file is created directly from the data captured by the camera's sensor, which, unlike a JPEG, involves no compression. As a Raw file retains all the bit resolution, it is capable of delivering a better tonal range and a higher quality throughout. But there is another advantage; you can make changes non-destructively. What this means is that if you make a change but then decide that it has not improved the image, you can reverse the process without degrading it in any way. This can also be done in Photoshop, but only if you use adjustment layers. Here we show you how you can use Raw Conversion software to correct exposure, change White Balance, improve the contrast, correct chromatic aberration, remove vignetting and sharpen the image.

When you shoot in Raw, you capture more detail than is immediately apparent. The exposure control in the Raw Conversion dialog is a useful means of exploring the potential of any image. At this stage, all changes can be made non-destructively.
Canon EOS 5D, 24–105mm zoom lens, 1/2 sec at f/16, ISO 100

Raw Conversion software

Does this mean that by using the Raw Dialog there is no longer a need for post-camera software? Not entirely. While Raw Conversion programs perform many of the functions of software such as Photoshop and Lightbox, when you make changes the adjustment will affect the entire image. Most Raw Conversion software does not allow selective changes to be made; a few packages, such as Nikon Capture NX, are the exception. One of the problems of shooting Raw is that there is not one universal Raw type; most camera manufacturers provide their own software for converting Raw into TIFFs. The required software can be downloaded directly from the camera manufacturer's website, or you can download compatible conversion software from Adobe (www.adobe.com).

The format of the RAW dialog will vary depending on whether you choose to use a download from Abode or decide instead to use the the camera manufacturer's version. But in essence, all offer a basic adjustment dialog with additional options available as well.

1. Correcting exposure

When using Raw Conversion software, one of the best facilities for improving the image is the Exposure slider. This allows you to make very subtle changes to the brightness of the image, helping you to retrieve lost highlight or shadow detail. It is worth noting that when shooting Raw, you are capturing more detail than is evident in the camera's LCD. While at first glance it may appear that valuable highlight detail has been lost, this can sometimes be recovered when using this facility. This can be particularly important when photographing in low-light situations where there is a lot of contrast. The dialog defaults to Adjust, which offers some extremely useful settings. By referring to the image in the dialog (see image below), we can see that parts of the shadow area lack detail, indicated by the bright blue highlights in the image. By reducing the shadows slightly (i.e., pulling the slider to the left) the severity of the shadows is reduced as more shadow detail is added. On a similar tack, excessively bright areas will be indicated by red; this can be countered by pulling the Brightness slider to the left.

2. Changing White Balance

This allows you to change the colour temperature of the image, which, from the standpoint of photographing in low light, is a particularly important facility. If the image presented appears to have a cast, select the White Balance preset from the Balance menu and then choose the appropriate option that best describes the lighting of your image. For example, opt for Tungsten if you have been shooting indoors under artificial lighting. You also have a couple of other tools that can help correct the colour temperature of the image, namely the Colour Temperature slider and the Tint slider.

3. Improving contrast

It is always helpful to be able to adjust the contrast of your image, as this can add much-needed impact. The Contrast slider is simplicity itself. It is just a matter of pushing the slider to the right if you want to increase contrast and dragging it to the left if you wish to decrease it. It is worth keeping an eye on the red and blue highlights; as altering the contrast will determine whether highlight and shadow detail is retained or lost.

4. Correcting chromatic aberration

When shooting digitally, whether you opt to use either Raw or JPEG, it is not uncommon to see a very faint coloured line, particularly at the edge of areas of high contrast. This feature can be particularly noticeable when using a wide-angle lens. It also happens when shooting on colour film, but is less noticeable, as the edges tend to be less sharp than with digital capture. It is caused by the varying frequency of coloured light hitting the sensor. While it is not always obvious on screen unless you use the Zoom tool, it can become evident when producing large prints. This should be removed using the Chromatic Aberration slider. With the Abode Raw Conversion Dialog this will be found under Lens. Assess the colour of the fringing, as sometimes there may be two different ones, and make the appropriate corrections using the sliders.

5. Removing vignetting

Vignetting most obviously occurs when too many filters have been stacked over a lens, creating a darkening in the corners. However, it can also occur when, with certain lenses, less light reaches the edges of the sensor; this can be particularly noticeable when using a cheaper wide-angle lens at full aperture. To resolve the problem, go to Lens and then find the Vignette controls, which should offer two sliders: Amount and Midpoint. Select the Amount slider first

and carefully adjust it until the tone at the edges appears to balance with the rest of the image. Then select the Midpoint slider; this can be used to allow the darker tones of the corners to gently bleed into the centre of the picture. By using these two sliders, it should be possible to balance the overall tonality of the image and thus remove all traces of vignetting. It is worth noting that vignetting can sometimes be used to enhance an image. Possibly more common among monochrome workers, there is a pictorial tradition for deliberately darkening corners in order to place greater emphasis on important elements within the picture. Using the Vignetting sliders is one way of achieving this.

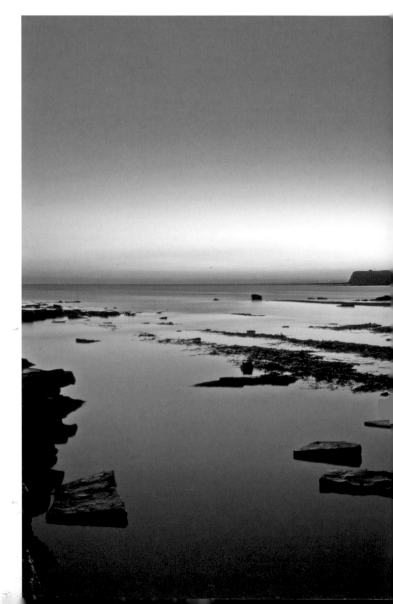

6. Sharpening the image

Most images captured digitally require some measure of sharpening, and this can be done within the conversion dialog box. The Raw converter will sharpen the image by default, but this is sometimes not enough. Check the sharpness by using the Zoom tool, and if necessary make the required adjustments, although this is possibly one of the features of the Raw Converter dialog I would not normally elect to use. Most sharpening is far better done selectively, something that cannot be done when using most Raw converter software.

Rather conveniently, the latest editions of Photoshop include an Adobe Raw conversion plug-in as part of the package. In common with other Raw plug-ins, it offers the usual range of adjustments, including the Chromatic Aberration slider. In addition it includes a red-eye tool and a retouch tool for performing simple cloning and spot-healing tasks. It also has a HSL/Grayscale option that allows you to make a grayscale conversion without going into Photoshop. In principle, it works very much like Photoshop's Black and White dialog. Remember, all these adjustments can be made prior to going into Photoshop.

Raw Conversion software offers a very comprehensive range of tools for making important changes to the image.
Canon EOS 5D, 20mm lens, 2 min at f/22, ISO 100

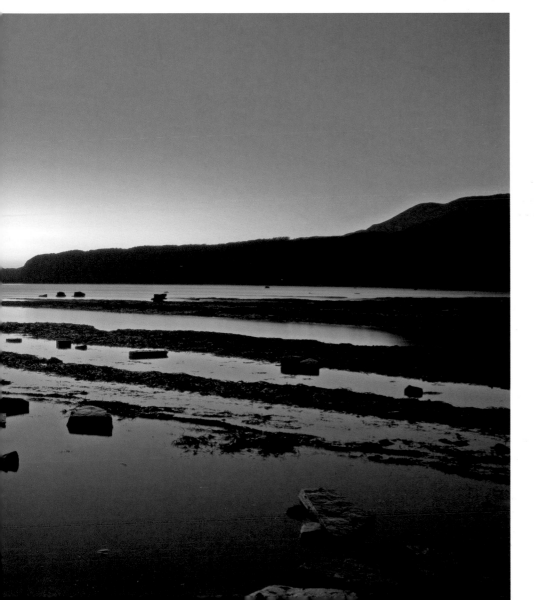

MAKING TONAL ADJUSTMENTS

Because so many low-light situations feature artificially illuminated areas, excessive contrast is a constant problem. There are several things you can do in-camera to partially control this, but sometimes further post-production work is also required. The overall tonality of the image is of primary importance. If this has not been altered using the Camera Raw software, then it can quite easily be remedied in Photoshop using Curves. This feature is available in all versions of Photoshop.

The Curves facility presents the most flexible set of controls for making tonal changes. It can be accessed by first making an adjustment layer and then selecting Curves.

The graph that appears is a straight diagonal line representing 0 (the darkest value) through to 255 (the lightest value), before any of the adjustments are made. The horizontal axis represents the input values (i.e., what was originally there); the vertical axis represents the output (or adjusted values). By adjusting the curve, you are able to remap the brightness values of the pixels.

To adjust the image, click the cursor near the midpoint on the curve; gently pull it upwards to lighten the image or downwards to darken it. In this example I wanted to lighten the darker areas, as the paler

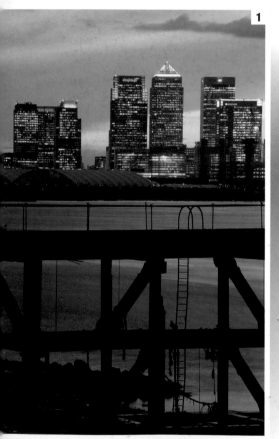

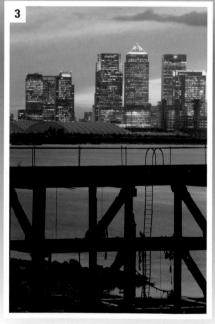

ONE Often when photographing in low light it is easy to underexpose, particularly if you rely on the monitor rather than the histogram. When shooting Raw this is easily remedied using the Raw Conversion dialog; however, many photographers opt to shoot JPEG instead. Using Curves in Photoshop is another way of resolving the problem.
Canon EOS 5D, 70–200mm zoom lens, 8 sec at f/16, ISO 100

TWO I was keen to retain the moody atmosphere of this riverside scene, therefore it was essential not to excessively lighten the shadow detail. This was achieved by firstly pegging the upper part of the curve and then gently pulling the bottom part upwards.

THREE Curves has successfully lightened just the darker parts of the image.

part of the image was already light enough. To achieve this I first needed to peg the highlights and then lighten the darker part of the image by pulling upwards.

Making more specific selections using Color Range

Usually improving the overall tonality of an image is just a matter of adjusting either the lighter or the darker tones, but sometimes quite a specific selection is required before any useful changes can be made. One very handy facility for making detailed selections is Color Range. Go to Select > Color Range and the Color Range dialog will appear. This allows you to select common areas of colour rather than just tone; you are then able to make very specific tonal changes. Use the picker to select the area you wish to change; then use the Fuzziness slider to expand or reduce the selection.

Making further tonal adjustments using the Shadow/Highlight command

Having made a further selection, I needed to subdue the brightest highlights slightly. This can be done by using Curves once again, although another possible solution is to use the Shadow/Highlight command (providing that your version of Photoshop has it). Go to Image > Adjustments > Shadow/Highlight. Select the Highlights Amount slider and drag it to the right to darken the highlights.

FOUR While the darker parts of this image have been successfully lightened using Curves, the lightest parts still reveal insufficient detail. In order to make further tonal changes, these brightest parts are selected using Color Range. Sometimes the selection can appear too harsh, so try feathering it by at least five pixels.

FIVE By carefully pushing the Highlight Amount slider to the right, increasingly more highlight detail begins to emerge, but do not over-do this otherwise the results will look false.

SIX The finished image of the Thames at Grenwich.

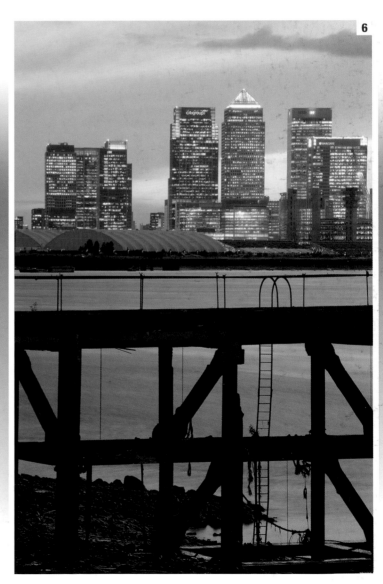

CORRECTING COLOUR CASTS

It is important to appreciate that natural and artificial light have quite different colour values, and these affect the final quality of the image. We are rarely aware of them because our eyes are very good at compensating; whether we are in a room illuminated by tungsten or fluorescent light, our eyes adjust accordingly. Unfortunately, the sensors in our cameras are not quite so flexible.

As I indicated in Chapter 1 (see pp. 14–15), all digital SLRs offer a White Balance facility, which if used carefully should obviate most problems. Of course, none of us is always quite so conscientious. It is surprising just how reliable the Auto setting is in most natural light situations, although problems can arise with artificial lighting. If you take a shot in fluorescent lighting with the White Balance set to Daylight, then the image will appear to have a strong green cast. Alternatively, if you use the Daylight setting in an interior lit by tungsten (which is the normal domestic lights most of us use in our homes) then there will be a distinct orange cast.

If you are shooting Raw, adjustments can easily be made in the Camera Raw dialog. If you have decided to shoot JPEG and have used the wrong White Balance setting, then you will need to make the corrections in some form of editing software such as Photoshop. The first thing that you will appreciate is that the cast created by not selecting the correct White Balance setting can be profound and should not be ignored.

The first task to establish is how to correct the cast; using Photoshop, the easiest way to start is to go to Variations (Image > Adjustment > Variations). This dialog box displays a variety of thumbnails that illustrate what the image would

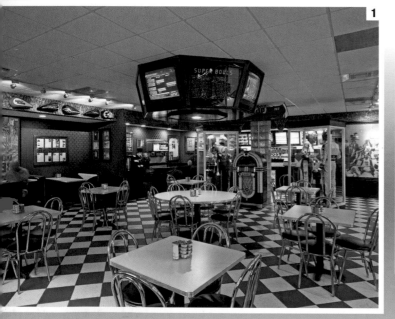

ONE This kind of mistake is easily made. As my mind was more concerned about the composition, I forgot to set the White Balance to Fluorescent. Consequently, the image has this unattractive green colour cast. As I had shot this image as a JPEG, I was unable to use Raw Converter software to solve the problem and needed to use Photoshop instead. Typically, most colour cast problems occur with artificially lit interiors.
Canon EOS 5D, 20mm lens, 3 sec at f/16, ISO 100

TWO Variations can serve as an excellent guide if you are not too sure how to overcome a colour cast using Color Balance.

THREE When using Color Balance, you can select to work on just the Highlights, Midtones or Shadows. As casts tend to be most prominent in the highlights, I usually deal with these first.

look like if additional colours were added. The Current Pick shows the results of any changes made. The Variations dialog also allows you to see how the colour changes can impact on the highlights and shadows. Having carefully examined the options in this example, I decided to add magenta in order to balance out the green. It is important to remember that you cannot access Variations when the image is still a 16-bit file.

Using Color Balance

The Color Balance dialog offers general controls for correcting the overall colour cast in the image. There are other methods, but this is the easiest way. This facility works on the principle of balancing complementary colours. Therefore, as this example had too much green, I dialled in the opposite colour, magenta, in order to neutralize the cast. It is important to appreciate that casts do not affect the full tonal range equally, as the cast is always more pronounced in the highlights than the shadows. It is worth making two separate adjustments, one for the highlights and a second for the midtones.

Finally, it should be noted that the overwhelming majority of colour casts occur in images photographed in mixed lighting (i.e., parts of the images are lit by artificial light, while others are lit by natural light). In those circumstances it is usually better to set the White Balance for the latter.

It is a matter of aesthetics, but often the orange or green casts created by artificially illuminated buildings, particularly when set against a richly coloured sky, can be visually very attractive. As long as the colour cast is localized, it can actually help an image; however, if you feel that it does pose a problem, then the areas showing a cast can easily be selected using Color Range and corrected.

4

FOUR Although most illuminated interiors will show some element of colour scatter – particularly if there are many reflective surfaces, as in this case – the overall greenness of the first example has been countered by adding more magenta using Color Balance.

CORRECTING HORIZONS AND CONVERGING VERTICALS

It is generally advisable that you use a spirit level attachment when working with a tripod to ensure that the horizons remain level. However, this basic rule can often be overlooked in the excitement of taking a shot, resulting in an image with a horizon that is not straight. Not being able to see clearly when working in subdued light can add to the problem. In addition, you may experience converging verticals when you are photographing buildings within a confined space, particularly when using a wide-angle lens. Fortunately, both of these problems can be easily rectified in Photoshop.

Straightening horizons

Some recent versions of Photoshop offer a Straighten tool. This simply requires you to draw a straight line along a sloping feature that should be made horizontal. However, if your edition does not have this tool, you can use the Measure tool instead. In the worked example I have included, there are a number of sloping horizontals, but straightening the roof of the conservatory helps the other offending horizontals to fall similarly into line.

To correct the sloping horizon, go to Image > Adjustments> Rotate > Arbitrary. If you select Arbitrary, a small dialog box will appear that will tell you how much rotation is needed to straighten the image (see step 3). Click OK.

Once the arbitrary rotation has been applied, while the sloping horizontal has been corrected, the edges will appear crooked (see step 4). The temptation is to crop it immediately, but it is always advisable to wait until the converging verticals have been corrected, as you may crop more than is required.

ONE As the light was disappearing quickly, I hastily put my camera onto the tripod but had not taken sufficient care to ensure that the horizon was level. This can often be difficult to judge, particularly in low light.
Canon EOS 5D, 50mm lens, 24 sec at f/16, ISO 100

TWO Before correcting a sloping horizon, it is important to select a line that you think should be straight. Select the Measure tool and, using the Cursor, draw a line along a straight surface you wish to correct.

THREE In this example the extent of the slope is 4.85 degrees, which is quite a lot. To correct it, click OK.

FOUR Once the Arbitrary Rotation has been applied, it is tempting to crop the image, but wait until the converging verticals have been corrected.

FIVE It helps to apply a grid so you can accurately assess which parts of the image need to be changed. In this example, all the distortion appears on the right of the image.

Correcting converging verticals

It is important to establish which of the verticals are converging and by how much. This is easily done by introducing a grid; go to View > Show > Grid. In the example illustrated, it is evident that while the left side appears correct, the right side converges inwards (see step 5). Using the Navigator, slightly reduce the size of the image so it appears over a blank canvas; go to Select All, then to Edit > Transform > Skew. Eight small bounding boxes will appear on the outside of the selection. As the left-hand side is correct, no changes need to be applied there. Using the cursor, select the bounding box in the top right and carefully drag it to the right until the converging verticals are corrected. Use the grid as a guide (see step 5). Having made this further adjustment, it is now safe to crop the image.

Once I considered how much needed to be removed from the example shown, I felt that too much sky would disappear. I decided instead to crop the top less severely, leaving part of the white background remaining (see step 6). I then used the Cloning tool to repair the missing part of the sky.

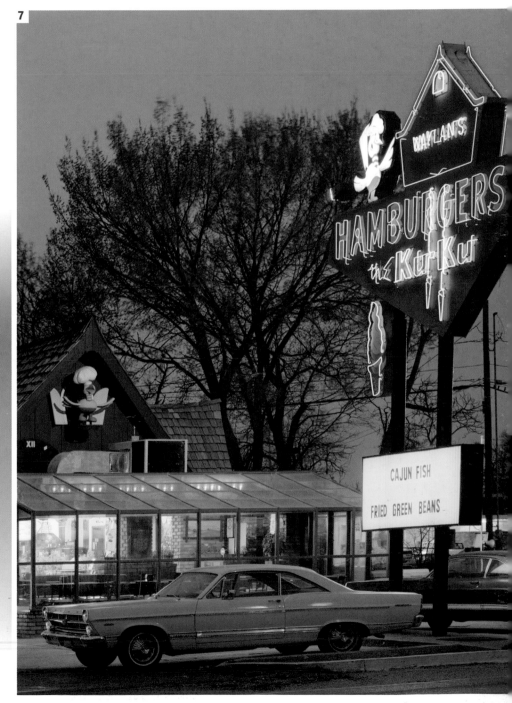

SIX Using the Skew option in Transform, I was able to correct the converging verticals merely by using the cursor to drag the top right bounding box outwards.

SEVEN It is always best to ensure that your image is as straight as possible at the taking stage, but with a little post-camera processing, many of these problems can easily be rectified in Photoshop.
Canon EOS 40D, 17–85mm zoom lens, 55 sec at f/11, ISO 100

CONVERTING TO MONOCHROME

No doubt you will have checked out your digital SLR camera and noticed that it has a monochrome option. Although you can obtain a black and white image using this facility, the quality will always be questionable. Because it is not compatible with Raw, you are not able to use the full potential of the data captured. It may seem somewhat ironic, but if you are aiming to achieve a high-quality monochrome image, shoot in colour first, then convert your image in Photoshop or other image-editing software. If you are an inexperienced black and white worker, shooting a frame using the Monochrome mode might help you to assess its potential, but you should revert back to colour once you are convinced.

Having discussed why it is better not to use the Monochrome option in the camera, it might be appropriate to consider the various methods for converting the image from colour to black and white.

Desaturate

In Photoshop, by far the easiest method is simply to desaturate; go to Image > Adjustment > Desaturate. However, although this method retains the image in RGB, this method is rarely satisfactory and is not generally recommended; the resulting tones often appear flat.

Convert to Grayscale

Another simple method is to change the mode to Grayscale by going to Image > Mode > Grayscale. This, in effect, gets rid of the three colour channels and replaces them with a single monochrome channel. This greatly reduces the file size. While this is quick and convenient, there are better methods for converting a file from colour to monochrome. You are able to continue using important facilities such as Curves and Levels while in this mode. Should you then wish to tone your image using either Hue/Saturation or Color Balance, you will need to convert the image back to RGB.

Using Lab Color

This is the method of choice for many serious monochrome workers; it is also a very straightforward process for converting to black and white. As I have already indicated, a Raw file comprises three channels: red, green and blue. It might help to open the Channels palette at this stage. Convert the image to Lab Color (Image > Mode > Lab

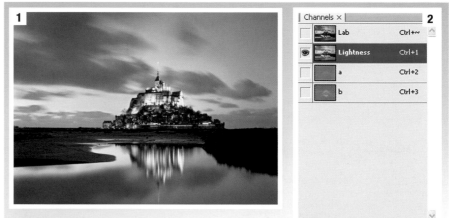

ONE A Raw file retained in full colour.

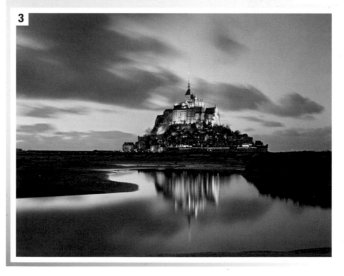

TWO Converting the image to Lab Color separates the monochrome element from colour. This is clearly illustrated in the Channels palette.

THREE Isolating the black and white channel using Lab Color prior to converting to Grayscale helps to retain good shadow detail and smooth midtones. *Canon EOS 40D, 17–85mm zoom lens, 174 sec at f/16, ISO 100*

Color). This has the effect of separating monochrome from colour, which is clearly visible in the Channels palette. The monochrome element is contained in the Lightness Channel; the green to red is contained in the 'a' Channel, and the yellow to blue is contained in the 'b' Channel. In order to remove the colour information, select the Lightness channel. Having done this, convert the image to Grayscale. This procedure reduces the image file size. This method has advantages over simply converting the colour file directly to Grayscale as it retains good shadow detail and delivers exceptionally smooth midtones.

Channels

As we have already discussed, a Raw image comprises three channels: red, green and blue. If we refer to the Channels palette while the image is still retained in RGB, each of the Channels is presented as monochrome, but reflecting the inherent colour channel. This presents us with various options.

First, we need to split the channels. Do this by clicking the small black triangle in the top right corner of the Channels dialog box, then selecting Split Channels from the dropdown menu. Three separate windows will appear, one stacked over the other. To make sense of these, rearrange them on screen so that they appear side by side. To do this, go to Windows > Arrange > Tile Horizontally. From here you are able to select the most suitable file.

Channel Mixer

One of the best methods for converting to monochrome utilizes the Channel Mixer. This retains the image in RGB and offers enormous flexibility. Go to Image > Adjustment > Channel Mixer (or, if your version of Photoshop allows, make an adjustment layer and select Channel Mixer.) The Red channel should automatically default to 100 per cent red. Click the Monochrome box and the image will appear as black and white. By adjusting the three sliders, you are able to adjust the tonal values of each of the colour channels. This offers an adaptable method for making tonal changes, but doing this randomly rarely helps. It is important that the total percentage values for all three channels add up to 100: less than that and shadow detail can be lost; more than that and you risk clipping your highlights.

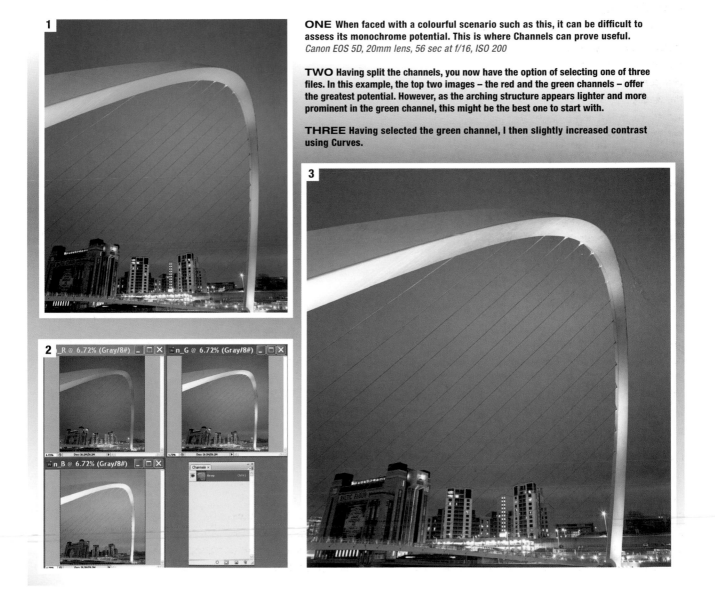

ONE When faced with a colourful scenario such as this, it can be difficult to assess its monochrome potential. This is where Channels can prove useful. *Canon EOS 5D, 20mm lens, 56 sec at f/16, ISO 200*

TWO Having split the channels, you now have the option of selecting one of three files. In this example, the top two images – the red and the green channels – offer the greatest potential. However, as the arching structure appears lighter and more prominent in the green channel, this might be the best one to start with.

THREE Having selected the green channel, I then slightly increased contrast using Curves.

Channel Mixer

Preset: Custom

Output Channel: Gray

Source Channels

Red: +40 %

Green: +40 %

Blue: +20 %

Total: +100 %

Constant: 0 %

☑ Monochrome

OK / Cancel / ☑ Preview

As a general rule, the total percentage values for all three channels should add up to 100.

The Black and White command in Photoshop CS3

Undoubtedly, the best facility for converting colour to monochrome can be found in the CS3 version of Photoshop. To access it, go to Image > Adjustments > Black and White. The Black and White dialog offers you six sliders: Reds, Yellows, Greens, Cyans, Blues and Magentas. These allow you to make very precise tonal adjustments. The principle is not dissimilar to Channel Mixer, except that Black and White command adjusts the actual colours within the image. Put simply, when using the Red slider in Channel Mixer, all the colours are adjusted to a greater or lesser degree. However, when using the Red slider using the Black and White command, Photoshop is able to identify only those parts that are red and responds accordingly.

The adjustments work like Channel mixer; drag the slider to the right to lighten tones and to the left to darken them. Unlike Channel Mixer there is no need to total the adjustments to 100 because the values are not components.

The second big advantage of the Black and White Command is that it is offered as an adjustment layer option. Consequently it is possible to make a black and white conversion non-destructively. Finally, it is possible to dispense with the sliders completely, by selecting the tones in the image you wish to change and then dragging to lighten or darken them.

Adding Hue/Saturation layer

Should you wish to fine-tune the tones further, activate the Background layer and make a second adjustment layer, but this time selecting Hue/ Saturation, ensuring that it appears below the Channel Mixer layer. By scrolling Master, each of the six colour channels (Red, Green and Blue, plus their complementaries, namely Yellow, Magenta and Cyan) will appear. Select each of the channels and use the Hue slider to tweak the tonal values. Do not expect to see drastic changes as this is about fine-tuning. Occasionally it also helps to use the Saturation slider, although excessive use of either of these sliders can cause parts of the image to posterize, so exercise caution.

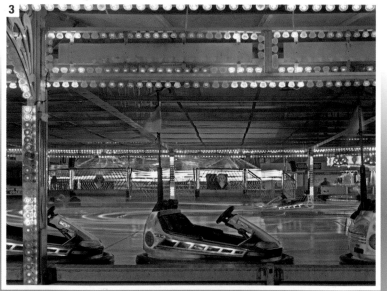

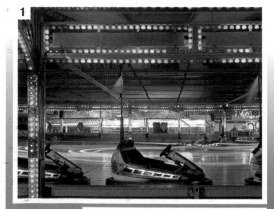

Black and White

Preset: None

Reds: 40 %

Yellows: 60 %

Greens: 40 %

Cyans: 60 %

Blues: 20 %

Magentas: 80 %

☐ Tint

Hue

Saturation %

ONE If you are unfamiliar with Black and White Command, try starting with a brightly coloured image and experiment with the various sliders to see how they affect the tonality of the image.

TWO The Black and White command in Photoshop CS3 is a sophisticated facility for converting colour to monochrome, as it allows you to make very precise tonal changes.

THREE There are always correct outcomes in these situations, although subjectivity plays a part too.

Seeing in mono

We are accustomed to seeing in colour and unless you use the mono facility in your camera, the image you see in the LCD will also be in colour. You need to develop a mindset that allows you to see tone. One of the greatest advantages of shooting digitally is that you always have options. For example, why not desaturate a selection of your colour files, particularly those that show a good range of tones, and see whether any of them make interesting black and white images. My experience of trying this is that the shots that are less impressive in colour often make excellent monochromes. As you become more experienced, you develop an awareness of which subjects are likely to work in black and white. For example, a landscape featuring a heavy grey sky rarely works well in colour, but is more likely to work in monochrome, particularly if there is an important highlight within the image to serve as a focus.

There are various techniques that can help you recognize this potential more easily. When I took shots using monochrome film, I would use a colour filter of some sort. While these were used to filter out a specific colour, they were also a useful means of allowing you to see the image in terms of tone and not colour. In most low-light situations the exposures that you are likely to use will take minutes rather than seconds. Within that context it should not be too inconvenient to look through the viewfinder with a filter on. If you are convinced that the shot has good monochrome potential remove the filter before taking the shot. Another technique is to use the Monochrome setting on your camera to see what the possibilities are. A further simple technique involves squinting at the subject before taking a shot; reducing the amount of detail you can see helps you to recognize the broader tonal masses.

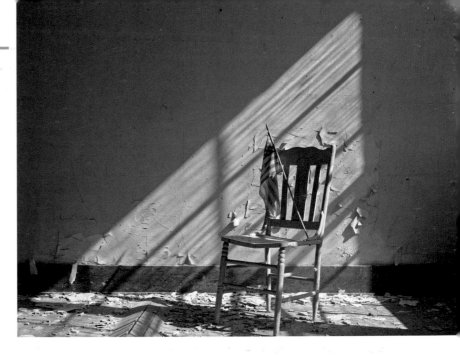

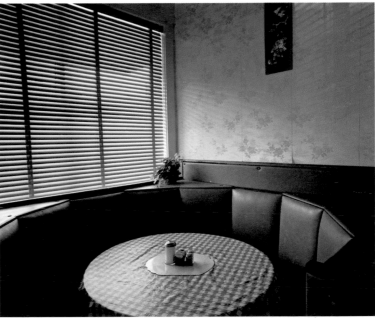

TOP RIGHT Successful monochrome images often show an interesting interplay between areas of light and dark. The shafts of light emanating from a nearby window introduce an important graphical quality.
Canon EOS 5D, 24–105mm zoom lens, 2 sec at f/11, ISO 100

MIDDLE RIGHT Often monochrome is more capable of engendering mood than colour. The interior of this wonderful American diner is a good example. Looking through the viewfinder, it seemed to offer very little in terms of colour, but because of the restricted lighting its tonal values became evident. Presenting it as a sepia image helps to evoke a sense of nostalgia.
Canon EOS 5D, 24–105mm zoom lens, 1 sec at f/16, ISO 160

RIGHT Nothing seems to suit monochrome quite so well as a moody low-key portrait; the emphasis clearly must be tonal. By ensuring that the background appears uncluttered, the features of the face assume far greater importance.
Canon EOS 40D, 17–85mm zoom lens, 1/30 sec at f/5.6, ISO 400

CREATING FILTER EFFECTS

While it is always better to use the correct filter at the right time, there will be occasions when we do not have the correct filter to hand; being able to remedy this in Photoshop offers us a second bite of the cherry. Some of the filter effects can be very plausibly recreated, while others are a little less successful. Many photographers are justifiably wary of applying many of the special filter effects offered by Photoshop, but if they are used judiciously, they can prove useful.

Achieving a neutral density effect using Motion Blur

The main purpose for using a neutral density filter is to slow down the shutter speed or to allow you to use a wide aperture in very bright light. It works like a pair of sunglasses, as it cuts down the amount of light reaching the sensor. Using a neutral density filter can help you produce an image that looks as if it has been taken in poor light, even though it was not. It is particularly good when you want to slow down the shutter speed in order to create blur in moving water.

The solution is to use the example illustrated right, and thereby retain the interesting sky, but to blur the water in Photoshop. I initially tried making a selection of the water and applying Motion Blur, but the result appeared too false, particularly near the horizon. I then decided to use a Gradient Mask and to apply the filter effect incrementally. To make the selection, I clicked the Quick Mask mode icon, and then used the Gradient tool set to linear. By dragging the cursor from top to bottom, a graduated red mask appeared over the image (see step 3). This can be converted into a selection by clicking the Standard Mode button.

Next, go to Filter > Blur > Motion Blur. The Motion Blur dialog box will appear. By carefully dragging the Distance slider to the right, the selected area will change. When you are happy with the result, click OK.

ONE Although this was photographed in moderately low light, I needed to use a shutter speed of ½ sec. This was still sufficiently fast to capture the detail in the waves, but I was hoping for a more blurred effect.

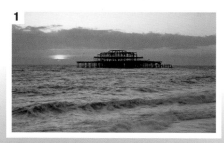

TWO This was taken 15 minutes later. The blur of the water has increased, but the more appealing aspects of the sky have been lost. The ideal would be to retain the sky of the first example while keeping the water in this one.

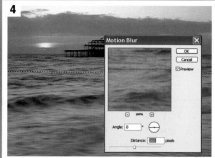

THREE Using the Quick Mask mode is a quick and convenient way of creating a graduated selection.

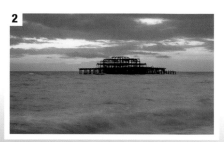

FOUR If you need to change the angle of the effect, use the cursor to manipulate the icon that looks like a steering wheel.

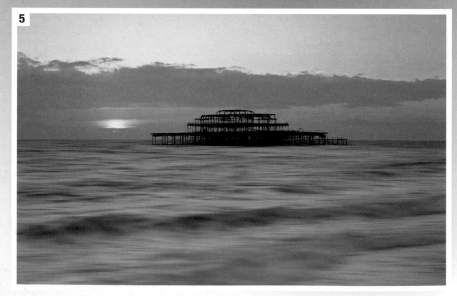

FIVE By applying Motion Blur, I was able to get the best of both worlds. I have retained the interesting sky featured in step 1, yet created an authentic blurring effect in the water.
Canon EOS 40D, 17–85mm zoom lens 1/2 sec at f16, ISO 160

Achieving a graduated filter effect using Gradient Mask

From the point of view of landscape work, the graduated neutral density filter is possibly the most useful filter, as it helps to balance up the brightness of the sky with the foreground; this is particularly evident when the sun is low in the sky. Graduated filters can also prove useful when the light is coming either from the left or the right side, which necessitates balancing out the exposure across the entire frame.

In Photoshop, I made a duplicate layer. Once again I applied a Gradient Mask, but this time I wanted to select the top part of the image. To achieve this, I needed to drag the cursor from the bottom upwards before clicking the Standard Mode button. I made an adjustment layer and selected Curves. Using the cursor, I carefully pulled the curve downwards so that the sky appeared to darken incrementally. Some of the tonal changes affected parts of the pier because it appears above the horizon, but that would be entirely consistent with using a graduated filter. When using Curves, it is always useful to refer to the histogram to ensure that a smooth tonality is retained.

1

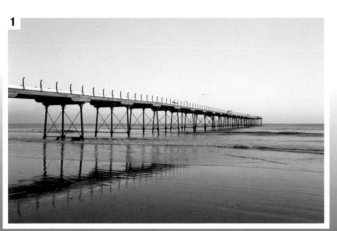

ONE This was one of those classic situations where I was in a rush and didn't have time to put a graduated neutral density filter over the lens; as a consequence, the sky appears pale and insipid.

2

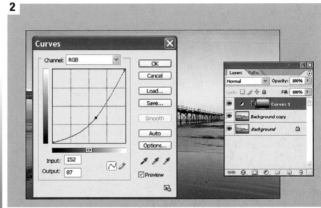

TWO Make an adjustment layer and gently pull the curve downwards. Check the Histogram to make sure that no 'spikes of doom' appear.

THREE I shot this in rich evening light, but I forgot to take into account the likely contrast between the sky and the foreground. By darkening the sky using a Gradient Mask and Curves, a more satisfactory outcome has been achieved.
Canon EOS 5D, 17–40mm lens 1 sec at f11, ISO 100

3

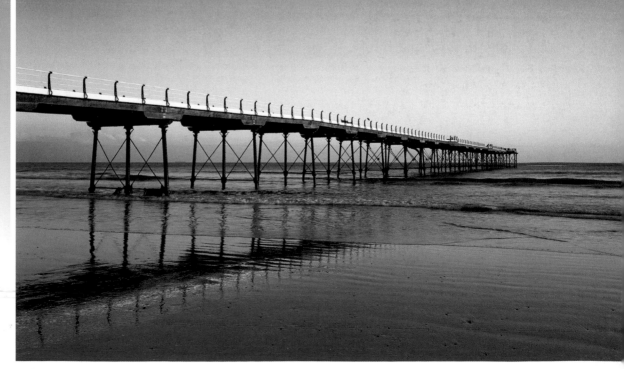

Achieve a polarizing effect using Selective Color

The third of the classic filters used in low-light situations is the polarizing filter. I stated at the outset that not all filter effects can easily be recreated using Photoshop, and this is one of them. The polarizing filter can achieve three things: it increases contrast, it increases saturation, and it removes unwanted reflections from still water. The first two can be very easily achieved in Photoshop, but the latter cannot, unless you are prepared to undertake a lengthy and tricky cloning exercise.

Polarizing filters are often used to add impact to blue skies, particularly if there are white clouds present; it does this by increasing the contrast and intensifying the blue.

This can be simulated in Photoshop using Selective Color. Call up the file, make a duplicate layer, make an adjustment layer and then choose Selective Color. From the dropdown Colors menu, which is at the top of the dialog, select blue. Start with Relative from the Method option and carefully push the Black slider until the blues start to visibly darken.

In effect, the black slider serves to darken just the blue channel in much the same way as a polarizer darkens the blue. If the effect is too subtle for your taste, try using Absolute instead of Relative. As the colour of the sky normally comprises both blue and cyan, repeat the process but this time select Cyan from the Colors box. This should give you a very convincing-looking polarizing effect.

ONE Photographing in early evening, I was blessed with this wonderful sky. However, as I had to meter for the foreground, the sky lacks the intensity I would have wished. Had I used a polarizing filter, the colours would have appeared more saturated.

TWO Start with Relative from the Method option and carefully push the Black slider until the blues start to visibly darken.

THREE As the colour of the sky normally comprises both blue and cyan, repeat the process but this time select Cyan from the Colors box.

FOUR In this example, only the blues have been intensified without affecting the other colours. A very plausible polarizing effect has been achieved.
Canon EOS 5D, 17–40mm lens 3 sec at f11, ISO 150

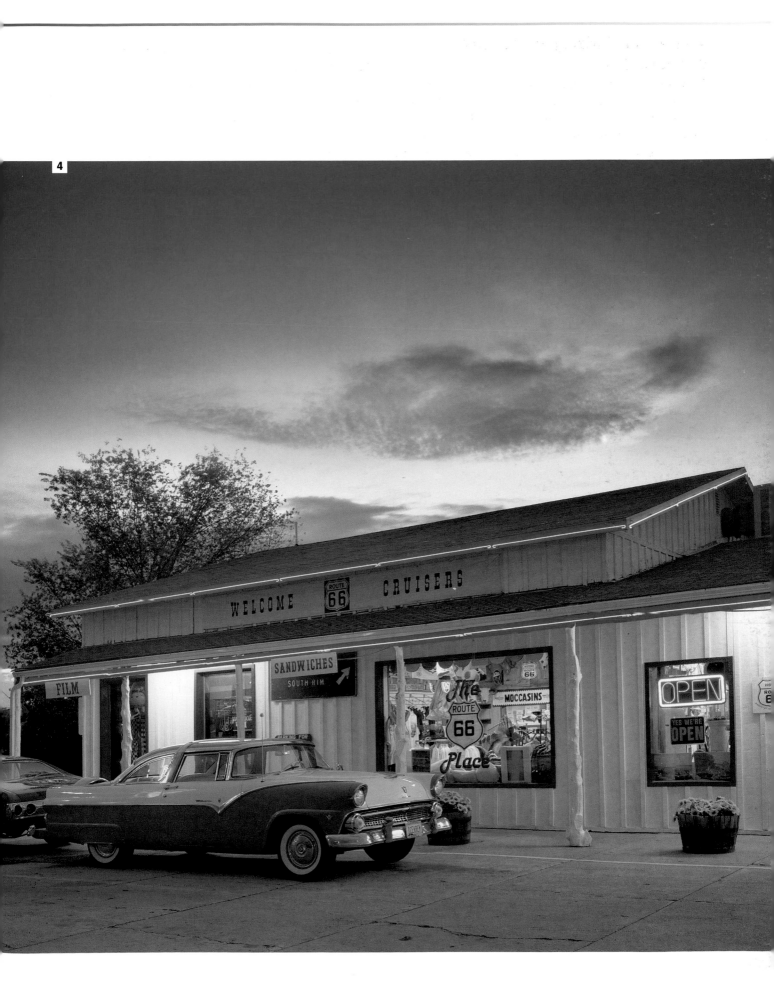

4

CREATING COMPOSITES

One of the features you will notice when photographing landscape in low light is how interesting many of the skies appear, but just occasionally it is worth swapping one for something better. Applying a simple cut and paste in Photoshop is all that is required.

I find one of the great advantages of using a digital SLR is that it positively encourages spontaneous photography, so whenever I see a great sky, I take it with a view to using it in a possible composite later on. As I am fortunate enough to live near to the coast, whenever the sky looks interesting I am able to photograph it with the sea in the foreground, which means that there are no unfortunate intrusions that might compromise my design. In fact, I have built up quite a bank of skies so that I am able to match them quite sympathetically. This is important: it pays to organize your files, so that skies

photographed at dawn are not mixed with those taken in the evening. It is essential that you ensure that the colour temperature in both elements remains consistent, otherwise the results of the composite will look phony.

Make a selection

This can be done in a number of ways. In this example, as the sky was flat and featureless and there are no contiguous areas of blue nearby, using the Magic Wand was the most appropriate tool to use.

Start by making a Background copy. While this layer is active, use the Magic Wand tool set to a tolerance of 40 to select the sky. This should be done without the selection impinging on any other parts of the image. If it does, use the Lasso tool set to 'plus' if you wish to add to the selection, and to 'minus' if you wish to remove any parts. Minimize the cinema file, open the new sky file, and then resize it so that it approximately matches the dimensions of the sky it is intended to replace.

TWO Making an accurate selection is the key to success. As there were no contiguous areas of blue, selection here was a simple matter of using the Magic Wand tool.

ONE While this lovely old cinema makes an interesting image, it is let down by the featureless blue sky. Making a selection was easy, as there were no complicated structures intruding over the horizon.
Canon EOS 5D, 50mm lens, 27 sec at f/16, ISO 100

THREE I selected this file, partly because it was photographed in the evening, but also because the hues are so similar to those in the building. It always helps if the sky you wish to use in a composite has no features that protrude above the horizon.

Replacing the sky

With the sky file on screen, go to Select All > Edit Copy. The familiar 'marching ants' will appear around the entire image. Bring back the cinema file, and while it is still active go to Edit > Paste Into. The new sky, which now becomes Layer 1, will appear in place of the old one. Sometimes the match is not perfect. With Layer 1 still active, go to Edit > Transform > Scale and, with the Shift key depressed, scale up the new sky. By activating each of the layers in turn, further tonal and colour changes can be made.

tip

Have various alternative skies to hand and be prepared to experiment.

FOUR By activating either the Background copy or Layer 1, you can make further tonal or colour adjustments to achieve a better match.

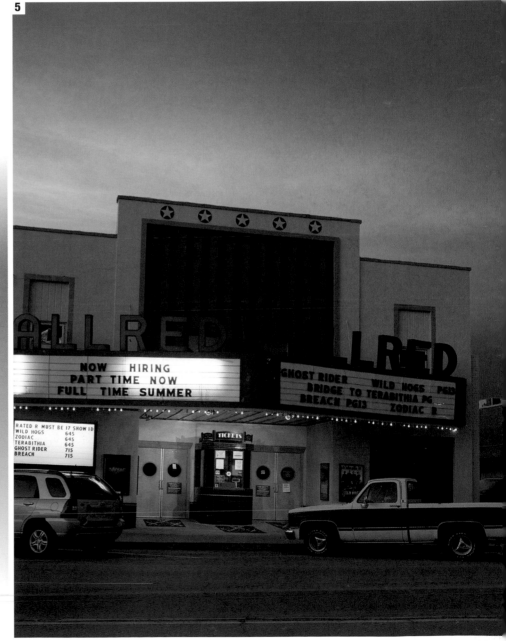

FIVE By selecting a sky file that was sympathetic to the original image, both in terms of scale and colour temperature, it has been possible to introduce it to the image without making the sky appear dominant.

EXTENDING THE DYNAMIC RANGE

Generally when photographing lit buildings, the best time to capture them is in crossover lighting; this is when the light in the sky precisely matches the illumination from the building. Obviously, for either practical or aesthetic reasons, you may wish to photograph the building later on when the sky and the other adjacent buildings appear darker. However, this is where you might experience difficulties with exposure. If you expose for the illumination, the sky and background will appear too dark; if you meter for the background, the highlights are likely to appear burnt-out. This is because you are exposing beyond the dynamic range of the sensor.

A digital camera does not have the same latitude compared to traditional colour negative film, although there are ways of expanding digital capture. What one really requires is a blend of the highlights of the first example with the background of the second. This can be achieved by creating a High Dynamic Range (HDR) image. A popular method for creating a HDR file is to use Photomatix, a piece of software that can be downloaded from the internet (www.photomatix.com). HDR files can also be achieved using Photoshop.

There are three simple ways to create an HDR file, which we outline below.

Method 1

To create an HDR image in Photoshop, you must first produce multiple examples of the same image each captured using a different exposure. When doing this, it is important to alter the speed setting, rather than the aperture, otherwise you risk inconsistencies in depth of field in each of the files.

Attach your camera to a tripod and take several exposures of the same image, ensuring that both the shadow and the highlight details have been captured. If you have not been able to take multiple exposures, but you have shot in Raw, you can create several files showing different exposures by using the Exposure slider in the Raw dialog, all from the same Raw file. You can take as many images as you require to cover the dynamic range of the image, although if you wish to use the Photoshop facility you should use a minimum of three images; in some circumstances you may require up to seven. Don't use the camera's auto-bracket facility, as the exposure changes are too small.

In order to create a HDR file using Photoshop, there are four simple stages.

Step 1

Select and adjust your Raw files in the Raw dialog, then save them as a DNG file. It is easiest to save them in a separate folder.

Step 2

To access the HDR command go to File > Automate > Merge. In The Merge to HDR dialog, click Browse and select the files you wish to use. In this example I have selected six.

Step 3

A second Merge to HDR dialog will appear that shows thumbnails of the selected images. It will also offer a Bit Depth menu and a slider for setting the white point. First, change the bit depth to 8-bits, then move the Set White Point Preview slider located below the histogram to set the white point for the merged image. Click OK to create the merged image.

Step 4

Having achieved your merge, you are still able to make further changes. The HDR Conversion Dialog will offer two sliders. The Exposure slider allows you to lighten or darken the entire image, while the Gamma slider allows you to change the tonality of the midtones. By clicking Toning Curve and Histogram, a curve will appear allowing you to make further changes. Finally, by scrolling Method you are able to select Local Adaptation. Using the pipette, select key tonal areas within the image and then click along the curve. Use these points to adjust the tonal range, and then once you are happy with the image click OK.

By creating a HDR in Photoshop, I was able to maximize the full tonal potential of the image.

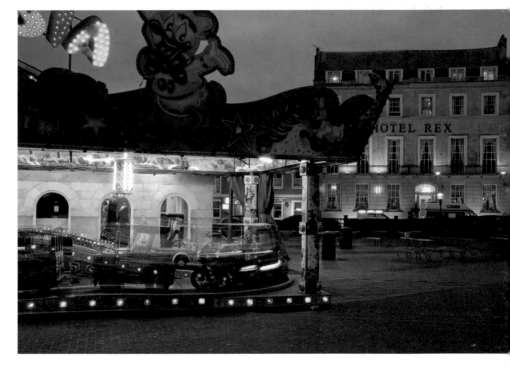

Method 2

A common problem encountered when photographing in low light is the excessive contrast of an illuminated building set against the background; often all that is required are two separate exposures, one for the illuminated parts and another for the background. Typically, if the background requires an overall exposure of 60 seconds, the highlights might need just 5 or 10 seconds. Checking the monitor can help greatly in these situations.

Step 1

Call up the darker file with the correctly exposed highlights. Then open the lighter image and, while holding down the Shift key, drag it over the Background layer; the lighter layer will become Layer 1. Set the foreground colour to black.

Step 2

With Layer 1 still active, create a layer mask. Then select a large soft brush tool, set to a low Opacity. Start with 20 per cent. If this proves too subtle, you can easily increase the Opacity, but err on the side of caution.

Step 3

It is important to use the Navigator at this stage; focus on an area that appears burnt out and carefully apply the brush tool to reveal highlight detail in the Background layer. Be prepared to change the Opacity either to increase or decrease the results. If you find that you have excessively burnt-in the highlights, mistakes can be remedied by toggling the foreground colour to white; this allows you to paint the detail back in from Layer 1.

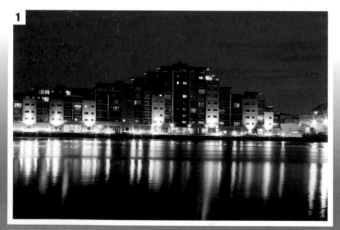

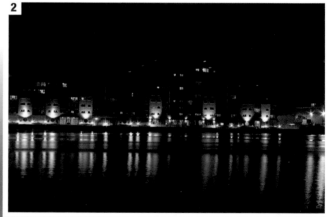

ONE If you photograph illuminated buildings as the evening drifts into night, you will encounter the inevitable burnt-out highlights. This required an exposure of 60 seconds.

TWO An exposure of just 8 seconds was required to capture the highlights without them appearing burnt out.

THREE By exposing the highlight detail of the Background layer through Layer 1, I was able to harness the best qualities from both files.

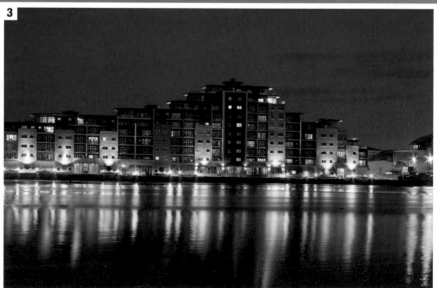

Method 3

Another simple technique is to select and drag the properly exposed highlights from the darker image into the lighter one. Make a selection of the properly exposed highlights and feather this by at least three pixels. One of the best facilities for selecting highlights is Color Range. Using the Fuzziness sampler, select the highlights you wish to use, call up the file with the properly exposed background and make this the Background Layer. Then, using the Move tool, drag the selected highlights from the darkest image into the lightest one. Accurately reposition this layer over the Background layer, which then becomes Layer 1. While this layer is still active, further tonal adjustments can be made without affecting the other parts of the image. Once you are happy with the results, flatten and save.

Use the Move tool to carefully drag the highlight detail from the darker to the lighter file. You will need to use the zoom facility at this stage. This becomes Layer 1.

Finally, many DSLR cameras now have a Highlight Tone Priority Feature. This function aims to optimize the cameras dynamic range by ensuring that the highlights cannot burn out. If you find yourself photographing in a high-contrast situation, selecting this facility from the menu might be a useful first step.

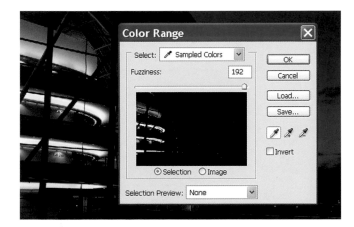

Color Range is possibly the best method for selecting highlights. Using the pipette sampler, choose a highlight from the darkest file and then use the Fuzziness slider to expand the selection.

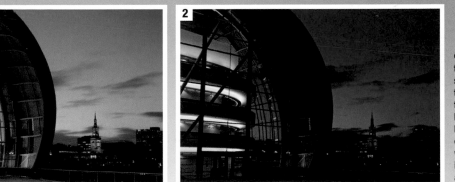

ONE While most of this image has been satisfactorily exposed, the highlights in the building on the left are excessively burnt out. This is a common problem when photographing illuminated buildings at night-time.

TWO On this occasion, I spot-metered the highlights in the illuminated building. Although these areas now appear perfectly exposed, it is at the expense of the rest of the image, which appears unacceptably dark.

THREE The problems of excessive contrast when photographing illuminated buildings, particularly in low light, can be easily overcome. You can either create an HDR image from variously exposed identical files or, as in this case, drag the correctly exposed highlights from the darker file into the lighter one.

INTENSIFYING LIGHT TRAILS

One of the ideas suggested in Chapter 3 was to photograph light trails. In order to get the best from this technique, you need plenty of vehicles to pass by. Of course, such matters are out of your control. One way of resolving this is to take various shots and then use the Blending mode in Photoshop to fuse several files together.

The first task is to establish a suitable vantage point and then to securely attach your camera to the tripod. Try to do this while there is still quite a lot of available light. Look carefully through your lens; once you have the perfect composition, lock the tripod head so that everything is secure. Pre-focus, and remember to switch off the autofocus.

You need to make various exposures of the same stretch of road. It is important that you do not nudge your camera or tripod, and this is where it really pays to have a remote release. Using a self-timer is not a good idea as it will require handling the camera. Try not to be over-anxious to take your shots and allow time for darkness to fall. Once this has occurred, start firing away, although try to wait for interesting clusters of vehicles to pass by. In the course of a session, you might expect to get five or six good shots. Once you have these, you will be in a position to create a composite from a selection of the images you have taken.

In Photoshop, open your files and select the best three or four. To see them on screen together, go to Windows > Arrange > Tile Horizontally. From this you should be able to make a better assessment. Select the file you wish to use as the Background layer. Then, while holding down the Shift key,

ONE Luck plays a part when photographing light trails. It depends on how many vehicles pass by during the length of the exposure, something of course, which is out of your control.

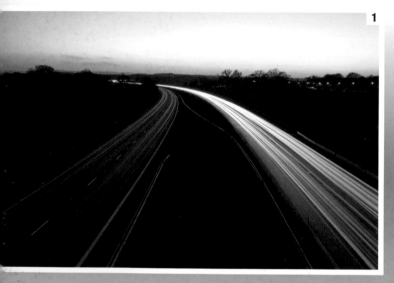

TWO In order to be able to evaluate your car trail files, go to Window > Arrange > Tile Horizontally. You can then plan how to stack your composite.

THREE Once you have successfully stacked the layers, activate each layer in turn, then apply Lighten from the Blending mode. Watch how each layer gradually intensifies the light-trail effect.

FOUR In order to emphasize the light trails, try darkening the sky. First make a selection, then make an Adjustment layer and select Curves. By carefully pulling down on the curve you will effectively darken the sky.

use the Move tool to drag one image over the other until you have stacked them all.

Open the Layers palette (Window > Layers). While the top layer is active, select Lighten from the Blending mode (see step 2). Once this is done, activate the layer below and repeat this process. The intensity of the light trails will increase as you do this. Having completed your stack, it can be useful to switch off the 'eye' icon to check that each of the layers is contributing. If not, keep that layer switched off, or simply remove it.

Once you have completed your composite, you may feel that the brightness of the sky needs to be reduced. Make a selection using the Magic Wand tool and feather the selection by five pixels. Make an adjustment layer and select Curves. Then carefully drag the curve downwards in order to darken the sky. Once you are happy with the composite, flatten and save.

tip
Use a small piece of card to cover the lens during an exposure when there are no vehicles passing.

FIVE By stacking your shots and using Lighten from the Blending mode you can use all the light trails accumulated over several exposures.
Canon EOS 40D, 17–85mm zoom lens, 5 min at f/16, ISO 100

5

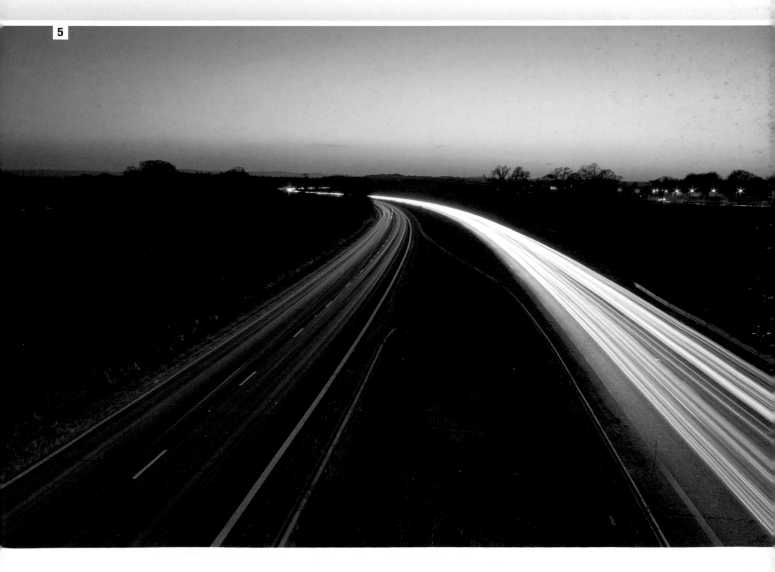

ACKNOWLEDGMENTS

Inevitably with a book of this complexity, help is forthcoming from a variety of sources. I am particularly grateful to the following people: to Neil Baber for commissioning this book; to Emily Rae for her constant advice and support; to Nicola Hodgson, who edited the work; and to Sarah Clark for her excellent design. Thanks also to my many models, including Mathew Beling, Keziah Brown, Mimi Winsor, Tim, Jack and Holly Rich, Olawale Omar Ajayi-Obe and my long-time 'marra' Jeremy Guy. I would also like to thank Canon UK, The Purbeck Sports Centre and the many groups of anonymous youngsters I kept meeting at night who – without exception and contrary to popular belief – were courteous, friendly and engaging. But I must reserve particular thanks for my wonderful wife, Eva. Not only has she provided me with some of the best images in this book, but I must thank her for checking my text, scouring the maps, putting my mobile in my bag, finding my cable release and all the other tasks she does that I cannot reasonably expect anyone to do.

ABOUT THE AUTHOR

This is Tony Worobiec's tenth book; past publications include *Ghosts in the Wilderness: Abandoned America*; *Icons of the Highway*; and the highly acclaimed *Black & White Photography in the Digital Age*, published by David & Charles.

A founder member and current chairman of the Arena group of photographers, Tony has won numerous awards both in the UK and internationally. His work is held in the permanent collection of The Royal Photographic Society and in numerous private collections in Europe, Japan and the US. He writes regularly on most aspects of photography for a variety of magazines in the UK and US. Tony lives in Dorset, England.

INDEX